PERSPECTIVES ON PHOTOGRAPHY

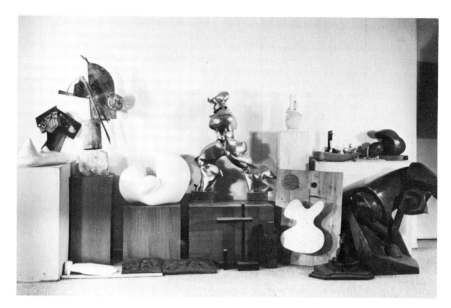

Beaumont Newhall, *"Not Art"—U.S. Customs, 1936.* "In 1936 Alfred Barr, director of the Museum of Modern Art, New York, imported from Europe pieces of sculpture and the constructions shown in this photograph for the exhibit 'Cubism and Abstract Art.' We of the staff assembled them in the museum lobby for inspection by U.S. Customs. Works of art lent for museum exhibitions are usually admitted duty free, but the agents declared these to be 'garden ornaments.' Alfred asked me to take this photograph, which we broadcast to the art magazines."

PERSPECTIVES ON PHOTOGRAPHY

ESSAYS IN HONOR OF BEAUMONT NEWHALL

Edited by
Peter Walch
and Thomas F. Barrow

University of New Mexico Press
Albuquerque

Design: B. Jellow

Library of Congress Cataloging in Publication Data

Perspectives on photography.

 Includes bibliographies.
 1. Photography—History—Addresses, essays, lectures.
2. Newhall, Beaumont, 1908– . I. Newhall, Beaumont, 1908–
 . II. Walch, Peter. III. Barrow, Thomas F.
TR15.P47 1986 770′.9 85-28824
ISBN 0-8263-0862-7
ISBN 0-8263-0863-5 (pbk.)

Contents

Preface

On April 20 and 21, 1984, the Department of Art and Art History of the University of New Mexico was pleased to host a series of lectures on the history of photography, dedicated to our eminent colleague, Beaumont Newhall. This book is an outgrowth of that symposium. Most of its contents are closely derived from the talks; Eugenia Parry Janis and Kirk Varnedoe, their lecture materials not being available for publication, have chosen to be represented here by articles which reflect the essential character of their symposium presentations.

Newhall's autobiographical sketch of his earliest years as a budding art historian is printed, with minimal editing, from a transcript of his talk. Everyone who has been privileged to hear a Newhall lecture will instantly recognize his style: an unparalleled combination of warmth and erudition, together with a generosity towards others' contributions that is frequently the hallmark of a first-class scholar.

The other essays are arranged here in the order in which they were originally delivered as talks. Roughly, we follow the history of photography from its early years through to the period between the two world wars, covering the span of time, and indeed many of the issues and figures, upon which Newhall has concentrated the bulk of his own prodigious research.

Mark Haworth-Booth's essay wonderfully reconstructs the milieu in which one of the most significant early Victorian connoisseurs of photography lived and formed his collection. The Rev. C. H. Townshend was a poet, a travel writer, and an essayist on religion. He collected old master pictures and gems as well as photographs. He was a friend of Charles Dickens and a champion of mesmerism. Haworth-Booth makes

a persuasive case for how these diverse interests each and all helped to shape Townshend's taste in photographs, a taste which has, as Haworth-Booth notes, fascinating predictions of currents in twentieth-century art.

We most often think of nineteenth-century photography as a progressive force, celebrating as it helped to document the advances of industrial civilization. There was, however, a darker, more troubled side of the century, to which photographers frequently turned their attention. Haworth-Booth's last illustration is an anonymous photograph of the Clerkenwell Explosion of 1867 in London; in "Demolition Picturesque," Eugenia Parry Janis writes about an extensive series of photographs documenting an 1852–53 clearance in Paris. Jean-Jacques Berger, prefect of the Seine, was in charge of this pre-Haussmann project; Henri Le Secq was the painter-turned-photographer who documented the demolitions in an album of twenty-two salt prints. In her text Janis dissects the motives—both political and aesthetic—of the administrator and of the artist. Relating Le Secq to currents of French thought expressed by such men as Victor Hugo and Théophile Gautier, Janis finds his images to be replete with protest, remorse, and melancholy at the forced disappearance of the beloved old city.

Anne McCauley is, in her contribution, concerned less with individual images than with untangling the social and financial structures within which French photography came of age during the Second Empire. She has sifted through mounds of primary documents to provide a statistically based and convincing picture of just exactly who became photographers (a striking diversity of backgrounds, and a goodly number of women as heads of studios), the costs and risks associated with running a studio, and the shifting locations of photographic establishments caught between the search for inexpensive rents and the necessity to locate near to prospective clients. From this evidence, and from contemporary literature and letters, McCauley gives us a more realized idea than hitherto possible of the hundreds of unsung pioneers of French photography.

Kirk Varnedoe's "The Artifice of Candor: Impressionism and Photography," examines the putative "historical partnership" between realism in painting (and, especially, in Impressionism) and photography. He takes issue with the commonly advanced notion that such artists as Manet and Degas were essentially indebted to photography for their visions of the world, that such eccentricities as peculiar cropping and overhead viewpoints came to painting from the world of lens and camera. Varnedoe argues instead that the Impressionists' tactics of representation were far bolder and more radical than those employed by contemporary photographers. From evidence both visual and written, he shows us that photography and painting in the 1870s had vastly different agendas.

Joel Snyder's essay brings us to nineteenth-century America, where he, like Varnedoe, is concerned with the relationship between photography and the established art mediums. Snyder writes partly in response to those recent critics who claim that "purely documentary" photographs—such as, supposedly, those made by Timothy H. O'Sullivan during expeditionary campaigns in the American West—should not be subjected to the same critical treatment as that given works of art. Snyder first examines this issue from a theoretical point of view, examining the difficulties inherent both in ascribing intentions and in attempting to separate the functional from the aesthetic. Next, he searches the archives of the expeditions to find under what orders and expectations O'Sullivan worked. He concludes that the available evidence fails to uncover any nineteenth-century distinction between the "art value" of photographic and hand-drawn landscape records. O'Sullivan's images were—and are—pictures.

Sarah Greenough's paper, "How Stieglitz Came to Photograph Clouds," has as its subject one of the more famous, yet least understood, bodies of work by that pioneering American photographer. These sometimes nearly abstract works, titled, variously, *Music: A Sequence of Ten Cloud Photographs*, then *Songs of the Sky*, and finally, *Equivalents*, are examined in the light of Stieglitz's own statements, of European aesthetic theory from the Symbolists onwards, and of early American modernist art. Greenough weaves these various threads into a convincing interpretation both of the Stieglitz images and of the highly charged notion of "equivalents" as it was received and modified by the Stieglitz circle.

The closing paper, provided by Amy Conger, deals with photographs of considerably more prosaic subject matter: a toilet photographed by Edward Weston over several days in 1925. Conger starts by carefully considering Weston's own lengthy remarks on the toilet photographs, recorded in his *Daybooks*. Before her essay has concluded, she has provided a brief history of modern plumbing fixtures, noted the publishing history of Joyce's *Ulysses*, and invited our consideration of the partial precedent for Weston's work given by Duchamp's 1917 *Fountain*.

These essays, thus, range widely in subjects and in methodologies. What all of their authors share is an abiding interest in the *contexts* of photography. Who made, or collected, or first wrote about these images? What art, or literature, or philosophical concerns helped to shape their styles and subjects? Formalist criticism is not forgotten in these essays—each of the authors can, and frequently in these pages does, write penetrating analyses of style—but formal concerns take a backseat to these other, broader issues. If a single word can characterize this shared interest, then we may call these *humanistic* histories of photography.

In Beaumont Newhall's essay, you will read that he objects strongly to being characterized as the "Father of the History of Photography" (and even more strenuously to being labeled in Vienna the "Papa" of photography!). You will also read his generous credit to Heinrich Schwarz for being one of the first to "consider the spiritual aspect of photography above the technical." But when we look at what we have labeled the common "humanism" of the essays in this collection, we have to recognize that it was Newhall above all others who brought to the fore this approach to the study of photographs and their history. His generosity, his learning, his wish to see photographs as part of culture, have informed the discipline beyond measure. The essays printed here are both tribute to and result of this remarkable man.

Peter Walch

The Challenge of Photography to This Art Historian

BEAUMONT NEWHALL

I want first to thank all of you for what truly is the greatest honor in my career. I have been fortunate to have had considerable recognition, but for you to come here from Europe and all parts of the United States to share your views and your research is an honor which I deeply appreciate.

This meeting began as a complete surprise party. I played no part in its organization. When I was asked for my approval, I enthusiastically agreed, and when I was asked to give the introductory lecture I thought that it would be appropriate to talk about the challenge of photography to the art historian. Then it became obvious that it might be more interesting if I made this a somewhat autobiographical sketch of how I got involved in photohistory. So I have changed one word in the title: "The Challenge of Photography to This Art Historian."

May I begin simply by asking what did I bring to my first university schooling? A lot of confusion at the age of eighteen! I recall I didn't know what I wanted to do. I now realize that I had a deep interest in historical research and in photography. Let me describe.

I was fascinated by the history of the clipper ships of the nineteenth century. I liked very much building scale models of them. I don't mean that I put together kits. I researched every aspect of the vessel I was going to model. I went to original documents, such as the builder's half model, from which I made measured drawings, and books of the period on shipbuilding and, in particular, rigging. I would like to think that the final model was equivalent to a written report. Indeed I made a written report for one model explanation. That report, with photographs of the model, was subsequently published in *The Mariner*, a journal of nautical history.

Motion pictures also interested me, particularly those experimental films produced in Europe. I found the film *Variety* more interesting for its photography than its scenario, and the camera work of Karl Freund than the acting of Emil Jannings. It was a circus story, a tale of two jealous trapeze artists who were in love with the same girl. One was going to let the other go in midair. The camera looked up and it looked down from a swinging trapeze. It was the imaginative, imitative camera work of Karl Freund and the vision of the director E. A. Dupont that gripped me. I wanted to become a motion picture director.

With those two juvenile interests I entered Harvard College in 1926. I thought the drama department would surely have courses in film, but I was disappointed that nothing on cinema or photography was offered. Then a wise freshman advisor said, "Why don't you try art history? Paintings are pictures, too!" So with that introduction I took every course on painting, sculpture, and architecture that was offered. As I look back upon the lectures, I realize that they were more archaeological than aesthetic. There was very little discussion of the visual aspects of the art of the past. But there were moments of great clarification.

I remember in particular Adolph Goldschmidt, who came to us from retirement in Germany as visiting professor. Although his speciality was medieval ivory sculpture, he lectured to us on Dutch and Flemish seventeenth-century painting. He opened our eyes. Instead of the usual slide examination in which we were required to identify the artist, title, date, and technique of a number of slides, he showed us just *one*: he told us it was *The Lacemaker* by Vermeer, gave its date, its provenance, its technique. He then said that the examination would be a description of the painting. He also used two slide projectors for comparative study, a technique now quite universal but unknown in the 1920s at Harvard.

As I went through my courses at Harvard, I did not forget my photography. To me, photography was like a personal diary, or someone playing the piano with no further thought than to please oneself and a group of friends. It never occurred to me that I would become a historian of photography.

I received my master's degree in 1931 and immediately went to work at the Philadelphia Art Museum as lecturer. Alas, the job—which I enjoyed—was short-lived. Like other junior members of the staff, I was informed on January 1, 1932, that there was no money to pay my salary. Because of the depression, the city budget for the museum had been severely cut. Fortunately I got a job almost immediately at the Metropolitan Museum of Art as an assistant in the Department of Decorative Art. This job, too, was short-lived for the same financial reasons. So I returned to Harvard to work for my Ph.D.

It was at this time that I became involved with the history of pho-

tography. I was regularly reviewing books for the *American Magazine of Art.* I think the editorial policy was rather peculiar in giving books on any aspect of art to a twenty-four-year-old art historian just fresh from Harvard, but it brought me a wide range of reading. One of the books was a collection of nineteenth-century photographs, *Aus der Fruhzeit der Photographie,* with historical texts by Helmuth Th. Bossert and Heinrich Guttmann, and published by the Societats-Verlag, Frankfurt am Main, 1930. I would like to read to you excerpts from my review:

> This excellent collection of 200 dated and documented photographs is interesting for the several lights that it throws on the art of the 19th century. The high level of the works of the many photographers represented, among them Nadar, Talbot, David Octavius Hill, Charles Victor Hugo and Karl Ferdinand Stelzner, will be a surprising revelation to many, particularly because of the astounding modernity of feeling.

I am sure that these "old masters" of photography are familiar to you, but I knew nothing of their work when I wrote this review. Why did I stress "the astounding modernity of feeling" of these photographs, all taken before 1870? The answer lies in the following sentences:

> Perhaps this is explained by the fact that the word "pictorial" had not entered the vocabulary of the photographer, a lack of technical perfection preventing him from vying with the painter. Pure photography was the only type possible. Today, those working with the camera are, for the most part, realizing that this is their only legitimate aesthetic, that the ability of the camera to capture the utmost possible detail of the natural world is its chief characteristic, and should be fully realized.

My generation at this period believed in this doctrine of "pure photography." We could not see the value of so-called pictorial photography, even as seen in the early work of Alfred Stieglitz and the members of the Photo-Secession. We particularly admired the photographs of Edward Weston, Ansel Adams, and Walker Evans. We were, of course, prejudiced by the "form follows function" aesthetic of the Bauhaus and the International style of architecture. My criticism of the pictorial was mild compared to that of my classmate Lincoln Kirstein, who wrote in the catalog of the 1938 Walker Evans exhibition at the Museum of Modern Art: "In the swampy margins of the half arts, the wallowing of the painter-photographer and the photographer-painter has spawned probably the most odious and humorous objects in the lexicon of our disdain."

I went on in my book review to point out art historical aspects of such early photographs as were published in the book.

For the student of painting, the collection furnishes material
for an illuminating study of the influence photography has
had on both the artist and the lay public. It seems very strange
to this reviewer that such an inquiry has never been thor-
oughly made.

It was not until later that I discovered that the book that had so
excited me was almost a plagiarism of several books already published
on the history of photography. I'm referring particularly to the mono-
graph on David Octavius Hill by Heinrich Schwarz. I came to know
Schwarz when he arrived in America, a refugee from his native Austria,
where he was director of the Belvedere Museum in Vienna. His writing
had a great influence on me. To my knowledge he was the only art
historian of this period to consider the spiritual aspect of photography
above the technical. This is not surprising when one considers that he
was a student of Max Dvořák, who himself, I believe, was a student of
Alois Riegl. These Viennese art historians had been introduced to me
by the wonderful director of the Philadelphia Art Museum, Fiske Kim-
ball. That has been a very important part of the challenge of photography
to this art historian, for it freed me from the need of rewriting the
technological history of photography.

In addition to the monograph on Hill there were published simul-
taneously in France and in Germany in 1931 two books with the same
plates, titled, respectively, *La Vieille Photographie* and *Die alte Photographie*.
This collection contained much material new to me, particularly the
photographs of the American Civil War from the collection of Berenice
Abbott. I also learned a great deal about the early days of photography
from the extraordinary exhibitions held by Julian Levy in his New York
art gallery. He had been inspired by Alfred Stieglitz, and it was his hope
to create a small gallery along the lines of "291." There I saw *original*
prints for the first time of Eugene Atget and Nadar. Unfortunately this
pioneer effort to sell old photographs was not successful, and the gallery
ceased showing photographs.

In 1934, while at Harvard working for my Ph.D., I was invited by
the chairman of the art department, Professor Paul J. Sachs, to represent
the graduate art history student body by giving a lecture at the College
Art Association in New York. This was a great honor. Professor Sachs
said, "Of course, as you know, the subject is up to you, and perhaps in
a couple of weeks you can come back to me with the subject and we'll
discuss it." I immediately replied, "Mr. Sachs, I know exactly what I want
to talk about: the relation of painting and photography in the nineteenth
century." Dear Mr. Sachs was so shocked by this he had to sit down.
Apparently he had never heard of such an extravagant proposition but

said, "Well, I gave you my word and I'll stick by it." So, at this meeting in the Metropolitan Museum of Art in April, exactly fifty years ago almost to the day, I gave my first lecture on the subject of what might be called "the art history of photography." It went over very well, and I was delighted that it was published in the College Art Association's monthly magazine, *Parnassus*.

So, I had proceeded a bit further in my study of this field, but the great moment came when I joined the staff of the Museum of Modern Art, New York, as the librarian. One fine day in 1936, Alfred H. Barr, the beloved founding director of that institution, stopped me in the corridor and said somewhat casually, "Would you like to do a photographic exhibition? We've always planned to have one. The trustees wrote it into the charter. I've got a budget of five thousand dollars." I asked, "What kind of exhibition do you want?" He answered, "It's not what *I* want, it's what *you* want." And that is a measure of what a fine man Alfred was. "Why don't we just do an overview to begin with?" I said. "Fine," he answered, and then he said, rather casually, "Of course you'll have to travel to Europe." I answered rather uncasually, "Why certainly."

At that point I really began to study the history of photography in earnest. I think I have made it clear that previously I was simply exposed to photography and it fascinated me, but I didn't really get down to work on the subject. Now, the first thing I did was carefully to go through the two finest histories of photography then available: the two-volume *Geschichte der Photographie* of Josef Maria Eder (1932) and *Histoire de la découverte de la photographie* (1925) by Georges Potoniée. Although both books were basically technological, they contained a wealth of illustrations of all kinds of photographs and a certain amount of aesthetic discussion. Then I read a more recent book, *La Photographie en France au dix-neuvième siècle: essai de sociologie et d'esthétique* by Gisèle Freund (1936). This book was, and is still, of great importance to me, for it goes into the social and aesthetic forces that shaped photography as a medium. A fourth book helped me greatly in putting together the exhibition and in writing the catalog introduction, and that was the catalog of the *Exposition internationale de la photographie contemporaine: section rétrospective (1839–1900),* held at the Musée des Arts Décoratifs in Paris from January 10 to March 1, 1936. The exhibition was very large: 1,236 photographs. Roughly speaking, half of these were contemporary, and the other half were historical, lent by some fourteen different private collections. When I went to France in the fall, I was prepared to meet some of these collectors. I could not have assembled such a fine exhibition at the Museum of Modern Art without their enthusiastic help.

Chief among these was Victor Barthélemy (who lent over a hundred photographs), Albert Gilles, and Georges Sirot.

How I put together this exhibition in the short space of time between the spring of 1936 and the following spring is only a testimony to the energy and optimism of youth. Unfortunately, Alfred Stieglitz, whom I wished to honor as chairman of the Advisory Committee, refused to participate; he felt I was too young and inexperienced. But we had the enthusiastic cooperation of Edward Steichen, Alexey Brodovitch, Laszlo Moholy-Nagy, C. E. K. Mees, director of research of the Eastman Kodak Company, Charles Peignot, publisher of the French annual *Photographie*, Paul Rotha, documentary film maker, and D. A. Spencer, president of the Royal Photographic Society, London.

Today, that exhibition is generally considered to have been historical. In fact 40 percent of the photographs were contemporary and 60 percent were historical. But it is true that the impact of the exhibition and its novelty lay in the little-known nineteenth-century prints. A handsomely printed hardbound catalog was published, containing an essay, the first of my writing about the history of photography as a whole. The show was a real success. Editorials appeared in the *Herald Tribune* and other newspapers. The *New Yorker* published Lewis Mumford's beautiful tribute.

I would like to conclude with a few words about what happened after the opening of the exhibition and how this led toward growing interest on my part and how I got into the flow of the subject and found other people working in the field. No sooner had the exhibition opened than I met Edward Epstean, a very fine man who had retired from his profession as a photoengraver and was translating all the classical histories of photography, including the titles I have already mentioned. All the time that I was struggling with Eder's two volumes in German, he had the manuscript of his translation in his New York apartment! Unfortunately the translation was not published until after World War II, when the German rights were released. When Epstean was asked by the Macmillan Company to read "Photography and the American Scene," a manuscript submitted by Robert Taft, professor of chemistry at the University of Kansas, he brought it over to me, dumped it on my desk, and said, "You do it, and they'll pay you fifteen dollars." I went to work at once and was fascinated to discover that this unknown author had gone over much of the same ground that I had and come to certain similar conclusions as myself. Indeed, I felt so strongly about it that I requested a letter certifying that the manuscript had been sent to Epstean after the publication of my own book. I highly recommend the publication of Taft's book, which, as I am sure you all know, became a classic, twice reprinted.

I think that what I have said covers just about everything up to 1940, when, finally, the already prestigious Museum of Modern Art formed its Department of Photography. The subsequent development of the appreciation of photography as a part of the history of art is known to you all.

I would like to wind up by saying a few words about what I think are my contributions to this field. I hope that you will agree with me that what I have done is to chart a course for future study. I object very much to being called the "Father of the History of Photography," as if the whole field sprang out of my head full-fledged. Even worse is to read in a Viennese newspaper that I am the Papa of Photography. Of course that's a play on words because not only the Pope of Rome is Papa, but also the man who knows most in his field. It didn't shock German-speaking people the way it did me, but at any rate, I have tried to build a core, if one can put it that way. My history is somewhat vertical, and I think that what we are doing now is spreading out horizontally from this core into many areas. So many of you have helped me in this that I can't extend my thanks or even name what you all have done. To me, it is most exciting and rewarding to have this broadening and enrichment of the field. Among your recent contributions are the handsome book *The Art of French Calotype,* by André Jammes and Eugenia Janis, and *The Golden Age of British Photography,* edited by Mark Haworth-Booth. The relation of photography and painting has been explored by Van Deren Coke and Aaron Scharf. Definitive monographs have been published: among them James Borcoman's *Charles Nègre,* and *Spirit of Fact,* a study of the Boston daguerreotypists Southworth and Hawes, by Robert Sobieszek and Odette Appel-Heine. I could go on naming many other books.

Of great importance is the recent republication of long out-of-print classics in the history of photography. To have so many books available is a great service, particularly to those of us who are distant from the great libraries on the East and West coasts. I salute the editorial work of Robert Sobieszek and Peter Bunnell for their work with the Arno Press.

And finally, I want to praise the publication of books reproducing selections from museum collections, such as Weston Naef's publication of the Stieglitz collection in the Metropolitan Museum of Modern Art, and Marnie Sandweiss's beautiful publication of American photographs in the Amon Carter Museum in Fort Worth.

There we have what happened to this art historian when he got in contact with photography.

A Connoisseur of the Art of Photography in the 1850s: The Rev. C. H. Townshend

MARK HAWORTH-BOOTH

The Bible shows the very same Hand that made creation—beautiful and large in its scope—wonderful in its minute details. The microscope of faith will show ever-increasing wonders in its least world. Like the brain, it has millions of fibres to the square inch.

—*C. H. Townshend, Religious Opinions,* 1869

There is something very sad, I find, about nineteenth-century written records of photography. If we look for monuments to those who invented, informed, or explored photography in its earlier years we find meager memorials. So much was allowed to slip away unrecorded and unremarked. Where we do find an obituary of a pioneer the chances are that its contents will prove to be lamentably wrong. We are left wondering quite how much photography valued itself if its memory was so faulty and its written monuments so scarce. This paper is an attempted corrective to that typical pattern of neglect.

It is also a good moment, perhaps, to try to find more witnesses of the early period of photography. It is a good moment for two special reasons. The first is that during the last fifteen years we have experienced and observed a fantastic reawakening of interest in photographs as items to be scrutinized, studied, cared for, and collected. We have seen, that is to say, a genuine and rather surprising development of connoisseurship in photographs. One of the chief areas of acquisition by the collectors who have emerged in this recent period—I mean such collectors as Mr. Sam Wagstaff and Mr. Paul Walter in New York City, the great corporate collections such as Seagram's and Gilman Paper Company's, and the many collectors in America and Europe known to students of photography, not omitting the major museum collections—one of the main areas has been the 1850s. The reason for this is, in part at least, because in the 1850s the medium of photography was dramatically broadened in terms of accessibility to amateurs and professionals and sharpened in terms of the accuracy combined with relative speed available with collodion on glass negative plates. New technology opened new

subjects to new practitioners, and exhibition-scale prints became a feature of the scene. The collectors of our own day have been alive to the romance involved in these sudden changes. The second reason for trying to look for some authentic witnesses of the 1850s is that sudden changes in the technologies of our own period may have placed us in a position of striking similarity to the 1850s vis-à-vis photography. In the 1850s much was said about photography, and the medium was at its most fashionable precisely because photography was on the verge of change. It was, in fact, on the verge of mass production and full industrialization, which occurred in the 1860s. With the current upsurge in electronic imaging technologies, traditional photography is seen to be precisely that—traditional. I do not suggest that still photography is postindustrial, but I do believe that the development of a new connoisseurship of photography of our day owes something to the replacement of the printed still photograph by the moving (video, televisual) photograph as principal carrier of mass information. We are, perhaps, in an especially good position to enter into some of the concerns that surrounded photography in its brilliant and just preindustrial period of the 1850s.

It is, I am afraid, the case that most contemporary connoisseurs of fine photographs have said all too little, publicly at least, about why they collect. I am not sure that many of them could really put their reasons or their compulsion into any convincing form of words: nor so far as I know did the subject of this paper, C. H. Townshend. The cause of this silence about underlying aims is probably that collectors do not simply collect photographs. They collect the shifting meanings that are associated with certain photographs at a particular moment. Pinning down those invisible surrounding meanings is not at all easy. However, I have found that a good guide to my own feelings about photographs—and not early ones only—is the person I should like to introduce in this paper. Over the past few years I have slowly found out a number of things about Chauncy Hare Townshend (1798–1868), poet, savant, dilettante, and collector.[1]

I became aware of and interested in Townshend because he bequeathed to the Victoria and Albert Museum a fine photograph by Camille Silvy. The photograph, *River Scene, France* (1858), was first exhibited at the Photographic Society of Scotland in autumn that year, and a contemporary critic wrote of it as "perhaps the gem of the whole Exhibition: We have seen no photograph which has taken our fancy so much as that exhibited under this unpretending title. . . . The natural beauty of the scene itself, rich in exquisite and varied detail with the broad soft shadows stealing over the whole, produce a picture which for calm, inviting beauty we have not seen equalled."[2]

It is worth recalling that this particular photograph was included in the famous Salon of 1859 in Paris when the new medium was shown—for the first and for many years the last time—as an art alongside paintings. In his review of the salon, a well-informed critic, Louis Figuier, placed Silvy at the head of the modern school of landscape photography. It was, then, not simply the quality of the photographs Townshend collected but also their place in history that drew me to him and gradually made me think about why he collected photographs—indeed, what other photographs he owned, what works of art, what books, what, if anything, he might have written, what other interests he had that might illuminate his somewhat rare status as a connoisseur of photography during the 1850s.

One of the good things about institutions of the longevity of the Victoria and Albert, whose direct ancestor the South Kensington Museum opened its doors in 1856, is their records. An old file in the museum's registry tells the story of how Townshend's collection came to the museum. It is set out in a memorandum written to the museum's founder and first director, (Sir) Henry Cole by G. F. Duncombe:

> Some years ago the Rev. Chauncy Hare Townshend of 21 Norfolk Street, Park Lane, a very old friend of my family, while walking with me through the Museum stopped to examine the jewels exhibited in the South Court, and to compare them with those in his own collection. Mr Townshend having no children, it occurred to me that it would be a noble thing for him to leave his collection by Will to the South Kensington Museum, which at that time had no precious stones except on loan. I made the suggestion to him, and he seemed pleased with the idea, and subsequently often referred to it. I endeavoured from time to time to keep it alive, and further suggested that as he resided but little in England, and his collection was nearly always at his Bankers, he might present it during his lifetime to the Museum where it would be properly displayed and taken care of for the public benefit and where he could always come and see it. I think he had quite resolved to do this; and even so recently as the 17th February last, when he came here to speak to me about some Hogarth engravings that had been stolen from his house during his absence, he told me that it had been his intention to present them at once to the Museum. That part of his intention, however, was never destined to be fulfilled for he died after a very short illness on the 25th of last month, just a week after his visit to me here.
>
> I have since had the satisfaction of learning that about

three years ago, Mr Townshend added a Codicil to his Will, by which he more than carried out the suggestion that I ventured originally to put to him. I was invited to attend his funeral on Monday last, when I was informed by his Agent & Lawyer, Mr Jackson, that in his Will he desires that the Lord President [at that time Lord Granville] will select for the S.K. [South Kensington] Museum any of his pictures that he may think fit, and of his books that contain engravings, Bewick's British Birds, and Quadrupeds, and bequeaths to the Museum his collections of jewels, coins and engravings.

Some of the Pictures are very valuable; there is a large Virgin and Child by Raffaelle, inherited, I think, from Lord Coleraine; Danby's large picture of the Upas Tree; a Robson; several Morland's; and many foreign pictures among which I remember that there is one by Théodore Rousseau.

Mr Hunt (Hunt & Roskell) told me that he had had a great deal to do with this collection of precious stones, and that he valued it at from £7,000 to £10,000. I believe also that the Swiss Coins are very valuable; but the Collection of Engravings has unfortunately lost one of its most important objects—the early Hogarth Prints which have been recently stolen.

The Pictures and Books not selected for South Kensington are to go to the Local Museum at Wisbech, in the neighbourhood of which were Mr Townshend's Estates.

Mr Jackson asked me how he had better make this bequest known, and when I told him to write to you officially as Secretary of the S.&A [Science and Art] Department, he said he should do so, as soon as the Probate Duty had been arranged.

G F Duncombe
6 March 1868[3]

On the basis of this memorandum we can see what a wide range of interests Townshend had. Precious stones come first; there are important paintings by old and modern masters, engravings, illustrated books, and coins. The photographs are not mentioned in the memorandum, but they appear in the inventory of Townshend's house and were accepted by the South Kensington Museum—although not, unfortunately, all of them.[4]

Townshend is the only major collector of early photographs in Britain identifiable now other than Prince Albert. (I know of no French or German collectors of fine photographs at this period.) I should like to concentrate here on the following topics: what is known of Townshend's taste and sensibility from his writings; the character of his art collections; the relationship between paintings and photographs in his collection;

some speculations as to how Townshend's other interests, and those of his circle, may have informed his vision of photographs.

Townshend was generally known in his time as a poet and connoisseur. His first prose work is *A Descriptive Tour in Scotland* (1840, 2nd edition 1846), a rare volume possibly worth reissuing for its lively style and its evidence of the sensibility of the years in which it was written, which are of course those in which photography was invented. The book gives ample evidence of the cult of Sir Walter Scott, the rise of tourism in the Scottish Highlands and Islands during the 1830s, the survival of the Picturesque taste of a generation earlier and, perhaps most important, its transformation by the growth of scientific rigor in description. Townshend has frequent praise for the guidebooks of Dr. Maculloch, whom he admired for setting a new standard of precise observation in natural history and antiquities, "presenting to the mind's eye an orderly and varied universe, in which each single object possesses its distinctive character."[5] Townshend often found fault with topographers for redrawing the lines of hills and valleys to suit their own artistic conventions or convenience:

> The pencils of the artists have produced more convulsions among the rocks of Glenmore than the deluge, and have, without any remorse or geological compunction, converted sloping into vertical strata, to say nothing of annihilating, at one flourish, some few thousand acres of ground, and so making very neighbours of the two sides of the glen which, in truth, keep at a respectful distance from each other.[6]

Townshend was a marvelous mixture of the interests of the 1830s. For example, he was a child of the Romantic age. When he journeyed to Fingal's Cave on the Isle of Staffa he was only twenty years behind John Keats and ten behind Felix Mendelssohn. Townshend, however, seems to represent that scientific, precisionist cast of mind characteristic of mid-Victorian, mid-century England. This is how he looked at the famous basalt columns of Fingal's Cave with their almost architectural regularity:

> . . . From my having seen so many views of the cave I had formed for myself a tolerably accurate picture of its general appearance. That wherein it chiefly differs from any representation, is that there is none of that artificial formality which the pencil perhaps necessarily conveys. All is bold, free and natural, though regular, and the detail of checkered colour and broken surface is so varied that one rises above all petty notions of the masonry of art.[7]

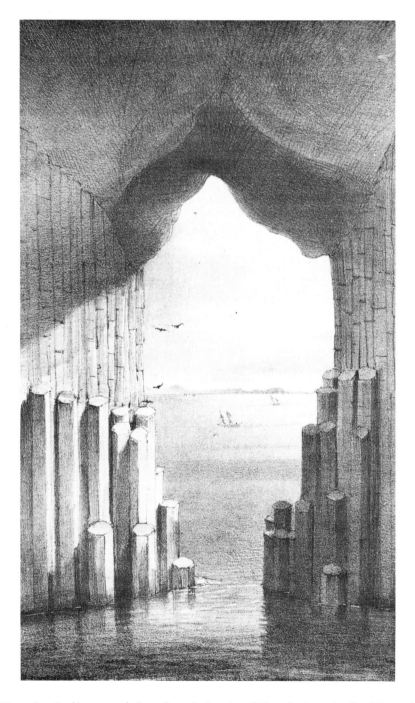

Figure 1. Looking towards Iona from the interior of Fingal's Cave, Staffa, lithograph by Fourmois from A Descriptive Tour in Scotland.

Townshend's interesting response is, surely, underlined by the ar-
tifice and order imposed on the subject by the lithograph in his book
that illustrates the scene (Fig. 1). His book reveals a sensibility well pre-
pared, it seems, for the abundance of detail and freedom from "con-
vention" offered by the pencil of nature. It is worth quoting in brief
Townshend's remarks on trees, which became a dominant picture subject
of early photography:

> Why is it that the sameness of a wood is never oppressive or
> fatiguing, while any other species of monotony wearies and
> disgusts? Is it that the apparent monotony of trees is not real
> sameness? The elements, indeed, are few and simple, but
> allow, in their combinations, an extreme diversity of light and
> shade, of form and colour. This evening, in particular, I was
> never weary of watching the changeful outline of the trees,
> which terminated the vista before us, and were thrown out
> into strong relief against the yellow sky, sometimes massy as
> mountains, sometimes light and fantastic as the tracery of a
> Gothic window.[8]

These sentiments are representative and have some bearing on the
dominance of trees as a photographic subject in the 1850s. They help
us to sense Townshend's possible response to the particularly good pho-
tographs of trees, by Le Gray (Fig. 2) and others, he was to acquire in
the 1850s.

Townshend also provided a fine definition of the typical Picturesque
subject matter of early photography which it is worth recalling here.
Writing on the Picturesque in *Blackwood's Edinburgh Magazine* in February
1830, Townshend (under the pseudonym Timothy Crusty) remarked on
our "primeval architecture":

> How beautiful are all its forms,—how congenial to the paint-
> er's art! Its very humblest work is as much embued with an
> imaginative spirit as its noblest. How admirably an old cottage,
> with its pointed gables, twisted chimneys, and carved porch,
> harmonises with the various outlines of nature.

Let us now turn to Townshend's art collection and its character. For
our guide, initially at least, we can turn to Dr. Waagen, director of the
Royal Gallery of Pictures, Berlin. Dr. Waagen drew attention to the
Townshend collection in his *Galleries and Cabinets of Art in Great Britain*.[9]
He regarded it as singular because "it not only contains many remarkable
specimens both of the earlier and modern English school, but is also
interspersed with admirable works by the best painters of Belgium, Hol-
land, Germany and Switzerland, which are comparatively seldom met

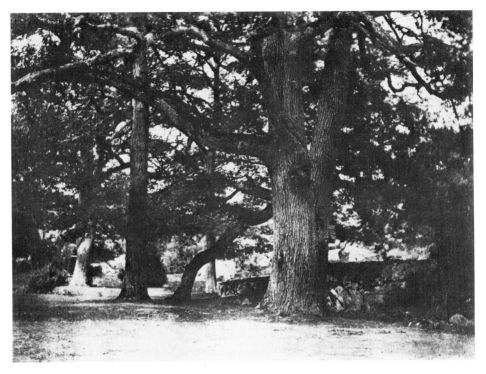

Figure 2. Gustave Le Gray, The Forest of Fontainebleau, *1851, albumen print (probably c. 1855) from waxed-paper negative.*

within England." Townshend's was an unusual collection, and Waagen also carefully noted that the paintings "have a most satisfactory effect in the light and handsome apartments in which they are placed." I have suggested in *The Golden Age of British Photography 1839–1900* that Townshend and his apartments at 21 Norfolk Street, Park Lane, are the prototypes for the famous fictional connoisseur Mr. Fairlie, master of Limmeridge House in *The Woman in White* (1860) by Wilkie Collins. Townshend's art collection shows a preference for works painted in a style more or less derived from seventeenth-century Dutch painting and typified by "very careful execution of detail," as Waagen noted of Francis Danby's *The Upas Tree,* or "picturesqueness of conception truth of every part, and careful execution," the words with which Waagen described a winter landscape by Andreas Schelfhout (1787–1870), whom he placed at the head of the modern Dutch school. Of English paintings especially noted by the German connoisseur were examples by William Collins, by Clarkson Stanfield ("A rocky sea-coast with a town. In front a vessel on the rough water; the sun is just breaking through clouds"), and by Wil-

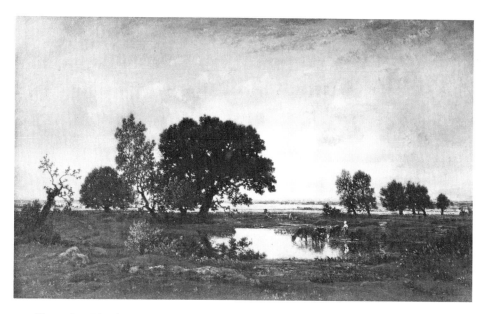

Figure 3. *Theodore Rousseau,* View in the Landes (near Bordeaux), *1855, oil on canvas.*

liam Mulready ("A richly wooded landscape, with a piece of still and transparent water. . . . The whole is imbued with the most refined feeling for nature, and notwithstanding the close individuality of nature, viz. in the trees, the keeping admirably preserved. . ."). The "keeping," the harmonious relationship of parts, gave both portrait and landscape photographers trouble in the early period, and the problem was crucial in Lady Eastlake's decision that photography could not be fine art.[10]

In both subject matter and style the paintings Townshend collected are fully congruent with most of the photographs he acquired in the 1850s. The landscape photographs he owned include the Picturesque themes collected together and published under the editorship of Professor Philip Henry Delamotte as *The Sunbeam* (1859), the woodland and marine photographs by Gustave Le Gray, and landscape featuring foliage, standing water, and cloudy skies by Camille Silvy (as already noted) and Albert Giroux. The stylistic convergence of landscape painting and landscape photography is most strikingly shown by two works probably acquired by Townshend in 1855, when he visited Paris to see the Exposition Universelle, or soon after. The first is the painting by Théodore Rousseau referred to by G. F. Duncombe above, a landscape known as *A View in the Landes (near Bourdeaux)* (Fig. 3). Dr. C. M. Kauffmann writes of this work in his catalogue of the foreign paintings in the Victoria and

Figure 4. Albert Giroux, Landscapes, *c. 1855, albumen print from two wet collodion negatives, signed with blind stamp.*

Albert: "This painting belongs to the period in the latter part of Rousseau's career, beginning in about 1852, when he came increasingly under the influence of the Dutch 17th century landscape painters, and his work betrays a greater emphasis on carefully finished execution."[11] The general features of the scene, but also the precise manner of treating the surface of standing water, is paralleled by a landscape photograph Townshend acquired (Fig. 4). It is by Albert Giroux (1801–79), a bronze medallist at the 1855 exhibition. Giroux can, like the photographer Le Gray, be classed with the Barbizon school. His photograph evidently relied on considerable manipulation of the negative to achieve a treatment so strongly reminiscent of the painted effects of Rousseau. Here, then, we find Townshend collecting a new style of painting (which drew inspiration from an early model but also looked forward to the experiments of Impressionism) and a new kind of photography which was painterly in its approach (i.e., manipulation of the negative and use of a second

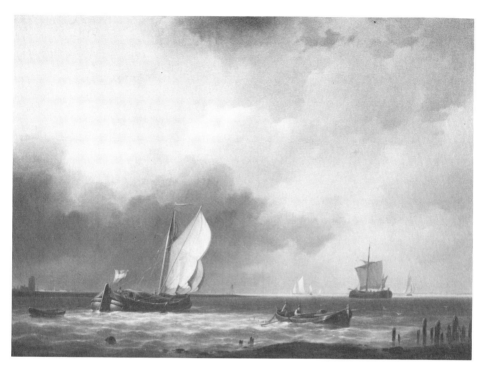

Figure 5. Hermann Koekkoek, Sea Piece, *1844.*

negative to print in the cloud detail in the sky). That is to say, Townshend collected a somewhat photographic painting simultaneously with a noticeably pictorial photograph.

In his study at 21 Norfolk Street a number of paintings were hung, as the inventory shows.[12] Among these were a modern Dutch seascape by Hermann Koekkoek (1815–82) dated 1844 (Fig. 5). It is instructive to compare this painting, and other works such as the seascape by Clarkson Stanfield (so ardent an admirer of photography) with the most sensational photographs acquired by Townshend in the 1850s—the marine studies of Gustave Le Gray (Fig. 6). Placing the paintings side by side with the photographs surely suggests why Le Gray's photographs were found sensational when they were exhibited in England in 1856 and 1857.[13] The near-instantaneous images of Le Gray offered a new paradigm of spontaneous vision, complete with a minuteness of record that surpassed their precedents in painting.

In this same study hung a painting that Townshend may have placed there with a slightly self-conscious idea of its appropriateness: *The Philosopher* (Fig. 7, noted by Waagen and therefore acquired prior to 1854–

Figure 6. Gustave Le Gray, Sea and Sky, 1856, albumen print from two wet collodion negatives.

56) by the Belgian Nicaise De Keyser (1813–87). This painting presided over the room in which Townshend apparently wrote, worked with his collections, read, and shared amusements with friends. In the form of a pastiche of seventeenth-century paintings in style and accoutrements— memento mori, incunabula, mundus, caskets, crystal goblets, and other rare and gleaming treasures—the philosopher sits, illuminated by a shaft of sunlight, poring over an ancient text, quill at his side. In Townshend's study we find, in the inventory, a framed print of *Our Saviour,* plaster copies of gems, ring cases, a hand glass, five stereoscopes, seven musical boxes, a large stereoscope, and many stereoscopic slides. Here also were portraits in cases—either painted miniatures or daguerreotypes or both (they have been mislaid or lost but may have passed to his family and could still exist)—and *A Photograph Album in Russia Leather* (also, like the stereos, not known to survive).

Given the presence of *The Philosopher* as a pretext, is it possible to conjecture about Townshend's view of photography? We have already seen that he brought to photographs many of the mid-century's received

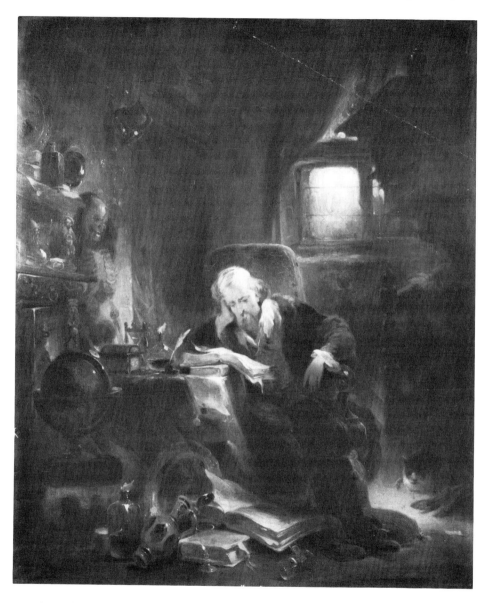

Figure 7. Nicaise de Keyser, The Philosopher, *oil on canvas. This painting was acquired before 1857 and hung in Townshend's study at 21 Norfolk Street, Park Lane, London.*

artistic ideas. Let us speculate about those ideas more typical of the years of the 1840s, 1850s, and 1860s. These ideas are frankly speculative, and I put them forward in the hope that others may find some aspects of them worth confirmation, denial, or adaptation.

I believe that Townshend's interests and the photographs (and other objects) he collected are related to four kinds of vision. They can be called, more or less loosely: (1) latent vision, (2) gem vision, (3) eyewitness vision, (4) detective vision. Possibly these four specialized branches of vision correspond with characteristic varieties of imagery which make up the epoch of photography from the days of Townshend to our own.

First, latent vision. I want first to place Townshend in time. The best way to do this is to look at his posthumously published book *Religious Opinions* (1869) and briefly at Townshend the man, as remembered in the prefatory remarks by his friend Charles Dickens, who served as editor of this volume:

> Mr Townshend's varied attainments, delicate tastes, and amiable and gentle nature caused him to be beloved through life by the variously distinguished men who were his compeers at Cambridge long ago. To his Literary Executor [Dickens himself], he was always a warmly-attached and sympathetic friend. To the public, he has been a most generous benefactor, both in his munificent bequest of his collection of precious stones to the South Kensington Museum, and in the devotion of the bulk of his property to the education of poor children.

Townshend's notes on religion, shuffled together into book form with great difficulty by poor Dickens, were seriously intended by their author to alleviate the distress of unbelievers and turn skeptics back to true religion. This arresting passage takes us to the heart of Townshend's intellectual concerns, I believe:

> Many years ago, when as young men at Cambridge, myself and my friends in pursuit of truth used to discourse on religious topics, I was struck by a remark made by Baptist Noel: "It is not fair to attack Christianity through the sides of Judaism." From that moment for a long time after, a separation in my mind was established between Judaism and Christianity; and the Bible was not merely separated into two grand divisions—the Old and the New Testaments—but was absolutely sundered and split in two, so that Judaism, in the form of the Old Testament, was lopped away like a withered branch from all assimilation with my spirit; and Christianity, under the guise of the New Covenant of God with man, was alone established in the inner sanctuary of my mind as the Bible, the

true Bible, or Word of God. "Behold, old things are passed
away. All things are become new," seemed to me a sentence
decisive of the fact that Christianity was not merely a reform,
but an abrogation—not a continuation, but a replacement; an
absolute phoenix starting out of the funeral pyre, and scat-
tering ashes over a past state of things.[14]

Here, of course, we have Townshend's version of the Romantic
sensibility in full flight, separating itself convulsively from an oppressive
prior dispensation in favor of new channels of feeling and a grand new
order. Townshend expressed this intuition of a profound split of dis-
pensations, exemplified by that between the Old and New Testaments,
in his poem "Jerusalem" (1817), which was awarded the then major honor
of the Chancellor's Prize Medal at Cambridge University, and the poem
is strongly marked by the imagery of violence characteristic of the period
during and after the Napoleonic Wars. Townshend seems to have rec-
ognized that he was born at a turning point of history. He challenged
the condescending attitudes of normative understanding by taking up
the cause of mesmerism, on which he published two books and which
he demonstrated in London society to sensational effect.[15] Perhaps it was
in part Townshend's adventurous love of the outré, the strange, and the
new which appealed to Dickens, who portrayed his friend as Cousin
Feenix in *Dombey and Son* (Fig. 8). The two men first met in 1840 at the
house of one of the most fascinating intellectuals of the period, Dr. John
Elliotson, another major proponent of mesmerism, or "animal magnet-
ism" as it was also known. Thinking about latent vision, let us recall one
of Townshend's sensational demonstrations of mesmerism. Fanny Kem-
ble remembered a demonstration which involved a "magnetic boy" called
Alexis, whom Townshend had found in Belgium and brought to London.
Thrown into a mesmeric sleep by Townshend, the youth—his eyes tightly
bandaged—was able to read aloud from books placed before him. It
may well seem far-fetched, but I believe there may be a mysterious and
almost invisible link between Townshend's ardent championship of mes-
merism—which did, after all, have hypnotism and its benefits as a central
feature—and his interest in collecting those subtle, spontaneous, and
sensational photographs of the 1850s (such as Le Gray's sea/cloud-scapes)
we have mentioned. I have adopted the phrase *latent image* to embrace
the two spheres of interest, but a more suggestive word might be *auto-
matism,* which would lead us directly to the crucial use of photography
in the period of Surrealism. I cannot dismiss Townshend's mesmeric
investigations as a fad. After his death his friend Dean Goodwin of Ely
Cathedral spoke of Townshend's book *Facts in Mesmerism* in these terms:
"It is impossible for any work to contain more startling experiences; and

it came upon the public with all the weight due to the known truthfulness of the author's character."[16]

With the concept of gem vision we are on much firmer ground. The Jewellery Gallery at the Victoria and Albert displays 120 gems, cameos, and intaglios bequeathed by Townshend. Looking at these treasures today it is interesting to align them with Townshend's photographic acquisitions. *Gem* is, of course, a cliché for photographic and other kinds of excellence, but the connections go deeper. The connoisseurship of gems must be among the most complex there is, as the differentiations are minutely subtle. One day we shall, I hope, see an exhibition in which Townshend's gems are shown alongside his other acquisitions, including such photographs as Silvy's *River Scene, France.* By the term *gem vision* I mean to indicate a vision which welcomes both extreme intricacy and something else. Unlike any other phenomena I can think of, apart from photographs, gems belong to two separate but completely intertwined disciplines. When Townshend's gem collection was catalogued and published, it was described from the viewpoints of both science and art.[17] A gem is a natural phenomenon, but it is also cut and polished with artifice. And, of course, if it is carved as an intaglio it then forms the equivalent of a matrix like a negative and its configuration needs to be reversed by printing to be fully seen. I also believe that gems were perceived very differently in the 1850s than they are now. Their symbolism was, perhaps, less sullied by monetary value and more open to metaphoric use. Townshend's poetry has many references to the traditional symbolism of gems. If we hold together in our minds the properties of gems and of the finest photographs of the 1850s we may move closer to the way in which Townshend, and maybe the photographers themselves, thought of the art. In this respect a book in Townshend's collection is of special relevance. *The Sunbeam* (1859), an anthology of photographs mainly of the British landscape and picturesque subjects, edited by Philip H. Delamotte, professor of drawing at King's College, London, displays extracts of poetry beside each photograph. The poetry, much of it derived from Wordsworth, is intended to provide metaphorical meanings for the photographs and reads today as an apologia for photography as a natural poetics.[18]

Eyewitness has a modern ring, but the dictionary shows that the term has a very long pre-Victorian history. A young friend of Townshend's, Charles Allston Collins, published a regular column in Charles Dickens's magazine *Household Words* in the 1850s. He signed his column "The Eyewitness," and when he gathered these pieces into book form in 1860 he explained that the idea of writing the series had been prompted by Townshend. It was Townshend who first told Collins about a demon-

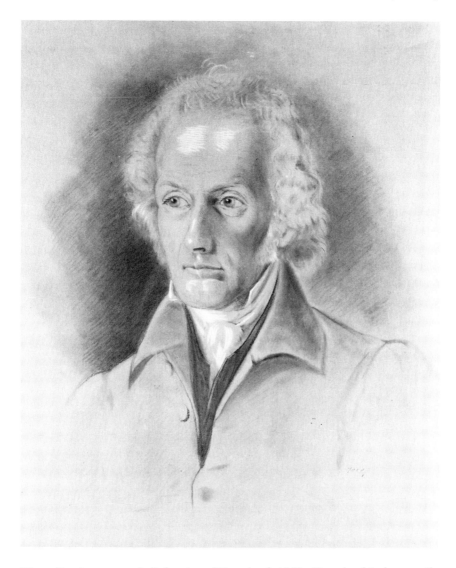

*Figure 8. Anonymous chalk drawing of Townshend, 1840s. Townshend is shown as the
 debonair aristocrat, the model of Cousin Feenix, the good-natured milord in Charles
 Dickens's* Dombey and Son.

stration in London of a phenomenon called the "talking fish," which
turned out when examined closely to be a whimpering and unfortunate
seal. Collins dedicated the book to Townshend, who owned, by the way,
the last painting exhibited by C. A. Collins in his financially unsuccessful
career as a Pre-Raphaelite. His essays are topical and shrewd and attack
a variety of impostures noted by Collins among the shows of London,

in which he included the National Gallery. The most clear-cut case of "eyewitness vision" in Townshend's collection is his set of photographs from the Crimean War by Roger Fenton. As David Hockney and others have been reminding us recently, one of the key characteristics of photography is that (space rocket and bank cameras apart) the practitioner has to be present at the scene described. Townshend's collection of Crimean photographs includes Fenton's portrait of an eyewitness who had a profound effect on British policy and institutions, the correspondent for the *Times* William Howard Russell. Russell's dispatches provided evidence of gross administrative incompetence which forced the resignation of Lord Aberdeen's government in February 1855. His reports distracted attention from fictional tales, as novelists like Wilkie Collins discovered to their cost. "The reading public, given a front seat by war correspondents and the new electric cable, abandoned literature!"[19] In the spring of 1855 a cable was laid from Varna in the Crimea to Bucharest, which brought London within twelve hours of the Crimea. Russell used the electric telegraph only once, after the capture of Sebastopol. His letters took fifteen to twenty-one days to reach London. Fenton's photographs illustrated the army's encampments in barren terrain, the anchorage and railhead at Balaklava, Sebastopol after its bombardment and surrender, the famous "Valley of the Shadow of Death," and portraits of the allied commanders, their officers, and entourage. The incompetence of government in the prosecution of the war gave impetus to the Administrative Reform Association, of which Townshend's friend Charles Dickens was a prominent adherent. It has been said that "the Crimea campaign . . . made the Circumlocution Office parts of *Little Dorrit* (1855–57) peculiarly topical, and they were substantially fair."[20] Among other things, the Crimean War threw into relief the dangerous incompetence of a civil service appointed by patronage rather than competition. The photographs of Fenton presented the theater of war in a new medium appropriate to the reforming passions the campaign aroused. They showed what was to be seen on the ground by one who was necessarily an eyewitness. They belong, with the reporting of Russell and the drastic revision of the structure of the civil service, as part of the apparatus of modern society.

The idea of the detective is a refinement on the new utility vision typified by the war correspondent and the war photographers. The detective is, obviously, an eyewitness, but perhaps he is something more. Charles Dickens produced a prototype of the fictional detective in the person of Nadgett in *Martin Chuzzlewit* (1843–44). This Nadgett, a confidential agent or "watcher," is remarkable for his sharpness of vision, but also for the fact that he seems to take in *everything:* "Mr. Nadgett's

eyes were seldom fixed on any other objects than the ground, the clock or the fire; but every button on his coat might have been an eye, he saw so much" (Chap. 27). This phenomenon if unsympathetic creature plays a crucial part in the novel and exemplifies a quality noted in Dickens himself by Walter Bagehot: "He has . . . the peculiar alertness of observation that is observable in those who live by it. He describes London like a special correspondent for posterity."[21] But Bagehot, like many later disadmirers of Dickens, found that the novelist's all-encompassing style of delineation drove out that sense of proportion characteristic of true art: "the diffused sagacity in his own nature . . . has made his pictures of life so odd and disjointed."[22] A writer in *The North British Review* condemned Dickens's style, as exemplified in *Martin Chuzzlewit*, because it displayed a "ludicrous minuteness in the trivial descriptive details" reminiscent of "a photographic landscape" in which

> not a leaf, or stone, or nail is wanting, or out of place; the very bird is arrested as it flits across the sky. But then, the imitating agent takes exactly the same pains with the dunghill and the gutter, as with the palace and the forest tree; and it is as busy with the latchet of the shoe and the pattern of the waistcoat, as with the noble features of the human face. Mr Dickens' pencil is often as faithful, and not more discriminating. He lavished as much attention on what is trivial or useless as on the more important part of the picture, as if he could not help painting everything with equal exactness. Neglecting the effective outline, the charm of harmonious grouping, and of contrasted light and shade, he crowds his canvas with figures and notes the very hat, neckcloth, and coat buttons of each; dwelling upon his city scenes, whether connected or not with the business in hand, till he has enumerated the tables and chairs, and even counted the panes of glass. There is no judicious perspective, and withdrawing from view of disagreeable particulars. We stand as close to the most offensive object, and see its details as nakedly, as if it was the most agreeable. Thus, when Tigg is murdered by Jonas, the author affects not to describe the actual deed of blood, but, in the reflections of the murder afterwards, he thrusts on us the most revolting details. He paints the criminal: "in fancy approaching the dead body, and startling the very flies that were thickly sprinkled all over it, like heaps of dried currants."[23]

The passage offers a fascinating comparison between a key characteristic of both photography and the style of Dickens. However, Dickens's special sharpness of looking is parallel to a characteristic and role which became institutionalized in the 1840s and 1850s. He published a

series of articles in 1850–52, beginning with "The Modern Science of Thief-Taking," in his magazine *Household Words*. His articles describe a night "On Duty with Inspector Field" in the London slums; "Down with the Tide" is an account of the work of the Thames River police (material used later in *Great Expectations*); "The Metropolitan Protectives" is about the night shift at a London police station. Philip Collins has convincingly suggested that Dickens found the new and centrally organized police and detective forces attractive because of the social advance they represented. Sir Robert Peel's Act of 1829 was calculated to make the police exempt from political jobbery by requiring that all posts save that of commissioner be filled from the ranks.

> From the start there was no separate "officer class" in the police, nor were the pay, conditions and status such as would normally attract "gentleman recruits." . . . Drawn from the lower but still respectable classes of society, they belonged to an organisation which had been founded in the face of traditionalist prejudice and which relied on a domestic system of promotion rather than on the jobbery that riddled the older bureaucracies."[24]

Dickens thought of the police as agents of reform as well as order. Dickens focused his ideas on this subject most completely in his creation of Mr. Bucket, the famous detective who makes his appearance in *Bleak House*. What marks him out, apart from his social mobility, is the quality of his vision. He was based on Inspector Field, who was described by Dickens as possessing a "horrible sharpness." He is first encountered at a meeting between the powerful lawyer Tulkinghorn and the little stationer Snagsby:

> Mr Snagsby is dismayed to see, standing with an attentive face between himself and the lawyer, at a little distance from the table, a person with a hat and stick in his hand, who was not there when he himself came in, and has not since entered by the door or by either of the windows. There is a press in the room, but its hinges have not creaked, nor has a step been audible upon the floor. Yet this third person stands there, with his attentive face, and his hat and stick in his hands, and his hands behind him, a composed and quiet listener. He is a stoutly built, steady-looking sharp-eyed man in black, of about middle-age. Except that he looks at Mr Snagsby as if he were going to take his portrait, there is nothing remarkable about him at first sight but in his ghostly manner of appearing. "Don't mind this gentleman," says Mr Tulkinghorn, in his quiet way. "This is only Mr Bucket" (Chap. 22).

The look of one taking a portrait is unlike normal social looking. It is

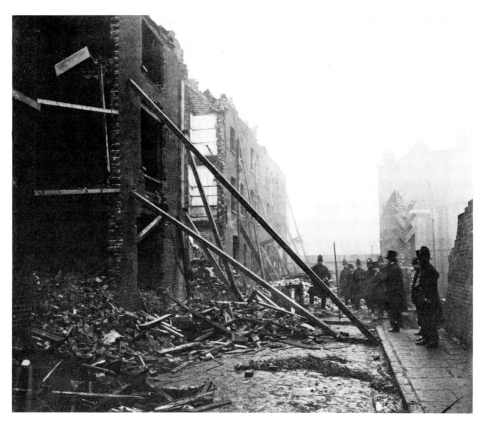

Figure 9. Anonymous, Clerkenwell Explosion, 1867.

functional, rather than sociable, and it is comparable with the close-up inspections we permit dentists and doctors but few others. In fact, Bucket's vision is not only functional and objective; like the real detectives of whom Dickens wrote in *Household Words,* he also had what would now be called a photographic memory. His vision was instantaneous and permanent. In the manuscript of the novel Dickens originally wrote: "Except that he looks at Mr Snagsby as if he were about to take his portrait, *and had got it . . .*" (but afterwards deleted the words in italics).[25] I should like to suggest that the act of looking at the world through a (photographic) lens has correspondences to the special kind of vision so abundantly located in the persona of the detective. Taken together with the detective's social mobility, which exceeds even that of a journalist, it is easy to see why the detective drama became the staple of fantasy entertainment: because it allows its audience to become both universal and asocial. The most forensic of the photographs acquired by Townshend document the Clerkenwell Explosion of 1867 (Fig. 9). In this example from the series we see police and detectives at the scene of the

crime. Above them, near the collapsing chimney pots is a trio of "watchers" observed and recorded as only a photograph could.

These four types of vision are associated with photography through the interests and the surviving collection of C. H. Townshend. Perhaps they also have some say in the interests of representative latter-day photographers. Thinking only of illustrious, recently departed masters of the art of photography, the idea of latent vision (or automatism) is associated with Man Ray, the gem vision with Ansel Adams, the eyewitness with Brassaï and Bill Brandt, and the detective vision with both of them but perhaps even more with the master of street photography and the fleeting details of behavior and their surprising—sometimes morally incriminating—relationships, Garry Winogrand. In closing, I should just like to add that the dominant feature of C. H. Townshend, whose activities prompted this discussion, is his precisionism. Reading and rereading the works of Professor Beaumont Newhall is also to participate in an intellectual precisionism so ably devoted to the history of the medium of photography.[26]

NOTES

1. The first full account of Townshend is my essay "The Dawning of an Age: Chauncy Hare Townshend, Eyewitness" in *The Golden Age of British Photography 1839–1900,* published by Aperture, a division of Silver Mountain Foundation, in association with the Victoria and Albert Museum, 1984, to accompany a major exhibition at the Philadelphia Museum of Art.

2. This famous photograph is best reproduced in the title referred to above, p. 13. A full discussion of it is my essay "Closely Observed Photographs," *Camera Austria: Zeitschrift für Fotografie* 11/12, 1983, 37–44.

3. Victoria and Albert Museum Registered Papers: C. H. Townshend Nominal File.

4. Missing are his stereographs, portrait daguerreotypes (he is known to have owned a daguerreotype of the novelist Edward Bulwer-Lytton), and, most tantalizingly, a framed photograph of a waterfall and *An Album in Russia Leather,* which are recorded in the Victoria and Albert Registered Papers. Also missing are his miscellaneous unpublished writings which could include remarks about photography.

5. C. H. Townshend, *A Descriptive Tour in Scotland,* 2nd edition, London, 1846, 266.

6. Ibid., 35.

7. Ibid., 133.

8. Ibid., 247.

9. Gustav Friedrich Waagen, *Galleries and Cabinets of Art in Great Britain,* London, 1857, 176–81.

10. Lady Eastlake's essay is now conveniently reprinted in Beaumont Newhall, *Photography: Essays and Images,* New York, 1980.

11. C. M. Kauffmann, *Catalogue of Foreign Paintings* II: 1800–1900, London, 1973, 90.

12. Victoria and Albert Registered Papers.

13. Haworth-Booth, *The Golden Age of British Photography,* 17.

14. *Religious Opinions* of the late Reverend Chauncy Hare Townshend. Published as directed in his will by his literary executor, London, 1869, 17.

15. Townshend published *Facts in Mesmerism, with Reasons for a Dispassionate Inquiry into It,* London, 1840, 2nd ed. 1844; and *Mesmerism Proved True: And the Quarterly Reviewer Reviewed,* London, 1854.

16. Harvey Goodwin, D. D., *An Address upon the Reopening of the Wisbech Museum, 31 May 1869,* Wisbech, 1869, 14–16. I am grateful to Jane L. Arthur, curator of the Wisbech and Fenland Museum, for her help in studying Townshend.

17. South Kensington Museum: *Precious Stones Considered in Their Scientific and Artistic Relations, with a Catalogue of the Townshend Collection etc.* London, 1905.

18. Haworth-Booth, *The Golden Age of British Photography,* 17–18.

19. Nuel P. Davis, *The Life of Wilkie Collins,* Urbana, 1956, 156.

20. Philip Collins, *Dickens and Crime,* London, 1962, 1966.

21. Philip Collins, ed., *Dickens: The Critical Heritage,* London, 1971, 390–401.

22. Ibid.

23. Ibid., 190.

24. Collins, *Dickens and Crime,* 219.

25. Manuscript in the Forster Collection, Victoria and Albert Library.

26. I should also like to acknowledge a debt to the essay "Morelli, Freud and Sherlock Holmes: Clues and Scientific Method," by Carlo Ginzburg, *History Workshop, A Journal of Socialist Historians,* Spring, 1980, 5–36. Ian Jeffrey kindly drew my attention to this.

Demolition Picturesque: Photographs of Paris in 1852 and 1853 by Henri Le Secq

EUGENIA PARRY JANIS

Paris de mon enfance, qu'est-tu donc devenu?

—Henri Le Secq

In memory of François Braunschweig

Georges Haussmann was not the sole force directing Napoléon III's great transformation of Paris. Important work was carried out by his predecessor Jean-Jacques Berger (1790–1859).[1] Berger's tenure as prefect of the Seine lasted less than four years, for he was reluctant to spend or raise the vast sums necessary to fulfill the new dream of reform and beautification, and the emperor eventually got rid of him. Most witnesses and modern historians consign his phase in public works to oblivion and define his cooperation as sluggish, ineffectual, and full of stalling tactics requiring official threats and confrontations. Viewed by the standard of Haussmann's achievement, that of Berger seems meagre indeed;[2] but in following the republican government's 1849 law[3] to clear the slums between the old Louvre and the Tuileries Palace (place du Carrousel) and extend the rue de Rivoli, the prefect's administration took the first giant steps toward mammoth changes that followed.

During the years of greatest turmoil between Berger and Louis-Napoléon, a painter Henri Le Secq (1818–82) recorded the center of Paris with a camera. In an album of twenty-two beautiful salt-print photographs from waxed-paper negatives dated 1852 and 1853, their bistre coloration magnificently preserved,[4] Le Secq reminds us not only of Berger's considerable efforts before "Haussmannization," but testifies to urban cataclysm, unprecedented, necessary, and full of dread.

Virtually ignoring pressures to begin constructing the Central Markets,[5] Berger turned to building clearance, which liberated important structures engulfed by dwellings, such as the tour Saint-Jacques-la-Boucherie. During his brief tenure he participated in the rather unglamorous, even tragic, side of Paris's radical redesign by opening up many

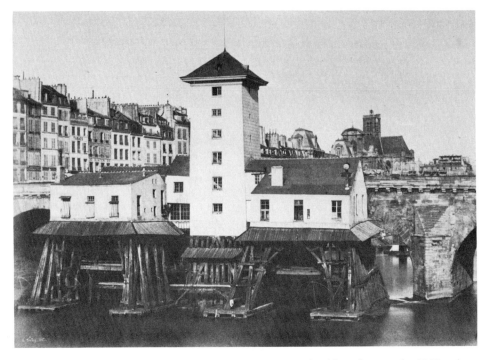

Figure 1. Henri Le Secq, The Notre-Dame pump (west side), photograph, 1852,
Album Berger. *Paris, Bibliothèque historique de la Ville de Paris. (Note: all illus-*
trations are photographs by Henri Le Secq from the Album Berger *unless otherwise*
noted.)

grand spaces Haussmann would elaborate with his uniform cachet. Le
Secq's album focuses on demolition, and the photographs single out
monuments whose obliteration seemed imminent. Scheduled for de-
struction was a seventeenth-century water pump supported by wooden
piles (Figs. 1, 2), a remarkable form on the Seine. Housed with its own
little bridge on the west side of the pont Notre-Dame it fed a score of
city fountains.[6] A hidden turret in the old place de Grève, (place Hôtel
de Ville, Figs. 3, 4) and what had been the architectural folly of the Bains
Chinois at 27 boulevard des Italiens (Fig. 5) are also photographically
isolated. Veritable phantoms of former brilliance and renown, they await
the wrecking ball. As for buildings cleared to unite the Louvre and the
Tuileries Palace, Le Secq's photographs show tenements leveled, work
nearly complete (Figs. 6, 7). In desolate spaces, the stones that formed
the "murderous" neighborhood Balzac deemed appropriate to house the
vicious and calculating heroine of *La Cousine Bette*,[7] and interestingly, the
site of English photography inventor William Henry Fox Talbot's first

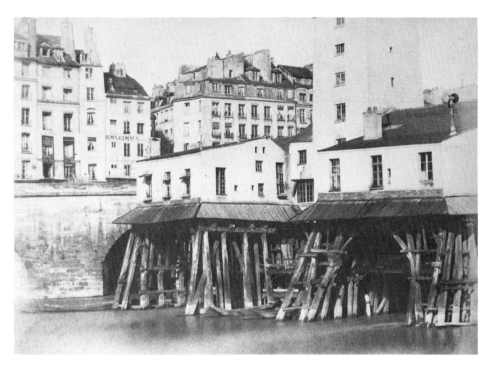

Figure 2. The pilings of the Notre-Dame pump.

lessons to the Parisians in the paper negative process in 1843,[8] now mix indistinguishably with the rubble of royal stables.[9]

Changes around the old Louvre affected Louis-Napoléon's other priority at this stage, the rue de Rivoli. The photograph album concentrates on the second stage of work extending the street farther eastward from the rue de Rohan to the rue de Sévigné. Berger proceeded at a snail's pace on this extension, but in early 1852 the emperor, via Persigny, minister of the interior, forced him to raise funds and accelerate progress.[10] Almost half the album pictures follow the axis crossing the rue de Rivoli along the pont Notre-Dame (Figs. 8, 9) as it continues northward, through demolitions on the rue de la Vannerie and the rue Saint-Martin (Fig. 10) to the newly emerging tour Saint-Jacques (Fig. 11), looking like a colossal mushroom suddenly exposed to light. Southward the pont Notre-Dame leads to the Latin Quarter via the Petit Pont, composed by Le Secq in a geometrical ensemble that locks the forms of the Marché-Neuf with the square towers of Notre-Dame Cathedral (Fig.

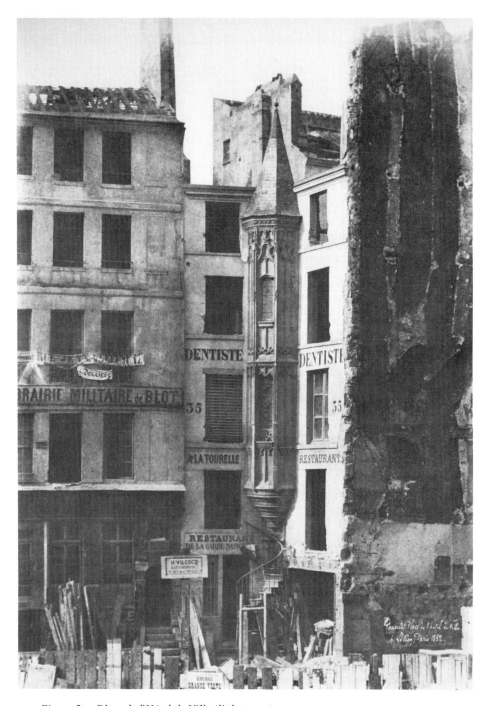

Figure 3. Place de l'Hôtel de Ville (little turret).

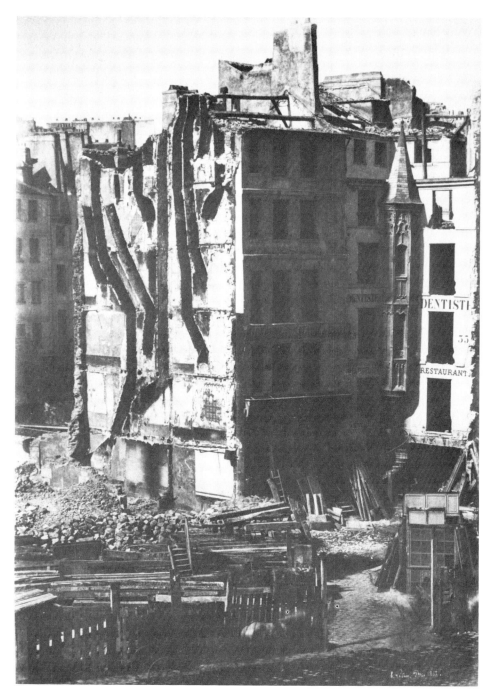

Figure 4. Demolitions of the place de l'Hôtel de Ville.

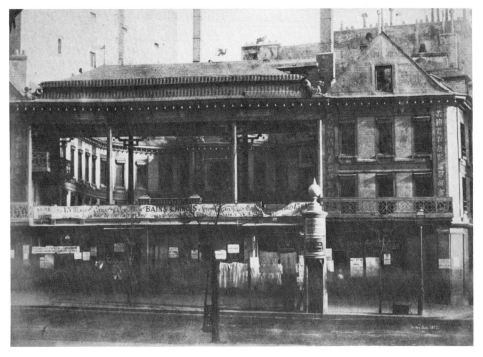

Figure 5. The Bains Chinois just before demolition.

12). This photograph's striking resemblance to Charles Meryon's etching
Le Petit Pont (1850) which Le Secq possessed[11] suggests the photogra-
pher's strong ties to a well-established picturesque tradition in the graphic
arts, a matter to which we shall return.

Le Secq saw Berger's work on the rue de Rivoli destroy many ancient
corners, meandering streets, and centuries-old buildings precious to French
heritage. "Car Paris c'est la France/ Pour un parisien de véritable aloi,"
goes his poem "Le vieux Paris," which continues, "Je suis ce qu'on appel
ami du pittoresque; pour moi la ligne droite irrite le bon goût,"[12] affirm-
ing the photographer's antiquarian position of protest. Victor Hugo's
incantations of "Rivoli, Rivoli, Rivoli" would more ferociously denounce
the street's relentless vector as a symbol of imperialism tearing into crowded
sectors, displacing the poor and seeming to summarize with its malady
of alignment all the evils of modern progress.[13] The extended rue de
Rivoli eradicated patterns of life for all classes. Particularly crucial for
Le Secq was the disappearance of the entire north side of the old rue
Saint-Antoine, site of the barricades, for Hugo the heart of the Paris of
the people and Le Secq's childhood neighborhood; he was born on the
rue des Juifs. The Le Secq family having moved nearby to the imper-

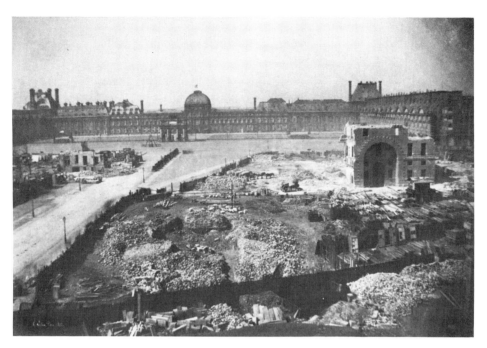

Figure 6. Place du Carrousel just before demolition of the old Royal Stables.

turbable île Saint-Louis by 1850,[14] Henri returned habitually to the cen-
ter city marking the changes with his camera.

Le Secq's album photographs mix the wonder felt in viewing radical
transformations of the familiar with a sense of remorse. Such contra-
dictory emotions wrenched the hearts of many Parisians. Daumier im-
mortalized the confusion in lithographs for the popular press. Théophile
Gautier reflected in *Le Moniteur universel:* "Sans doute le penseur sent
naître en son âme une mélancolie, en voyant disparaître ces édifices . . . ;
l'alignement coupe en deux plus d'un souvenir qu'on eût aimé garder."[15]
Herein lies the complexity of the photographs. In recording Berger's
public works, and isolating architectural fragments subject to irretriev-
able loss, the images inevitably raise issues that consumed the opposition
among antiquarians, historians, and other enemies of progress so vocal
during the Berger and Haussmann years.[16] The photographs are the
lament of an "ami du pittoresque," the word *picturesque* understood less
as bygone charm than as tantamount to oblivion.[17] We must not assume
that Berger himself was free of these sentiments, although it is unknown
how this consummate politician actually felt about the Paris "qui dis-
paraît."[18]

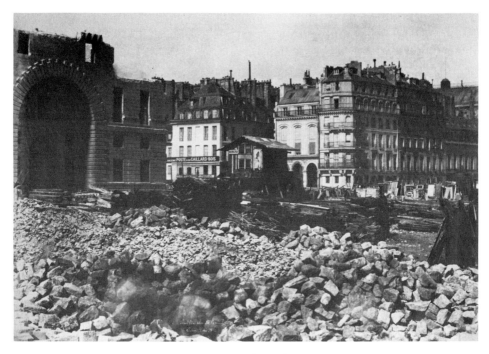

Figure 7. The rue de Rivoli (left corner of the place du Palais Royal) just before demolition.

 Whatever predispositions or pecuniary habits led Berger to buck Napoléon III and his ministers by treating the national budget as cautiously as his own pocketbook, and despite the doubtlessly unpleasant circumstances requiring his removal by 1853, the album, which includes no work from the Haussmann period, clearly aims to point out the significance of the former prefect's role in terms of modern French history. This would explain the album's two introductory photographs: in the first (Fig. 13), a windblown facade of the Hôtel de Ville, festooned with flags and posting results of the plebiscite, November 21–22, 1852— "7,824,189 oui" proclaims the beginning of the Second Empire. "L'Empereur est Empereur," concluded Edmond Got in his journal.[19] In the second photograph (Fig. 14) the facade of Notre-Dame stripped of original sculpture (before Viollet-le-Duc's restorations there) and draped with painted cardboard and cloth festival architecture and sculpture surrogates, photographically translating into an effect of byzantine mosaic, heralds the sumptuous marriage of Napoléon III to the marble-complected Spaniard Eugénie de Montijo January 30, 1853.[20] Through symbols of imperial consolidation in state and church, the album sets a

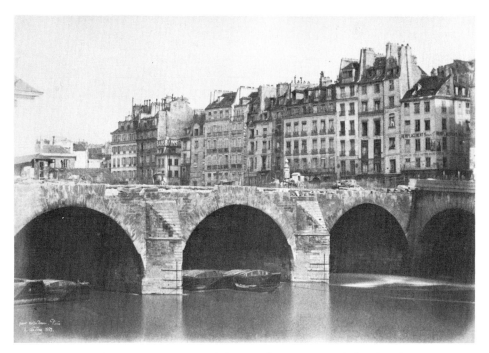

Figure 8. The pont Notre-Dame and the quai de Gesvres (just before demolition).

tone celebrating the majesty and popular acceptance of the Bonaparte regime Berger had served for better or worse.

If Le Secq sequenced the pictures, their order suggests that his own political loyalties did not deviate from those of many well-entrenched bourgeoisie of property. His own father's desire to maintain order and continuity above all probably led him to favor Napoléon III,[21] who as we shall see found him reliable. Henri's interest in photographically promoting the architectural glories of the past links him with Hugo's artistic idealism, expressed before and after 1848. But this did not result in a break with reigning bourgeois ideals and expectations, which forced Hugo's exile to the Channel Islands for the duration of the Second Empire. Le Secq's photographic art would transpose Hugo's extravagant pulsations of light and shade into a radically new visual poetics because those associations suited his new medium. In terms of social politics he was not particularly engagé. Throughout the Second Empire Le Secq took to his island too, but it was the île Saint-Louis.[22]

There is no evidence of the album's being commissioned, nor is there evidence beyond the pictures themselves to confirm my suggestion

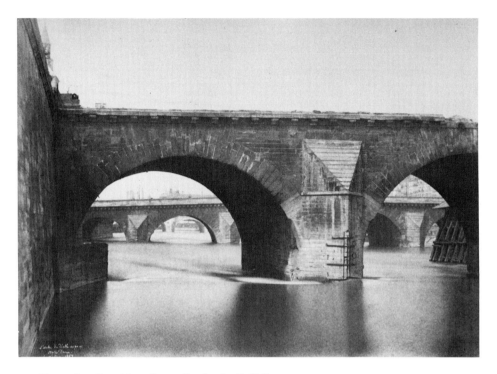

Figure 9. Pont Notre-Dame ("arche du diable").

of its commemorative function. Lacking this, some details worth mentioning connect Le Secq to Berger and to the Prefecture of the Seine. Henri's father, Auguste-Jean-Catherine (1791–1861), former student engineer of Ponts et Chaussées (Bridges and Causeways) and mathematics teacher, was associated with one of the mayoralties under Louis-Philippe, combining this with various business speculations. In mid-1845 he was serving the prefecture as "chef du bureau des archives," which eventually gave him contact with Berger, his exact contemporary.[23] In 1853 when Haussmann replaced Berger, Le Secq also left the prefecture. He was appointed mayor of the ninth arrondissement (fourth today). He held this position until 1860; it gave him jurisdiction over the Hôtel de Ville, Arsenal, île Saint-Louis and île de la Cité, areas greatly affected by massive demolition or migration before and after 1853. The year 1853 was a turning point for Berger and the elder Le Secq, guardians of established order with significant commitments to the city. In 1853, Berger was not only stepping down, he was taking with him his younger son Amédée, who had served as his private secretary in the prefecture for the past four years.[24] The two departing Bergers might have received the photographs in a gesture of moral support from their associate, about

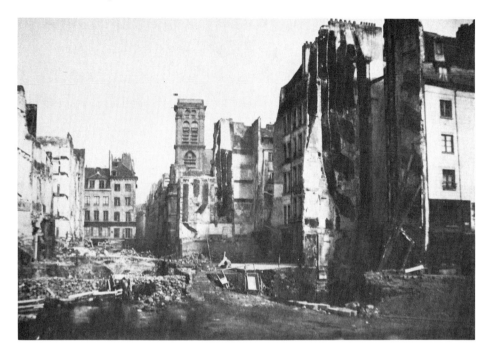

Figure 10. Demolitions in the rue Saint-Martin.

to step up to new civic responsibility, and his painter son, Amédée's contemporary, Henri, a salon prizewinner regarded internationally as one of France's foremost practitioners of the new medium of progress.

Henri Le Secq had been an artistically conventional young painter, one of the horde of Paul Delaroche's students during the 1830s, yet claiming to know his teacher well through assisting him around 1838 on the Hémicycle decorations of the École des beaux-arts.[25] After an 1842 salon debut and a third-class medal in 1845, received when in Rome, Henri exhibited faithfully at the salon all his life. Given the mediocrity of his pictures one wonders how he passed through so many juries since his medal did not exempt him from judgment. Along with other artists in 1848 he turned to photography, perhaps to aid his painting, an idea Delaroche would not have discouraged. Inspiration came from another Delaroche student, Gustave Le Gray (1820–82), whose exceptional grasp of photographic technique and conviction that the new medium might become an art as richly complex as any other made him a memorable teacher. Le Gray's dedicated experiments produced a beautiful oeuvre. If technically less curious, Le Secq's exploitation of Le Gray's dry waxed-paper negative process (called papier-ciré-sec) sur-

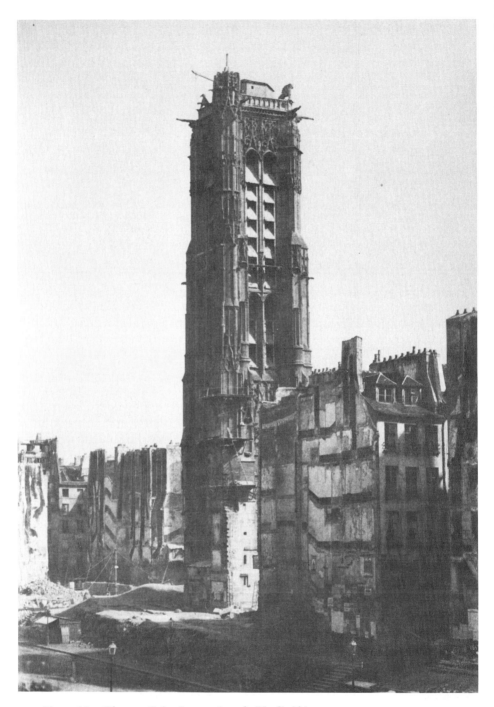

Figure 11. The tour Saint-Jacques (rue de Rivoli side).

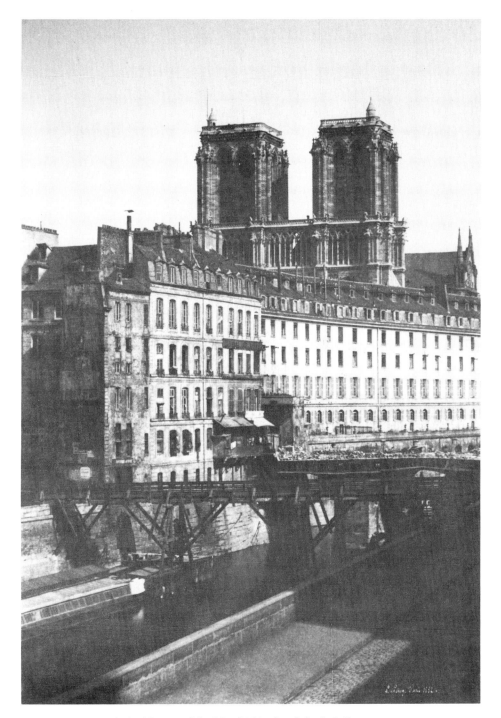

Figure 12. Block of houses of the Marché-Neuf and the Petit Pont.

Figure 13. Decoration of the Hôtel de Ville for the proclamation of the Empire.

Figure 14. Marriage of the emperor, right portal of Notre-Dame.

passed Le Gray's inventiveness, at least where architecture was concerned.[26] All who knew Le Secq's camera work marveled at its dramatic force, selective simplicity, and original conception of design, qualities eliciting admiration today. A mystery of early French photography is the number of lesser painters it attracted whose limited artistry was transformed through using the new medium into prodigious gifts, as if by enchantment. Henri Le Secq was one of these painters.

Briefly (from c. 1848 to c. 1856) he photographed the great cathedrals of Amiens, Chartres, Reims, and Strasbourg and many other ancient monuments, exhibiting these images at the Great Exhibition in London in 1851 and at the Society of Arts there in 1852, as well as in the most important French photography exhibitions through the Paris Universal Exposition of 1855. If his painting suggests a plodder of little consequence, technically mediocre at that, the photographs ascend to another order entirely. Honoring their subject matter, so disgraced by vandalism and neglect, the images elucidate the structures' complexity with intelligence, a sense of grandeur, and emotion. In negatives technically impeccable,[27] Le Secq throws a mantle of shadow around architectural detail, alternating these elements in marvelous discontinuities of mercurial illumination, a hugolian effect best characterizing the painter photographer's original eye for picturing architecture in a romantic spirit.[28]

Before photographing the city of Paris, Le Secq had a brief experience giving significance to endangered French architectural patrimony. He was employed by the Commission des Monuments historiques, a government agency that sent him during the summer of 1851 into Champaign, Alsace, and Lorraine on one of five "missions héliographiques." These missions were itineraries based on vast lists of buildings awaiting restoration and repair, compiled by Prosper Mérimée inspecteur des monuments.[29] In photographing the buildings on his list, Le Secq began to evolve his unique style. He bathed the venerated structures in ragged opaque shadows, which in bold contrast to the details of the broken stones exposed their desperate need. As subsequent restoration transforms these buildings, the "missions héliographiques" photographs alone testify to the architecture's original, if lamentable, state before the benign hand of repair introduced its more insidious form of desecration. In Paris the situation was different, for often Le Secq was faced with total obliteration. The problem of describing the old city before it disappeared must have been overwhelming and terrifying.

Contrary to early hopes for the medium and to what is still generally believed, photography is not an art of description. There is much that photographs cannot tell us, for the medium is limited to showing the

here and now from a single vantage point, one moment at a time. Thus it selects from the situation it purports to record.[30] That there was a universe of discovery in this was the challenge photography posed to artists who learned to take advantage of its natural partiality to serve their interests. Photographs neither give reasons behind events nor point to the future. Le Secq's album reveals little of the explicit politics surrounding Berger's public works except through symbols. It does not describe the frustrations or arguments over loans drafted or advances from the Bank of France or details of land and building expropriations. These matters are better recounted in writing, as we can read in Persigny's *Mémoires,* and at the time much detail was publicly available in *Le Moniteur universel.*[31]

Le Secq's pictures signal neither past nor future except for what our hindsight brings to them. This "beholder's share" gives the images (and most photographs for that matter) their great emotional appeal by permitting our imaginations to assign them new meanings as time passes.[32] When this occurs, as it does frequently in the work of Le Secq and his contemporaries, a photograph begins to share the life of works of art.

Despite their witnessing of important events, Le Secq's photographs hardly express their own contemporaneity, for a mysterious melancholy pervades the pictures' warm patina; the tour Saint-Jacques (Fig. 11), the Bains Chinois (Fig. 5), even the symbolically celebratory facades of the Hôtel de Ville (Fig. 13) and Notre-Dame (Fig. 14), sheathed in dappled light and opaque shadow, seem almost fantastically suspended in temporal cocoons.[33] There was a practical reason for these effects. The dry waxed-paper negative process often required exposures of several minutes, forcing Le Secq's camera eye to linger over a subject, during which time subtle variations of clouds and light accumulated to lend the images a distancing opalescence.[34]

This feeling of physical and psychological distance differed greatly from the photographic option of instantaneity in the 1850s. To capture rapid movement and lock it into a picture was an attractive counterpart to the lingering camera eye of Le Secq. Instantaneity seemed to authenticate the experience of modern life. It certainly would have powerfully authenticated Le Secq's views of the Paris cataclysm. But this photographic illusion did not attract him. His photography, like his antiquarian's taste, was antiprogressive. This choice significantly colored the facts before his lens. It also exposed his preconceptions as a photographer of architecture. His pictures consistently betray an expressive mood that alludes to the supreme stillness of the earliest daguerreotypes. Le Secq dwells on the more potent psychological drama of demolition: never the act itself but fearful imminence, lamentable aftermath.

No visible life invades his streets or facades. Close observation of

the Hôtel de Ville photograph or that of Notre-Dame reveals ghosts, ephemeral personnages once part of the throng, now lost because their natural movements made no lasting impression on the intractable chemistries. Thus, even public celebrations take on a peculiarly overcast mood, for everyone seems to have evacuated the site. Unlike Hugo's all-observing eye that devoured all things seen ("choses vues"), Le Secq's technical interpretation denied lived experience. Similarly reexamination of the left foreground of the "Demolition of the Stables" (Fig. 7), doubtlessly an anthill of workers, depicts them as little more than a blur. In a mode perfectly suiting a morose view of the urban trauma, Le Secq's photographs agree with Alfred de Musset's despair over nineteenth-century architectural change in general: "nous ne vivons que de débris, comme si la fin du monde était proche."[35]

Le Secq's method was to extract fragments from life's greater confusion and compose them into evocative symbols. Hardly a compelling poet in written language Le Secq proposed certain poetic elements from his new medium. Accepting as a ground rule photography's necessary selectivity, he further pared down fact. His work reminds us still of how laconically photography may speak when it speaks well. Two album images of the pont Neuf illustrate this approach. A view of "The Small Branch of the Pont Neuf (east side)" (Fig. 15) evenly illuminated, indicates the bridge's shorter expanse and general appearance of the eighteenth-century stone shops once lodged in the piers' distinctive lunettes. In this conventionally distant orientation, Le Secq establishes proportion and scale by relating the bridge to its surroundings; note the pont des Arts' cast-iron tracery clearly visible through the arches. The image would seem to lack dramatic interest if not for the unexpected still life detail of drying laundry in the foreground and massive stones along the quay where the tripod stood. In comparison, the photograph of "The Arch of the Bains Vigiers" (Fig. 16) dramatically isolates one pier. Forcefully symmetrical with the pier's vertical line sharply dividing the image and showing segments of the city through the flanking arches, we see on one side the river perspective of little boats, on the other trees and buildings along the bank. Despite a clear presentation of background detail the eye returns to the massive pier, a bizarre new form with its striking disposition of light and shadow. Like a wash of india ink, shadow obscures and selectively illuminates details of stone and ornament, intermittently sculptural and graphically flat. Thus, Le Secq redefines the bridge with complete understanding of the way photography "describes," artfully making the most of the medium's partiality. He denies architectural forms the full linear definition that would produce an illusion of three-dimensionality, sinking them instead into murky oblivion. He also upsets

Figure 15.　The short branch of the Pont Neuf (east side).

his composition's symmetrical scaffolding with a low vantage point that makes the pier loom and seem physically close. In this example we know the pont Neuf less coherently as a whole but achieve new intimacy with its stones. This is the photographer's sacrifice that leads us to an experience of greater intensity. Le Secq has taken the bridge apart and reconstituted it in abstract discontinuities which, like memories, stand in place of the whole.

Characteristically ignoring the human activity around his chosen monuments meant eliminating the most important features of the pont Neuf, the banks of shops (heavier traffic on the west branch doubled the rent for shops on the east branch), flower sellers, pullers of teeth, singers, and so on.[36] Le Secq suggests life on the bridge through minimal detail easily overlooked. The edge of a ladder-back chair, the corner of an awning left of the shop, alone indicate the commercial populace. Le Secq populates with shadows, creating a melancholy souvenir of something "que nous avons vu toujours et si connu qu'on distait: *connu comme le Pont Neuf*. Il faudra rayer le proverbe avec beaucoup d'autres illusions," Delacroix painfully noted in 1852.[37] More profoundly perhaps, the magnificent shadow pattern Le Secq achieved on the stones and under the arches leads the imagination into the darker reveries that absorbed Gautier: "L'écorce terrestre n'est qu'une superposition de tombeaux et de ruines. Tout homme qui fait un pas foule la cendre de ses pères; tout

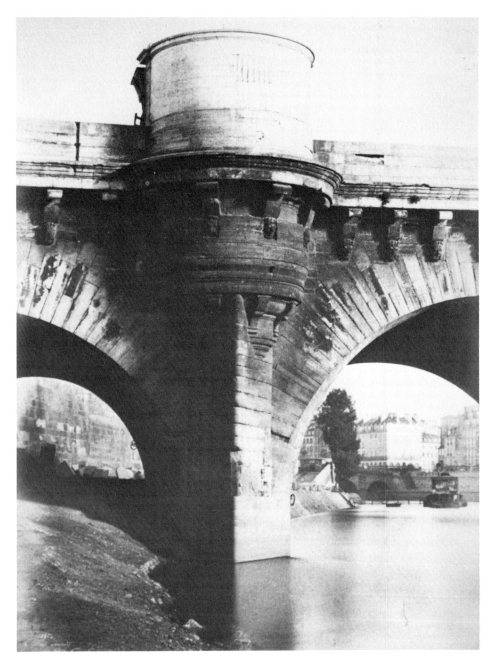

Figure 16. Pont Neuf (arch of the Bains Vigiers).

édifice qui l'élève a dans ses substructions les pierres d'un édifice démoli,
et le present quoiqu'il en ait, marche sur le passé," the poet reflected.[38]
The words "Souvenir de l'ancien Pont Neuf, Paris" accompany Le Secq's
signature and date 1852 on the negative. Repairs on the bridge began
in 1848. By 1855 the stone shops in the lunettes were gone.

Thus a collection of photographic documents, felicitous testimony
of Berger's sincere efforts at a moment of great political transition and
grave personal misunderstanding for the prefect and his son, extends
beyond the album's commemorative function to realms of significant
expressive content. Analyses as these preceding may not apply to nine-
teenth-century photography generally, but they are telling for Le Secq's
camera, directed by the despairing "regard d'un amateur de beau."[39]
Although the aim was to record, the album is aesthetic and nostalgic.
Few early French photographers distinguished between "art" and "doc-
ument." In insisting on separating them, our age almost misses the point
of the pictures.

The inseparability of art and document in early photography was
reinforced by the preceding tradition of the picturesque in prints. It is
useful to compare this tradition with the French photographic endeavor,
for the two often seem to operate in critical dialogue. Two views of the
old place de Grève (place Hôtel de Ville, Figs. 3, 4) show its northwest
corner from the same vantage point as an 1830s lithograph (Fig. 17).
Le Secq's images of desecration almost mock the picturesque view's cheerful
domesticity. The lithograph obliterates all associations with a formerly
sinister square from which the guillotine was only recently removed.
Renamed the place Hôtel de Ville, it continued to be a gathering place
for the unemployed.[40] The lithograph's conception has to do with for-
getfulness and portrays the life of the idler as an ideal. Behind the
foreground scene of wine barrels delivered by a horse-drawn cart, people
converse in doorways; women pass the time with a military man; a waiter
serves his customers. This touristic version of Paris daily life combines
precision and gossamer delicacy, traditional since Nodier and Taylor's
first volume in 1820 of the *Voyages pittoresques*. Drawing modulations are
as exact in architectural description as they are enchanting evocations
of air and light. This is no breeding ground for crime, no scene for a
condemned man, no refuge for the chronically indigent. The little turret
in cool retreat, its surrounding windows spilling over with ingratiating
foliage, presides over a neighborhood. All the printed signs underscore
the notion of continuity, business as usual.

Le Secq's closer view of the corner (Fig. 3) eradicates continuity.
The little turret is untouched, but it no longer offers its cachet of history.
There is no history. The neighborhood has been swallowed up in ruins

as hollow as a scull. Against the broken walls and their windows' blind
sockets, the signs "Librairie," "Dentiste," "Restaurant" seem veritable tra-
vesties of human discourse. Turning the corner (Fig. 4) the turret is
more specifically related to changes that quadrupled the original space.
On one wall violent pathways of fireplace chimneys exposed for all to
see make of the family hearth a bizarre spectacle. Gautier reflected in
"Paris démoli" upon "de hautes murailles zebrées de raies de bistre par
les tuyaux des cheminées abattues, découvrent, comme la coup d'un plan
d'architecture le mystère des distributions intimes."[41] Le Secq's photo-
graphs rouse parallel sympathies; not only despairing they seem moved
by the age-old pleasure in ruins, the pinnacle of picturesque feeling. As
Gautier noted: "ce bouleversement n'est pas sans beauté; l'ombre et la
lumière se jouent en effets pittoresques sur ces décombres, sur ces ac-
cidents de pierres et de poutres tombées au hasard."[42]

Le Secq depicts the beauty of upheaval through these delectations
of chance and coincidence, elements also fundamental to the language
of photography with its necessary selection. The album photographs
exceed old-style picturesqueness by constructing memorable forms from
the collision of unrelated urban forms as in the vantage point that results
in Notre-Dame Cathedral's towers conferring a noble "pediment" on the
group of condemned houses near the Petit Pont (Fig. 12), a composition
rooted in previous pictorial history. But Le Secq's originality surpasses
even this stunning solution. The only view in the album made on the
Left Bank shows the rue des Maturins (former rue Coupe-Gueule, Fig.
18) which surrendered to the new rue des Écoles. In a splendid arrange-
ment, a burst of sunlight fragments a corner of the old College of the
Sorbonne.[43] Le Secq meshes this miserable shred of architectural fabric
with what look like malevolent silhouettes of ragged black teeth of tem-
porary fencing and demolished walls in the foreground. He uses his lens
to search the ruins for the few remaining details of the building. As in
Daumier's lithograph of human tragedy on the rue Transnonain, we are
at the scene of an architectural crime. Yet on the rue des Maturins, waste
and dissolution of an older order are reorganized by the artist's pho-
tographic eye into a monumentally beautiful picture. As Gautier knew,
the ambiguity of beauty and despair was the essence of the experience
of demolition. It lies at the heart of the Le Secq album and of all the
most poignant views of the modern city. Photographers of the urban
scene have been searching for these ironies ever since.

Look at the image of the old Notre-Dame pump's wooden footbridge
(Fig. 19). Le Secq frames the structure by slicing bold and simple geo-
metrical segments from the old pump on the left and the pont Notre-
Dame on the right. Bridges, pump, pilings, piers, and a checkerboard

Figure 17. T.T., Turret (at the northwest corner of the place de Grève), lithograph c. 1830. Paris, Bibliothèque Nationale.

Figure 18. Demolition of the rue des Maturins (formerly rue Coupe-Gueule).

of buildings behind them are locked puzzle pieces. But the construction is crowned by a touch we come to expect in Le Secq's architectural dialogue with the human spirit: a pair of trousers hung in the window by some resident of the local hotel. They are framed too centrally in the design for the photographer not to have noticed them. Picturing the city was finding symbols for the transient life outside and inside the walls.

In the middle of the nineteenth century photography was still new. First publicized in 1839 it was defined as a gift from science to art. Really neither one nor the other, it seemed the ultimate means for a technological age to record absolute truth. But photography by artists changed this by revealing that truth was relative and contingent, that recording facts was a matter of choice affected by circumstance, leading to results undreamed of by photography's inventors and champions.

That the pictures contain meanings complicating their ostensible documentary purpose raises questions about photography's powers to impose ideas on the facts before the lens, versus the medium's presumed natural limitations as a mechanical process not subject to the variabilities

Figure 19. The wooden bridge of the Notre-Dame pump.

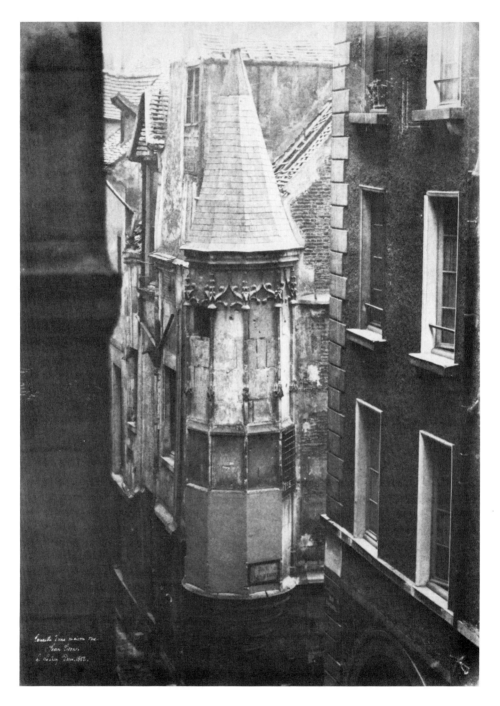

Figure 20. Turret on the rue Jean Tison (destroyed in 1852).

Figure 21. Adolphe-Martial Potement, turret of the Hotel Schomberg, etching based on a photograph by Henri Le Secq, no date. Private collection.

of human fancy. French photographers' commitment to personal expression is not a twentieth-century invention superimposed onto what many regard as nineteenth-century photographic positivism. The mood in much early French photography was rooted in late romanticism.

Le Secq's romantic photographs endure today because they ultimately transcend the political and physical conditions that engendered them. Their somber beauty persists over time and permits us to reexamine them not only as the documents that would console Jean-Jacques Berger and his son but as an original art form. To modern eyes Le Secq's search through the rubble of Paris led to the creation of symbolic extracts, essential units of meaning in the evolving language of photography. Arranged in compositions that find parallels in the poetic intonations of Nerval, Gautier, and Hugo, and in the pictorial grandeur and theatrical mysteries of chiaroscuro elaborated by the great printmaking tradition from Rembrandt to Charles Meryon, Le Secq's photographs are surrogates for a beloved city before it disappeared. He rebuilt Paris for himself in a historical collection of pictures of artistic originality consecrated to defy the loss of memory.

Years after the date of the album, an etcher A.-Martial Potement produced a series of three hundred views of old Paris based, as he occasionally noted, on photographs belonging to the city (compare Figs. 20, 21—see pages 58–59). Many of his compositions are based on photographs by Le Secq although unacknowledged. Evidently Potement, an artist of rather little originality, in the 1860s, regarded the lowly documentary photograph as not much different from life itself—there for the taking. Potement was betrayed by his chronicler E. Bénézit, who recognized something original in the etchings which he said were engraved "notamment d'une pointe spirituelle."[44] Here lies the legacy of Henri Le Secq.*

*This article was originally commissioned for a special number of the *Revue du Louvre* on photography and archeology in 1983 and translated into French as " 'Bouleversement pas sans beauté'—Photographies de démolition de Henri Le Secq, Paris 1852–1853." The project is still in press.

NOTES

1. Berger was mayor of the former second arrondissement (Chaussée d'Antin) from 1830. Inherited from the regime of Louis-Philippe and seemingly reliable because he had signed an act of accusation against Louis-Philippe's ministers in 1848, he became prefect of the Seine after the December 10, 1848

vote electing Louis-Napoléon Bonaparte president of the Second Republic. Gustave Vapereau, *Dictionnaire des Contemporains*, Paris, 1861, 164–65, lists Berger's public works as: canalizing the left branch of the Seine, completing the Palais de Justice, laying stones on the quays and boulevards, isolating the Hôtel de Ville, extending the rue de Rivoli, opening the boulevards of Strasbourg, Mazas, and Diderot and the rue des Écoles, and embellishing the Bois de Boulogne. Berger's character, achievements, and relationship with his predecessor, the marquis de Rambuteau, is summarized in J. M. and Brian Chapman, *The Life and Times of Baron Haussmann, Paris in the Second Empire*, London, 1957, 59–64.

2. This is David Pinkney's argument in *Napoléon III and the Rebuilding of Paris*, Princeton, 1958, 49–55. He is consistently hard on Berger, using the *Mémoires* of Fialin Persigny and *Souvenirs* of Charles Merruau to substantiate his view of Berger's pig-headed resistance to Louis-Napoléon's expenditures. Not denying that work was well under way before Haussmann's official tenure began on June 29, 1853, Pinkney wishes to celebrate Haussmann's achievement, and Berger is made to play the do-nothing in the drama. That Pinkney's excellent scholarship means to deemphasize Berger is born out in his plate 12 illustrating Le Secq's view of the Louvre and Tuileries (here Fig. 6) without naming the photographer or indicating that it derives from an album specifically annotated to identify Berger's role in the "travaux de la ville in Paris, 1849–1853." A similar view toward Berger prevails in the Chapmans' study. See note 24.

3. The Law of 4 October 1849 introduced in the National Assembly, cited by Pinkney, 80.

4. Handsomely bound in a green leather album, seeming to date from the middle nineteenth century (H. 428 mm × L. 594 mm), gold stamped with initials J. J. B., the photographs, approximately 235 mm × 335 mm, presumably once belonged to Berger. They were presented in the Bibliothèque historique de la Ville de Paris (Res. F° M° 68) after the death in 1881 of his second son, Amédée Berger, who acted for four years as his father's private secretary (chef du cabinet) at the Prefecture of the Seine. He contributed articles to the *Journal des Débats* on the city of Paris. The photographs, pasted to album leaves, are annotated on the mounts in pencil in handwriting that may be that of Amédée Berger, for it resembles but cannot be verified as Le Secq's. The handwritten information is cited below as given. The list of photographs also indicates the presence of Le Secq's own identifications, signature and date written on the negatives and visible in the positives, and gives figure numbers from the present article.

Page 1, *recto:* Photographies relatives aux travaux de la ville de Paris/1849–1853/ A. Berger

Page 2, *verso:* E 11495, Legs de M. Amédée Berger, président de la Cour de Comptes, fils de M. J. Berger, ancien préfet de la Seine, decédé le 27 janvier 1881

Photographs: 1. Décoration de l'Hôtel de Ville pour la proclamation de l'Empire (unsigned, undated, Fig. 13)
2. Mariage de l'Empereur. Portail de droite de N. Dame (signed and dated lower left: h. Le Secq 1853, Fig. 14)
3. Place du Carrousel moment de la Démolition des anciennes Écuries du Roi (signed and dated lower left: h. Le Secq Paris 1852. Fig. 6)

(notes continued on page 62)

4. La rue de Rivoli (angle gauche de la Place du Palais Royal) au moment de la Démolition des Écuries (identified, signed, dated lower center: démolitions place du Carrousel. h. Le Secq. Paris. 1852. Fig. 7)

5. Ilot des maisons du marché neuf et le Petit Pont (signed and dated lower right: h. Le Secq. Paris. 1852. Fig. 12)

6. Place de l'Hôtel de Ville (La Tourelle) (identified, signed, and dated lower right: Tourelle Place de l'hôtel de ville. H. Le Secq. Paris. 1852. Fig. 4)

7. Démolitions de la place de l'hôtel de ville (signed and dated lower right: h. Le Secq. Paris. 1852. Fig. 3)

8. La Tourelle de la rue Jean Tison (démolie en 1852) (identified, signed, and dated lower left: Tourelle d'une maison rue Jean Tison. h. Le Secq. Paris. 1852. Fig. 20)

9. Démolitions de la Rue de Rivoli (ancien Logis Jean Tison) (identified, signed, and dated: Maison rue Jean Tison. h. Le Secq. Paris. 1852.)

10. Démolition de la rue des Maturins (l'ancienne rue Coupe-Gueule) (signed and dated lower left: h. Le Secq. Paris. 1852. Fig. 18)

11. La tour St. Jacques (façade de l'est) (signed and identified lower right: h. Le Secq. Paris. Tour St. Jacques la Boucherie.)

12. La tour St. Jacques (façade sur la rue de Rivoli) (signed and dated lower right: h. Le Secq. 1853. Fig. 11)

13. Le pont N.D. et le quai de Gervres [sic] (au moment de la Démolition) (identified, signed, and dated lower left: pont notre-Dame. Paris. h. Le Secq. 1853. Fig. 8)

14. La tour St. Jacques, la rue St. Martin et la rue [sic] Vannerie (signed, dated, and identified lower left: h. Le Secq. 1853. Tour St. Jacques la Boucherie. Paris.)

15. Le Pont de Bois de la Pompe N. Dame (signed and dated lower left: h. Le Secq. 1853. Fig. 19)

16. Pont N. Dame (l'arche du Diable) (identified, signed, and dated lower left: l'arche du diable au pont Notre Dame. h. Le Secq. 1853. Fig. 9)

17. La Pompe N. Dame (façade de l'ouest) (signed and dated lower left: h. Le Secq. 1852. Fig. 1)

18. Les pilotis de la Pompe du Pont N. Dame (signed and dated middle on right side: h. Le Secq. 1853. Fig. 2)

19. Les démolitions de la rue St. Martin (unsigned and undated, Fig. 10)

20. Le Petit bras du pont Neuf (côte est) (unsigned and undated, Fig. 15)

21. Pont neuf (l'arche des bains Vigiers) (dated, signed, and identified lower left: 1852. h. Le Secq. Souvenir de l'ancien Pont Neuf. Paris. Fig. 16)

22. Les Bains Chinois au moment de la Démolition (signed and dated lower right: h. Le Secq. 1853. Fig. 5)

The album was exhibited at the Grand Palais in 1979. See "Photography," essay

and catalogue entries by Eugenia Parry Janis, in *The Second Empire (1852–1870): Art in France under Napoléon III*, Philadelphia, 1978–79, 401–44.

5. Pinkney, 49–50.

6. Jacques Hillairet, *Dictionnaire historique des rues de Paris*, 7e éd. Paris, 1963, II, 185–86.

7. Pinkney, 80; and Louis Chevalier, *Classes laborieuses et classes dangereuses à Paris pendant la première moitié du XIX^e siècle*, Paris, 1958, 70.

8. Further discussion is in André Jammes and Eugenia Parry Janis, *The Art of French Calotype, with a Critical Dictionary of Photographers, 1845–1870*, Princeton, 1983, 8, 143–44.

9. According to Hillairet, I, 279, these stables, formerly les écuries du duc d'Orléans, c. 1780, originally were the elegant hôtel de Crussol-Uzès before the eighteenth century when they were in part successively the Vaux-Hall d'Hiver, the bal de Panthéon and the Théâtre du Vaudeville which burned in 1836. Louis-Philippe turned the remainder into his stables. After 1848 they were a barracks before being demolished in 1852. Hillairet, *ibid.*, illustrates an engraving of the stables which verifies the identification of Le Secq's depictions seen so fragmentarily in Fig. 7.

10. Pinkney, 51–52. See also Chapman, 63–64, on the dispute between Persigny and Berger.

11. Le Secq shows the moments when the pont Notre-Dame (Figs. 8, 9) and the Petit Pont (note temporary wooden bridge, Fig. 12) underwent height adjustments to conform to the new pavement level dictated by the rue de Rivoli. Space permits only alluding to Le Secq's relationship with Meryon here, but it is discussed at greater length in my article "The Man on the Tower of Notre-Dame: New Light on Henri Le Secq," *Image* 19 no. 4 (December 1975): 13–25, along with four images from the album presently discussed; and "Charles Meryon und die Photographen von Paris," translated into German by Gerhard Fries in *Charles Meryon, Paris um 1850, Zeichnungen, Radierungen, Photographien*, exhibition catalogue, Städelsches Kunstinstitute und Städtische Galerie Frankfurt am Main, 1975–1976, 139–66. I am ever grateful to Dr. Margret Stuffmann, organizer of this exhibition, who first called my attention to this album by Le Secq.

12. "For Paris is France, for a Parisian the two are inseparable. I am what you'd call a friend of the picturesque, to me a straight line offends good taste." The present author recently discovered "Le vieux Paris" among some dozen other unpublished Le Secq poems in a French private collection. Hardly revealing the photographer as another Hugo, Le Secq's poems are tantamount to a small notebook of private thoughts of capital importance to the historian of photography, for they are a source of Le Secq's opinions, hitherto surmised and pieced together from odd facts and from the photographs themselves. Probably written in the middle 1860s (some are dated) after the death of his wife in 1862, they bridge various subjects, from that of his "first born," to the changing seasons, to history painting, to differences between city and country marriages. "Le vieux Paris" is especially relevant to the album under discussion in alluding to disappearing childhood memories. Like the album, it displays a marked ambivalence, on the one hand despairing the loss of medieval treasures: "mais tout a disparu! son souvenir, sa trace!" (but everything has disappeared! its memory, its trace!). Yet on the other hand, it acknowledges Paris's need to move into the future: "allons Paris moderne, à toi le nouvel age" (carry on modern Paris, you are the

new age). All subsequent citations from "Le vieux Paris," the only poem by Le Secq quoted in this article will refer to note 12.

13. Victor Hugo, *Les Années funestes*, 1852–1870, Paris, n.d. Poem 48, "Les 'Embellissements' de Paris," of 1869, 146–47, deplores modern urban alignment alluding to "Paris percé" (Paris pierced through), a body wounded in a duel by "quinze ou vingt rues/ Neuves, d'une caserne utilement accrues" (fifteen or twenty new streets the result of a barracks usefully accrued). The latter reference is to Napoléon III's military precaution to build two dismal barracks for thousands of men with underground passages to the Hôtel de Ville. See Hillairet, II, 49–51.

14. Seemingly imperturbable. They had to abandon their house on the quai Bourbon for one on the quai Bethune when it was destroyed to make way for the new rue Jean du Bellay (1860) which extended the new pont Louis-Philippe (1860–1862). Hillairet, I, 673.

15. "Unquestionably, a reflective person feels melancholy rising up in his soul, in seeing these buildings disappear; the alignment cuts in half more than one precious memory." This was his preface to Édouard Fournier's *Paris démoli*, 2e éd., Paris, 1855, iii, first published in *Le Moniteur universel*, January 21, 1854.

16. The "Comptes fantastiques d'Haussmann," published by Jules Ferry in 1867 in *Temps* are well known. Other criticisms of the changes in Paris are summarized in J. Mallion, *Victor Hugo et l'Art architecturale*, Paris, 1962, troisième partie, Chap. 8, and Howard Saalman in *Haussmann: Paris Transformed*, New York, 1971. It is not clear from Gautier's preface to Fournier that he was necessarily against the changes.

17. "friend of the picturesque." Chevalier, 100.

18. "which was disappearing." Victor Hugo's observations of Berger in 1849 may cast some light: "Autre causerie. Au dernier dîner du préfet, M. Berger, lequel a fait réparer et remettre à neuf l'Hôtel de Ville, M. de Rémusat l'a pris à part et lui a fait remarquer au-dessus d'une porte un médaillon de Louis-Philippe fendu en deux, par quelque coup de sabre de Fevrier. 'Je vous remercie, cela m'avait échappé,' a dit le préfet; 'je le ferai restaurer demain.' " (Another bit of gossip. At the last dinner of the prefect, M. Berger, who has done the repairs and made the town hall look like new, M. de Remusat took him aside and pointed out a medallion of Louis-Philippe above a door, cut in two by the stroke of some sabre in the February revolution. "I thank you, it had escaped my notice," said the prefect. "I'll have it restored tomorrow.") *Choses vues, souvenirs, journaux, cahiers, 1849–1869*, Paris, 1972, 139.

19. "The Emperor is Emperor." *Journal de Edmond Got, sociétaire de la Comédie française, 1822–1901*, 4e éd., Paris, 1910, I, 287.

20. Compare the bizarre spectre of the facade as photographed by Le Secq to the gorgeous trappings described in writing by the Duchess of Kent: " 'Nothing could be more splendid . . . than the decorations of the cathedral—velvet, ermine, gold and silver, flags and hangings of all colors were combined and harmonized with the splendid costumes of the clergy, the uniforms civil and military, and the magnificent dresses of the ladies.' But Eugénie outshone them all. 'Her beautifully chiselled features, and marble complexion, her nobly set on head, her exquisitely proportioned figure and graceful carriage were the most striking and the whole was like a poet's vision!' " quoted by J. M. Thompson, *Louis Napoleon and the Second Empire*, Oxford, 1965, 143.

21. In the Second Empire, "the driving force was ambition, and worldly honor open to all was its reward," writes Theodore Zeldin in *The Political System of Napoleon III*, London, 1958, 44, which gives an excellent breakdown of who might have been expected to support the Second Empire government. Also Roger Price, *The French Second Republic: A Social History*, Ithaca, 1972, summarizes the mentality of the Orleanists who were among the best supporters of the new regime, and in which the Le Secq family with their financial speculations and "belle fortune" would seem to fit.

22. Le Secq was not altogether apolitical. By the 1860s he was defending salon reform and artists' rights. See Henri Le Secq, *Les Artistes, les expositions, le jury*, Paris, 1866; and *Aux Artistes, aux amateurs des beaux-arts*, Paris, 1864, a printed tract of four pages.

23. His position as "chef du bureau des archives" (head of the archives office) was recorded in May 1845 on p. 59 of a genealogy belonging to Le Secq's descendants called *Génélogie des le Secq ou le Sec: Documents*, handwritten at different times by various members of the family, notably Gustave Le Secq, Henri's older son.

24. J. M. and Brian Chapman, 74–75. Vapereau, 164–65 verifies that this younger son was Amédée Berger, who bequeathed the album of photographs to the Bibliothèque historique de la Ville de Paris. Amédée "became private secretary to Fould in the Ministry of Finance and from there conducted a campaign against Haussmann." Chapman, 75.

25. Henri Le Secq, *Les Artistes, les expositions, le jury*, 7, note.

26. Found first in Le Gray's *Traité pratique de photographie sur papier et sur verre*, Paris, June 1850, which knew three subsequently revised editions in 1851, 1852, and 1854. See Jammes and Janis, 269–70.

27. He had certain difficulties with print permanence. Substantial collections of beautiful waxed-paper negatives and positive prints by Henri Le Secq are in the Département des Estampes et de la Photographie, Bibliothèque Nationale, Paris, Bibliothèque des Arts Décoratifs, Paris, and the International Museum of Photography at George Eastman House, Rochester, New York. The Bibliothèque des Arts Décoratifs plans to exhibit some of its collection of Le Secq photographs in September 1986; a more comprehensive exhibition of the photographer's work is scheduled for 1988 at the Musée d'Orsay, both with catalogues by the present author.

28. Jammes and Janis evolves a theory of the art of the paper negative in romantic terms with many references to the work of Le Secq and discusses his biography and peculiar style on pp. 206–10. To date this is the most complete account of his work and its context.

29. Mysteriously never published or used for any purpose, the negatives established the massive archive of the Direction de l'Architecture, Palais Royal, Paris. For more speculation and information on the "missions héliographiques," see the catalogue accompanying the exhibition of missions photographs in Paris by Philippe Néagu et al., *La Mission héliographique, Photographies en 1851*, Paris, 1980, and Jammes and Janis, 52–67.

30. See note 20. These ideas have been elaborated in the publications of John Szarkowski, notably in *The Photographer's Eye*, New York, 1966, and *Looking at Photographs*, New York, 1973.

31. Pinkney, 52, n. 7.

32. The expression is Ernst Gombrich's, *Art and Illusion,* Princeton, 1960.

33. Observers of these changing sites provided their own fantasies about them. As Delacroix noted, November 14, 1853: "J'ai vu encore en passant à la tour Saint-Jacques retirer des os en quantité et encore juxtaposés. L'esprit aime ces spectacles et ne peut s'en rassasier." (As I went past the tour Saint-Jacques I saw some men digging up a great quantity of bones that were still in their original position. How our minds love scenes of this kind, we never have enough of them.) *Journal de Eugène Delacroix,* Paris, 1932, III, 111.

34. Photographing with a sensitivity to weather conditions to give the same monument a range of salutary appearances was advised by one of French photography's most important early popularizers, Blanquart-Évrard in "Des Monuments," *Traité de photographie sur papier,* Paris, 1851, 36–37. Discussed also in Jammes and Janis, 56–57.

35. "We're living in ruins as if the end of the world were upon us." From *La Confession d'un enfant du siècle, Oeuvres complètes en prose,* Paris, 1951, 105, quoted in J. Mallion, 632.

36. Hillairet, II, 174–77. Note illustration of a print, 177, showing the pont Neuf around 1850 from a vantage point including the piers and shops' distinctive shapes, as well as the bridge's normally crowded commercial activity, which, as mentioned, Le Secq's radical conception eliminates from his views.

37. "That we've seen all our lives, and which are so familiar that there used to be an expression *as well known as the pont Neuf.* Now this will have to be given up like so many illusions." *Journal de Eugène Delacroix,* I, 442.

38. "The earth's crust is only a superposition of tombs and ruins. With every step we take we disturb the ashes of our fathers; every edifice built has in its foundations the stones of a demolished structure and the present, such as it is, advances on the past." Preface to Fournier, iii.

39. "gaze of a lover of the beautiful." See note 12.

40. "The place de l'Hôtel de Ville" rooted itself in the bourgeois literature faster than the "place de Grève" disappeared from the popular literature, observed Chevalier, 100. The guillotine was removed to the barrière Saint-Jacques in 1830 after the place de Grève proved to be the site of many heroic acts of bravery by the people during the July Revolution.

41. "from the high walls striped like a zebra with brown furrows from the demolished chimney flues, they discover as if by glancing at an architectural plan, the mystery of intimate domestic arrangements." Preface to Fournier, ii.

42. "this destruction is not without beauty: shadow and light interplay in picturesque effects on these ruins, on these casualties of stones and beams fallen by chance." *Ibid.*

43. In his entry on the rue de la Sorbonne, Hillairet, II, 527–28, discusses the old rue des Maturins which faced the hôtel de Cluny before the rue des Écoles was opened in 1852; he illustrates, 528, a print showing the college de la Sorbonne in 1550 whose trefoil window detailing resembles that in Le Secq's photograph.

44. "with a particularly spiritual line." *Dictionnaire critique et documentaire des peintres, sculpteurs, dessinateurs, et graveurs . . . ,* nouv. éd., Paris, 1976, VIII, 446.

Of Entrepreneurs, Opportunists, and Fallen Women: Commercial Photography in Paris, 1848–1870

ANNE McCAULEY

Within a year of the January 1839 announcement of Daguerre's process in the Académie des Sciences, the cartoonist Maurisset published a vision of Paris inundated with businesses manufacturing the miraculous light-created images (Fig. 1). Cameras adorned rooftops, dangled from balloons, arrived by boat and train, and focused on eager sitters who formed long lines outside studios. Meanwhile, engravers hung themselves on rented gallows. Daguerreotypomania, the wild public enthusiasm and flourishing commerce depicted in this bird's-eye view, seemed to be the triumph of the day.

Maurisset's caricature was, however, only a pipe dream which took over twenty years to materialize. The development of commercial photography in Paris occurred slowly in the 1840s as chemists and amateurs tried to reduce exposure times and minimize production costs. Many of the first men to sell portraits—Lerebours and Secretan, Richebourg, Chevalier, and Susse frères, the firm featured in Maurisset's print—were established manufacturers of optical instruments who continued selling telescopes, glasses, and microscopes after appending glass studios to their shops. During the years of slow economic growth preceding the depression of 1847–51, only a few individuals committed themselves wholeheartedly to the production of daguerreotypes: in the annual commercial register, the Bottin *Annuaire général du commerce et de l'industrie*, approximately sixty names of daguerreotypists and supply dealers appear prior to 1848. If second-hand reports can be believed, some operators, such as Vaillat at 42 Palais Royal, who was selling 2,000 portraits a year at 10F apiece by 1849, or Ph. Derussy on the rue des Prouvaires, who claimed an annual production of 3,000 portraits, built up substantial

Figure 1. Maurisset, La "Daguerréotypomanie," *1840, lithograph. Bibliothèque Nationale, Paris.*

businesses during a decade in which photography remained a rather exotic but uncompetitive business.[1]

The most complete data on the state of the Parisian photographic industry on the eve of and shortly after the February 1848 revolution are provided by the Chamber of Commerce's statistical survey of 1847–48. Including daguerreotypy under "Groupe 8—Industries chimiques et céramiques," the report documented fifty-four managers employing forty-eight workers who sold a total of 346,500F of products, which included cameras, mats, lenses, chemicals, and paper in addition to the photographs themselves. Two studios earned 25,000F or more annually, ten sold between 10 and 25,000F, eight between 5 and 10,000F, with the majority (thirty-four) grossing 1–5,000F, and two struggling with less than 1,000F of sales. Only one studio had more than ten workers, while forty-nine (or 91 percent) were one-person operations. The employees consisted of thirty-four men, eight women (six of whom were wives of owners), and six children, with males earning an average of 3.95F a day and women and children considerably less.[2]

The 1848 revolution disrupted economic and social life as well as

the political regime and resulted in a severe decline in photographic activity. The Chamber of Commerce report stated that twenty-seven of the forty-eight photographic workers were laid off from February to late June 1848, and that the total volume of business in 1848 dropped to 135,145F, or about a third of what it had been the previous year. Thus, the usually slow season, defined as the period from November to March when the weather was cold and cloudy, extended into the spring and summer, normally the busiest and most profitable period.

With the election of President Louis-Napoléon Bonaparte in December 1848, and the return to a more stable, if increasingly autocratic, regime during the period from 1849 to 1851, the Parisian photographic industry began a dramatic upswing that peaked in 1868. In the absence of year-by-year statistics on volume of production, one is forced to use the number of names listed in the Bottin *Annuaires* as an indication of change. Since businesses had to buy space in this directory and since the divisions between "artistes photographes" (presumably producers of images) and "fabricants" of supplies are often arbitrary, the number of photographers listed cannot be accepted as accurate. For example, the 1848 Bottin cited thirteen photographers and forty-four supply dealers, with four names appearing in both categories. This total of fifty-three names can be compared with the fifty-four enterprises surveyed the same year by the Chamber of Commerce. Although one can safely assume that some of the individuals listed as manufacturers of photo supplies took portraits, one cannot determine how many did so. For the purposes of this analysis, only the names included as "artistes photographes" will be considered.

A graph of the number of operators from 1848 to 1870–71 (Fig. 2), based on the Bottin register, reveals a consistent increase from 1848 to 1856, a slower increase around the period of the 1857 economic depression, a dramatic rise between 1860 and 1862, steady growth until 1868, and then a decline during the Franco-Prussian War. The number of Parisians per studio thus decreased from 81,000 in 1848 (based on a population of 1,153,000) to 5,141 in 1866 (population 1,825,274). In the peak year, 1868, there were 359 names listed, which represents a thirtyfold increase from 1848. If this graph were continued into the Third Republic, one would see a leveling off, with 326 studios in 1876, 339 in 1878, and 321 in 1886.

Further evidence of rapidly expanding photographic production during the Second Empire can be found in the Dépôt Légal registers, which record the titles of all works on paper (extended to cover photographs in 1851) offered for public sale in Paris and the provinces.[3] A graph of the number of photographic titles recorded in Paris each year

NUMBER OF STUDIOS

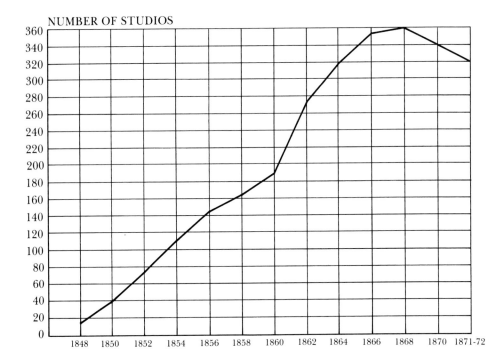

Figure 2. Number of Parisian photographic studios, 1848–1871/72.

(Fig. 3), which in no way indicates the number of prints made from each negative, shows a more irregular increase from 1853 to 1864, with a marked drop until 1870. At the same time, the number of prints produced in the traditional media declined, which confirms that photography threatened more than miniature painting. Although the Dépôt Légal registers reflect only the production of photographs with a broad public appeal and ignore the small issues of family or private commissions, they can serve as indices of the efforts made by studios to touch a large audience and the introduction of industrialized printing techniques.

The Second Empire therefore emerges as the key growth period for Parisian photography during the entire nineteenth century. The reasons for this remarkable proliferation of businesses are complex, but they include the general economic upswing in the 1850s in France, improvements in photographic technology, and the creation of an urban middle class interested in upward social mobility and conspicuous consumption. Although France continued to lag behind England in industrialization and remained a predominantly agricultural country, it made considerable advances in industrial productivity, personal income (the

DÉPÔT LÉGAL REGISTERS—PRINTS AND PHOTOGRAPHS

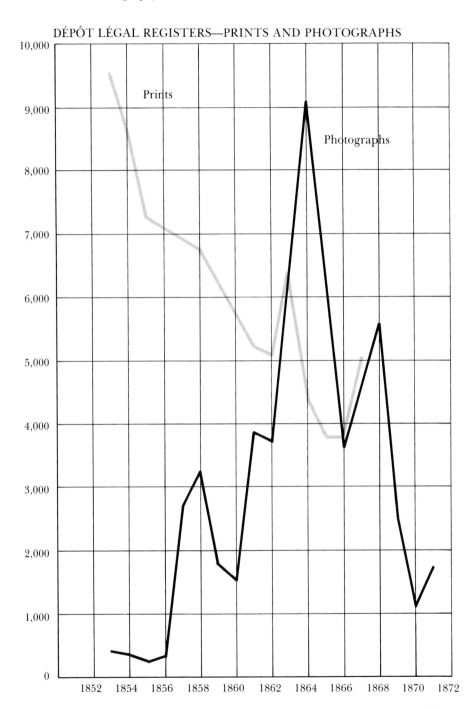

Figure 3. Dépôt Légal Registers: Number of Prints and Photographs Recorded, 1853–1871.

total private fortunes of Frenchmen doubled between the periods of 1851–55 and 1871–75), and gross agricultural production (valued at 5,845 million francs in 1850 and 9,893 million francs in 1870).[4] During the 1850s, the influx of Californian and Australian gold, the public works expenditures of Napoléon III, and credit and banking reforms put more money into circulation and encouraged consumer spending. At the same time, the development of the collodion-on-glass negative process in 1851 and the manufacture of prepared albumen paper made possible the rapid production of hundreds of photographic prints, which were cheaper than the unique daguerrean image.

It is more difficult to explain the continued increase in the number of studios between 1860 and 1868, during a period of slow economic growth and major recessions triggered by foreign policy blunders, military spending, lack of confidence in future prosperity, and banking crises. The introduction of the carte-de-visite format, which lowered the cost of a single portrait to one franc and expanded the photographic market into the lower middle class, encouraged many semiskilled individuals to enter the field in the early 1860s and fueled the myth that photography was the route to riches and fame. Other shifts of fashion, such as the taste for the larger cabinet view which developed around 1867, kept the public interested in the medium without lowering the cost of the product or attracting a broader clientele. The leveling off of the studio growth curve after 1868 suggests that the market had become saturated and that incentives (monetary or stylistic) to attract new customers were increasingly difficult to devise.

Who were the men and, infrequently, women who were attracted to commercial photography during its most dynamic growth years? Most of the figures listed in the Bottin will have to remain mysterious—anonymous operators without personalities and often without existing works. A few, like Nadar, Carjat, Le Gray, Marville, and Mayer and Pierson, have been singled out for monographic studies and, in the process, have too often been painted as extraordinary geniuses who somehow overcame the stigma of "commercialism." The qualities they shared with their less successful peers and the limitations that the business of running a studio imposed on them have not been clearly articulated. And, in some instances, their very status as commercial photographers has been denied or ignored in an effort categorically to qualify their products as "art."

For our purposes, a commercial photographer can be defined according to the statutes set forth in the Code de Commerce in effect during the Second Empire. Title 1, Article 1 of Book 1 of the code defines a "commerçant" as one "who exercises acts of commerce and makes of them his habitual profession." The code then qualifies this

definition by pointing out the difficulty of distinguishing between an artisan and a "commerçant" and specifying those individuals who cannot practice commercial activities: ecclesiastics, magistrates, lawyers, notaries, bailiffs, foreign consuls, government employees, military leaders, and stockbrokers. Minors under eighteen years of age could not run businesses, nor could women become "public merchants" without the authorization of their husbands. Various commentators on the code also noted that there were certain facts which in and of themselves presupposed the quality of "commerçant": the opening of a store, posting of signs and posters, and payment of the *patente* tax implied that a commercial enterprise was in existence.[5] Although the application of the *patente* tax to photographers varied in the course of the nineteenth century as the courts argued whether or not photography was an art (and, therefore, exempt), this tax continued to be levied during the Second Empire despite such cases as *Mayer and Pierson* v. *Betbeder and Schwabe*, which, after appeal, was decided in favor of the plaintiffs and allowed photographs the same copyright protection given other creative products.[6]

An analysis of the biographical information included in bankruptcy reports filed with the Tribunal de Commerce and now preserved in the Archives de la Seine, combined with accounts in contemporary periodicals and recent monographs, allows us to create a profile of the typical individual who set up a studio during the Second Empire. Approximately 192 bankruptcies of photographic studios and supply dealers were filed between 1843 and 1899, with the largest number in any single year (13) recorded in 1865. Since many bankruptcy files are incomplete, we are left with birthplaces and dates for only 108 persons. In this group, fewer than one-third of the photographers were born in Paris (7 out of the 29 cases during the Second Empire, and 18 out of 79 cases between 1871 and 1899). Almost one-fifth of the bankrupt photographers were born outside of France (20 out of 108). A comparison with demographic analyses of the Paris population as a whole during the Second Empire, derived from census data, shows that bankrupt photographers were typical in their overwhelmingly non-Parisian origins.[7]

Both the bankruptcy data and the Bottin listings confirm that the vast majority of studio owners were men. Only four of the sixty-two Second Empire bankruptcies were filed by women, two of whom were widows who had continued businesses with the help of assistants and family members after their husbands' deaths. The Bottin includes two or three women each year, expanding to a maximum of eight female-run studios in 1868–71; a total of twenty-four female operators are recorded during the Second Empire, with additional women cited as

supply merchants. More female operators and managers may have existed, however, since widows often continued businesses under their husbands' names.

The existence of single or divorced women as heads of studios is surprising, since they have received scant notice in photographic histories. The British writer Jabez Hughes, in an 1873 article "Photography as an Industrial Occupation for Women," stated that most women worked in assembling, printing, retouching, and mounting prints, but he advocated putting more females behind the camera: "It [photography] is an occupation exactly suited to the sex; there are no great weights to carry, no arduous strain of body or mind; it is neat and clean, and is conducted indoors."[8] French ideas of propriety seem to have been less enlightened, so that a young woman who ran a studio had to possess an abnormal amount of courage and economic need to enter the field. For example, Mme. Louise Rosalie Gaspard, who was separated from her husband in 1866, exhausted her private fortune and decided to open a photo studio with a relative who served as manager. After this relative became ill, Mme. Gaspard was forced to hire employees, who subsequently cheated her, and then declared a bankruptcy in 1869.[9] Other women also had difficulties maintaining studios, since their names rarely continue for more than two or three consecutive years in the Bottin.

Traditionally, photographic historians have implied that many of the new operators setting up studios in the 1840s and 1850s were trained as artists or miniature painters. The bankruptcy data reveal that the average novice photographer had had no connection with the fine arts and was more likely to have had experience in another small business. For example, Disdéri (Fig. 4) worked in a series of women's clothing and accessory enterprises before setting up a daguerreotype studio after he left Paris in 1848; Vion produced chemical products; Dupont sold fancy goods, as did Decagny (ribbons), Leroy (shawls and dresses), and Blanc. Several photographers had served as petty clerks or bureaucrats: A. R. Bisson, Varroquier (notary clerk, then law student, patent agent, and bank employee), Ernest Mayer (notary and law clerk, typographer), Boiçevaise (administrator for the *Assistance publique*), among others. Those figures who had had contact with the arts were more likely to have been connected with the industrial than the fine arts: Carjat (wallpaper designer and caricaturist), Leroy (painter on fabric), Disdéri (topographic draftsman and diorama painter), Aubry (industrial designer), Rouxel (painter/decorator), and Crosnier (fan painter).[10]

What is striking about the professional backgrounds of Second Empire photographers is their diversity. Civil engineers (Placet), journalists, teachers, dentists (De Nugent), actors, and even a masseur (Charavet)

Figure 4. Disdéri, Self-portrait, *c. 1863, uncut sheet of cartes-de-visite. Albumen print from collodion-on-glass negative. Private Collection, Paris.*

were attracted to the medium, which promised easy profits for a modest initial outlay and short apprenticeship. For most, photography was only one occupation within a lifetime of varying activities. J. B. A. Lacroix, whose career is typical, ran a provincial daguerreotype studio in 1853, advertised himself as a painter in Marseille in 1854, directed the periodicals *L'Artiste méridionnel* and *Echo du Commerce*, produced plays in theaters in Digne, Clermont-Ferrand, Salon, and elsewhere in southern France in 1857–58, moved to Paris and served as a dramatic agent in 1858–59, and bought a studio in 1860. Etienne Carjat similarly moved from an apprenticeship with a carpet and wallpaper designer to acting in and writing plays, illustrating magazines, traveling as an itinerant artist and caricaturist, founding his own comic papers, and finally setting up a photographic business in 1861.[11]

Photographers can therefore be described as men who had been unsuccessful in other jobs and who were still young enough to venture into a new and untried area. The average and mean ages of operators at the time of their bankruptcies during the Second Empire were forty and thirty-nine respectively; during the latter part of the century, the studios seem to have survived slightly longer, with the average and mean ages advancing to forty-two and forty-one. Since the average life of a studio founded between 1852 and 1861 was less than five years, one can conclude that most operators set up businesses when they were in their thirties.

The ownership of a photographic business could be obtained in two ways—by purchasing an existing studio or constructing a new one. During the 1840s and 1850s—the first generation of commercial photography—a studio had to be constructed by locating an apartment on the top floor of a building, obtaining a lease that stipulated the rent payments (at times for up to twenty years), cutting skylights, openings onto balconies, or even staircases leading directly from the street to the studio, purchasing equipment, and hiring employees if the enterprise was envisioned on a grand scale. The initial installation and construction costs were enormous and, on several occasions, burdened the new studio with such heavy debts that it was never able to operate in the black. Léopold Mayer and Louis Pierson, who established their celebrated studio at 3 blvd. des Capucines in 1854, paid 10,000F a year for the right to occupy several suites of rooms on the second floor facing the street and the third floor of the courtyard. They also had to convert a tailor's shop into a studio by adding a cast-iron and glass room, covering a terrace on the boulevard, and enlarging the windows in one of the apartments. In addition, they cut through an entry from 35 rue Louis le Grand for a total expenditure of 9,000F.[12]

During the 1860s, the tendency was to avoid the unpredictable costs and headaches of construction and the slow process of building up a clientele by purchasing an existing studio. With the purchase came the right to use the name or trademark of the original business (the new owner dubbing himself the "successeur"), the equipment and negatives, unsold paper prints, the clientele, and the lease, if it had not yet expired. Purchase costs for this package ranged from 1,000F for the widowed Mme. Bugette's modest kitchen, living room, dining room, bedroom, and studio with its single camera and small lab and dressing room in the unfashionable eleventh arrondissement, to 80,000F, the sum that Varroquier paid in 1865 for the Furne fils and Tournier establishment on the rue de Seine.[13] In the late 1860s Nadar attempted to sell his famous incorporated studio on the blvd. des Capucines to Pierre Petit for 300,000F, an enormous sum which exceeded Petit's capital.[14] Most studios, however, sold from between 5 and 20,000F and were often worth much less than the purchase price, as hapless novices rapidly discovered.

After purchasing or constructing a studio, an aspiring photographer learned his trade by trial and error, reading manuals, taking a few lessons with an established owner, or employing trained operators. A small percentage of owners had already worked in some type of photographic business: Petit started with Disdéri, Juhan had worked with a framer, Varroquier trained with Furne fils and Tournier, Walckmann was employed by Truchelut. Some studios passed from father to son or to other relatives: Disdéri's wife and son became photographers as did Braquehaïs's wife and Nadar's, Petit's, and Collard's sons. Braquehaïs entered photography by marrying the daughter of the daguerreotypist Gouïn; the three brothers Gustave Adolphe, Léopold Ernest, and Louis Frédéric Mayer all became cameramen. Although no statistical comparison between the success rates of family as opposed to first-generation studios has been compiled, the long life of the Nadar, Petit, and Collard businesses suggest that this kind of studio profited from the inherited know-how, capital, and renown that were passed from generation to generation.

The prerequisites for becoming a photographer were, therefore, not terribly restrictive: anyone with several thousand francs and ambition could purchase a studio and, with a little practice, obtain an image. Few, however, entered the business without some sort of outside financial support. For a small studio, money from a dowry (as in the case of Nadar's first studio on the rue St. Lazare) or an inheritance was all that was needed, but when the photographer wanted to expand or purchase a large business with several employees and branch operations, funds were solicited from friends, relatives, and investors whose names would

not always be known to the public. When two or more individuals contracted a partnership (a *société en nom collectif*), all the members were known to the public and equally liable for the company's debts: Furne fils and Tournier in 1858 formed this type of company. The fact that both men's names were identified in the company's name does not, however, prove that they were both photographers. In this case, Charles Paul Furne fils was listed as the photographer and Henri Tournier was an employee at the Ministry of Finance who later became an operator.[15]

More common was the company founded with the funds of silent partners, the so-called *société en commandite*. One or more individuals, normally the owners of an existing studio, pledged the entirety of their assets to the company and joined with one or more silent partners, who were liable only to the extent of their initial investment. The silent partners could not actively manage the business but could supervise or give advice and dissolve the contract if they were unhappy with the profits or behavior of the manager. Although most silent partners identified in the acts of incorporation were landowners and speculators who were friends of the photographer, some aristocrats and wealthy businessmen backed the largest Parisian studios. The Marquis de Briges and E. C. Comte de Briges were behind Gustave Le Gray's blvd. des Capucines studio; Dollfus-Ausset of the wealthy Mulhouse textile family invested 100,000F in the Bisson frères; the Comte de Cröy from Geneva backed De Torbechet Allain et Cie.[16] A certain landowner, Theodore Privat, committed 80,000F in March 1861 to Pierre Petit's company on the rue Cadet and also became the silent partner in Jean Baptiste Giraldon's photo studio established in September 1861.[17]

A third and much rarer kind of photographic business was a joint stockholding company known as either a *société en commandite par actions* or a *société anonyme*, depending on exactly how the company was set up.[18] In this case, a photographer with a well-established clientele and a certain experience and renown would expand his company by selling shares until all of the preestablished operating capital had been subscribed. Managers would direct the company, while shareholders would receive dividends and vote at the company's annual meeting. This kind of company was relatively new during the Second Empire, and legislation to protect the public from fraudulent companies only evolved during the period. Nonetheless, several photographers tried to issue shares, but few were successful in finding enough buyers to make up their declared operating capital. In 1860 Nadar established a *société générale de photographie* with an operating capital of 200,000F, consisting of forty shares at 5,000F apiece. The stated goals of this company, which was to be housed at 35 blvd. des Capucines, were the practice of photography in

all its applications, the publication of a collection of portraits of celebrities, and the sale of photographic instruments. For his clients, studio furniture, 140 negatives of contemporary celebrities, lease, and notoriety, Nadar received thirty shares.[19] According to a document in the Nadar Archives at the Bibliothèque Nationale, this company was established with 400,000F operating capital with shares sold to the chemist Testé du Motay (20,000F), the landowner Arosa (20,000F), the banker Dreyfus (10,000F), the printer Lemercier (20,000F), the editor Philipon (10,000F), and the Nantes landowner Groos (10,000F), among others. Either all the shares were not sold or the purchasers did not deliver the promised funds because the company was declared "a disaster" by Nadar himself.[20]

Within any sort of incorporated photographic studio (often, but not always, indicated by an "& Cie." after the photographer's name), the managers of the studio may have received a share of the profits depending on their relative contributions to the enterprise as fixed in the act of incorporation, but they could count only on a monthly salary also determined in the operating statutes. Therefore, the reported millions that were gained by studio owners were either fabricated by journalists or stolen from the pockets of partners or stockholders. Nadar's salary on the blvd. des Capucines was 1,000F a month as were Mayer and Pierson's; Carjat received 800F a month, Petit and Trinquart 400F each, Le Gray 300F a month in 1860, and Petit advanced to 700F a month after he dissolved his partnership with Trinquart in 1861 and reconstituted a new company. Although these salaries far surpass average working-class wages (in 1864, 1,500F a year for a mechanic, 1,350F a year for a carpenter, 900F a year for a baker, and so on), they do not justify the reputation that photography had as a highly paid profession.[21] Furthermore, these salaries were paid to the men running some of the largest and most prestigious houses and were not typical of the incomes earned by the owners of one-person studios (64 percent of the total in 1860).

Whether incorporated businesses or family operations, studios can be divided into two distinct physical types—transformed apartments overlooking the street or a courtyard and freestanding buildings. Because of the existing, dense construction and high price of land in the city of Paris, the majority were appended to or built within domestic apartments. A photograph of the entry into the Place Dauphine on the Ile de la Cité reveals the exteriors of two of the oldest and largest photo houses—Lerebours and Secretan and Charles Chevallier (Fig. 5). Lerebours, whose optical firm had stood on this site since the 1830s, joined up in 1845 with Secretan, an astronomy professor living in Lausanne, and installed the glass studios visible on the top of the building.[22] The

Figure 5. View of Lerebours & Secretan and Chevallier businesses on the Place du Pont Neuf, Paris, c. 1860, albumen print from collodion negative. Bibliothèque historique de la Ville de Paris.

"ingénieur Chevallier," member of a large family of opticians and photographers, similarly advertised his name on the façade of the building housing his studio and added precarious glass boxes to the roof line.

This photograph also reveals the glass showcases on the street level that were used to exhibit the photographer's wares. Lerebours and Chevallier may have gained the right to use these cases with their leases for the boutique and studio spaces, but other operators with less advantageous locations paid dearly for the privilege of showing their prints in rented vitrines throughout the city. In 1854 L. E. Mayer rented two such panels, 1.28 × 1.40m on the blvd. des Italiens and 1.28 × .95m on the rue Vivienne, from the owners of a lace store. The 2,000F a year that he paid for this exhibition space and the 30F that went to the servant in charge of servicing the cases and lighting the gas jets that illuminated them at night would presumably be recouped through increased sales.[23]

J. C. Tourtin's studio at 32–34 rue Louis-le-Grand, active between c. 1867 and c. 1878, is more typical of Second Empire establishments (Fig. 6). A ramshackle construction on the sixth-floor terrace was supplemented by a dining room, living room, antechamber, three bedrooms,

Figure 6. View of Tourtin studio, rue Louis le Grand, c. 1868, albumen print from collodion-on-glass negative. Bibliothèque historique de la Ville de Paris.

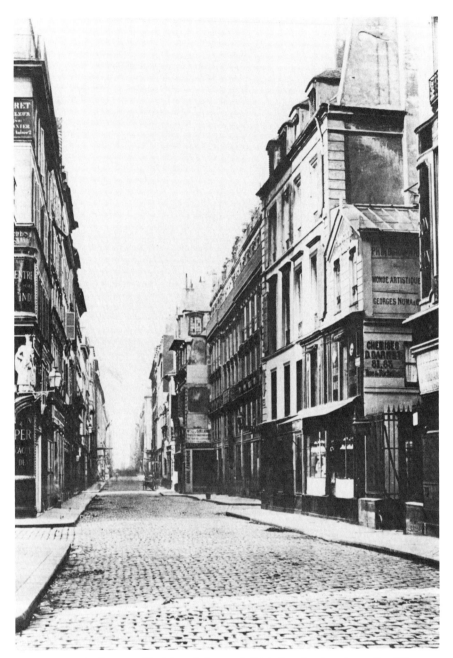

Figure 7. Charles Marville, View of the rue de Richelieu showing the studio of Georges Numa, c. 1865, albumen print from collodion-on-glass negative. Bibliothèque historique de la Ville de Paris.

Figure 8. View of Gueuvin's studio, 20 rue Cassette, probably taken by Gueuvin, c. 1862, albumen print from collodion-on-glass negative. Bibliothèque historique de la Ville de Paris.

and a kitchen.[24] The unimpressive facade of this studio and the lack of advertisements at the pedestrian level suggest that few elegant clients would have been encouraged to mount to the top floor. On the other hand, Georges Numa's business at 83 rue de Richelieu (Fig. 7) appears to have been constructed on top of an existing two-story building and contains a large glass room capping an imposing masonry facade. Declaring himself the photographer of the *monde artistique*, Numa ran his carte-de-visite business at this address not far from the Paris Bourse from 1862 until the Franco-Prussian War.

Very few Parisian photographers were fortunate enough to be able to build a large studio according to their own needs and designs. Gueuvin's elegant structure at 20 rue Cassette in the sixth arrondissement, which he inhabited between 1862 and 1867 (Fig. 8), contained an airy portrait sitting room with a sophisticated system of mobile drapes and windows on the top story and a salesroom and mounting and retouching labs on the ground floor. The entire pavilion was hidden from the street in a tree-filled courtyard and thus could not depend on accidental passersby for clients. Similarly, the sculptor Adam-Salomon's studio was

installed in a separate building behind the house on the rue de la Fais-anderie that he had purchased for 70,000F in 1863. Adam-Salomon's status was rather different from that of most photographers in that he already had a successful career as a sculptor which continued after he took up photography. His elegant, full-plate portraits, which normally sold for 100F apiece, were taken by appointment and appealed to aris-tocrats and notables. According to a later description by the English visitor Baden Pritchard, his studio included a gallery with Turkish car-pets and Louis XIV furniture and a spacious, skylit sitting room on the second story.[25]

The largest and most well-known photographic businesses main-tained their studios on wide, fashionable boulevards and rented cheaper warehouses in the suburbs where printing was done and negatives were stored. Although such a photographer had guaranteed exposure to the thousands of individuals who passed in front of his shop (Fig. 9), he paid high rents that often ate up his profits. Mayer was charged 10,000F a year for his rooms on the blvd. des Capucines; Nadar paid a similar amount for his studio on the same street; and Disdéri rented his blvd. des Italiens space for 15,000F a year. These figures can be compared with Second Empire rents for studios on the Right Bank (Baldus, 16 rue St. Dominique, 1,000F in 1856; Titus-Albitès, 30 rue de Bac, 3,000F in the 1850s), the new Haussmann boulevards (Sylvain Lévy, 5 blvd. des Filles du Calvaire, 500F in 1862; Collard, 39 blvd. de Strasbourg, 2,000F in 1867), or on other right bank streets (Quinet, 90 rue St. Honoré, 1,700F; Franck, 15 place de la Bourse, 1,700F; or even Nadar, 113 rue St. Lazare, 1,200F in the 1850s). According to the Chamber of Com-merce's 1860 industrial statistics, the average annual rent for a Parisian studio was 1,651F, or approximately one-seventh the price paid on the *Grands Boulevards.*

Despite the higher overhead for studios in the area surrounding the ring of streets that connected the enlarged place de la République to the church of the Madeleine, photographers migrated to the area in remarkable numbers during the 1850s and 1860s. In 1848, the daguer-reotype trade, which had grown out of optical firms, remained concen-trated in the quarter traditionally associated with the manufacture of precision instruments, the quai de l'Horloge.[26] The other center for daguerreotypy was the Palais Royal, whose arcades housed Bodson, Charles Chevalier fils, Lévy, Victor Plumier, B. H. Sabatier, Sabatier-Blot, and Vaillat, or seven of the thirteen firms listed in the 1848 Bottin. Although the Palais Royal's heyday as a center for chic restaurants and clubs is generally identified as the eighteenth century and the Restoration, it must have preserved an aura of gentility at the end of the July Monarchy.

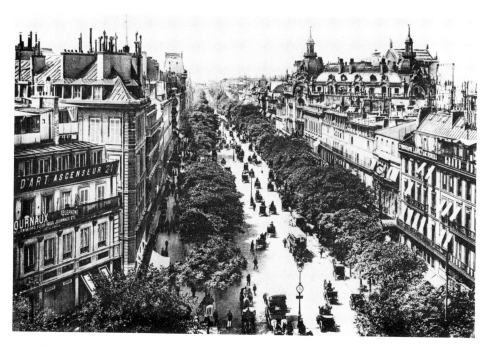

Figure 9. Boulevard des Italiens, c. 1890. The former home of Disdéri's studio can be seen in the right foreground.

By 1860, the picture had changed completely, and the 207 studios surveyed by the Chamber of Commerce (compared with the 191 listed as photographers in the Bottin) were concentrated in the new first, second, and ninth arrondissements (see Table 1). The largest number of studios (40) with the largest gross income (2,094,000F), the largest number of workers (139), and the largest average rent (3,201F) were located in the second arrondissement, or the region just south of the grands boulevards. Although the first arrondissement also contained forty studios, their sales were almost half those of studios in the second (1,195,300F), and the average rent was only 1,436F. However, it was the ninth arrondissement that had the highest average income per studio (59,238F) and the largest number of workers per studio (5.9).

The density of studios in these three arrondissements can be extracted from information provided in the 1860 Bottin. On the blvd. des Capucines were Mayer frères and Pierson (#3), Alophe (#35), Le Gray (#35), and De la Blanchère (#39); the blvd. des Italiens featured Zacharie (#1–3), Disdéri (#8), Adrien Tournachon (#17), Numa Blanc (#29), and Mulnier (#25). Other streets such as the rue de Richelieu (David, #16, Blake-Horridge, #25; Mayer, #102, Reutlinger, #112) and

the rue Vivienne (Malacrida, #12, Fixon, #33, Plumier, #36, Arnaude, #49) attracted the overflow clientele that promenaded north and south of the main boulevards.

The impression that was created by this bombardment of shop signs, photographic display cases, and clusters of curious strollers gathered around celebrity portraits was described by an anonymous writer in the 1857 *Revue photographique:*

> Le nombre des photographes augmente dans les proportions éffrayantes. Chaque jour, entre l'épicier et le marchand de vin, on voit apparaître une nouvelle enseigne. M. Philibert Audebrand, dans la *Gazette de Paris*, ne craint pas d'affirmer que, si l'on voulait se donner la peine de procéder à un rencensement sérieux, on arriverait à comter dans Paris 20,000 photographes, c'est à dire la nombre d'âmes et de boîtes suffisant à peupler une ville aussi grande que les Batignolles.[27]

Although this mock serious account greatly exaggerated the actual invasion of photographers, it reveals a certain apprehension within the photographic press that perhaps photography was becoming too popular and might end up destroying itself through vicious price-cutting and competition.

The geographical distribution of studios in 1868 remained essentially the same as in 1860, with the second and ninth arrondissements becoming even denser.[28] Studios also began to appear in the areas farther away from the old city that had been annexed in 1860: Adam-Salomon near the Bois de Boulogne, Andrieux in Passy, Autier and Decagny in Belleville, Bordeau in Vincennes, Coq and Godet in Batignolles, Delton on the avenue du l'Impératrice, Disdéri on the avenue d'Eylau, Duchesne in Montrouge, and so on. Hoping to profit from the lower rents in these districts, these businesses, with the exception of the equestrian portrait facilities on the west side of the city, never received the notoriety of their more visible and centrally located competitors. The Left Bank contained more studios in 1868 than in 1860 but continued to trail far behind the Right Bank, with only 63 out of 359 studios (18 percent) catering to the students and bureaucrats concentrated in that area.

A photographer's chances of succeeding or even breaking even during the Second Empire depended on several factors, including the location of his studio, the amount of capital that he had when he began, and his managerial skills. In 1862, De Torbechet Allain and Cie. attempted to set up an elaborate studio on the rue St. Dominique to draw the wealthy St. Germain clientele, who never were attracted to their neighborhood photographers and continued to patronize the well-established *Grands Boulevards* establishments. A bad location also plagued

TABLE 1—Parisian Photographic Studios and Supply Dealers in 1860
Based on the Chambre de Commerce, *Statistique de l'Industrie* (Paris, 1860)

Arrondissement	No. of Studios	Avgerage Annual Rent per Studio (in francs)	Average Annual Sales per Studio (in francs)	Avgerage Number of Employees per Studio*
1	40	1,436F	29,883F	1.95
2	40	3,201F	52,350F	3.48
3	24	1,124F	23,292F	1.75
4	14	601F	5,000F	.57
5	5	471F	6,800F	1.40
6	14	1,574F	38,640F	5.36
7	6	741F	20,583F	1.67
8	6	1,867F	22,000F	2.33
9	21	2,321F	59,238F	5.90
10	17	1,219F	16,964F	2.82
11	5	970F	29,400F	3.00
12	2	600F	5,675F	—
13	1	300F	6,000F	—
14	2	450F	6,250F	—
15	2	375F	5,000F	.50
16	—	—	—	—
17	4	368F	4,625F	—
18	2	600F	24,000F	2.50
19	1	600F	10,000F	—
20	1	250F	2,900F	—

*The owner was not considered an employee.

Charavet, whose studio on the rue de la Grange Batelière in the ninth arrondissement lasted three years before going bankrupt. When this studio was acquired by Robert in 1867, exactly the same thing occurred, with a bankruptcy declared in three years and the syndic's report listing a disadvantageous location as a major cause.[29]

Improper management, either the willful abuse of funds (thus liable to criminal proceedings and the declaration of a *banqueroute* rather than a *faillite*), or innocent fiscal disorder resulting from a lack of business experience, was one of the most frequent causes of bankruptcy. Photographers, like all businessmen in France, were required to keep several ledgers recording their receipts and expenses; many apparently were haphazard and negligent in their bookkeeping and had little idea of their studio's fiscal condition. Some characters, like the young Anne Méline Brochard, had no business experience. Marrying at eighteen after leaving a boarding school, Brochard had one child during the three years that she spent with her husband, who worked for the railroad. Fleeing to Madrid and then Paris with her father, she purchased a studio renting for 6,000F a year in 1867 and then incurred numerous debts by buying first elaborate oak and then mahogany living room furniture. She soon moved into an apartment rented for her by a M. Sibut, but less than a year later she was evicted from her 2 rue de la Bourse photo studio and cast out of her apartment by Sibut, who kept her clothes and private furniture. What happened to the twenty-four-year-old woman at this point can only be left to the imagination.[30]

Another more well-known operator, Bruno Braquehaïs, a deaf-mute who had married the daughter of the daguerreotypist Gouïn and continued his father-in-law's sale of portraits and *académies,* also squandered his fortune and brought about the downfall of his family and business. After Gouïn's death in 1855, Braquehaïs and his wife continued the studio and moved to more luxurious quarters at 11 blvd. des Italiens in 1864. Shortly after this expansion, he began to speculate on the stock-market and lost not only his family's savings but also over 81,000F that he had borrowed from a friend. Badgered by his creditors, he mortgaged his furniture for 23,000F but ended up being imprisoned in December 1873 for a criminal bankruptcy. Dying suddenly after his release from prison, Braquehaïs left his wife to carry on what was left of the studio until she declared a second bankruptcy in 1883.[31]

The size of a photographic studio does not seem to have been a determining factor in its chances for success. Although the 1860 Chamber of Commerce data suggest that operators working alone could expect to gross 3–10,000F a year while the owners of large studios, who paid their workers a maximum of 1,500F a year, reaped much greater benefits

(See Table 1), the bankruptcy reports contain the names of the famous as often as the obscure. Disdéri (bankrupt in 1856, 1872, and 1875), Mayer (1874), Bisson frères (1863), Bisson jeune (1866), Carjat (1865), and Delton (1866) filed balance sheets during the Second Empire; Adrien Tournachon (1872), Bertall (1873), L. E. Mayer (1874), and even Baldus (1887) survived into the Third Republic before giving in to their creditors. These studios often sold large numbers of works but were plagued by high overheads and overextended credit. For example, Bisson frères, who had started a photographic business in 1840, formed a company with Dollfus-Ausset in 1855, with Dollfus contributing 100,000F. By 1857, this company, which maintained a printing shop on the rue Garancière and an office and boutique at 35 blvd. des Capucines, was dissolved and the arrangement with Dollfus was renegotiated so that Dollfus would pay the back rent and be owed only 75,000F to be repaid over five years. Bisson frères' other creditors settled for 50 percent of the sums due and agreed to wait five years for the remaining 50 percent. Continuing to operate on the rue Garancière, the brothers paid 10,000F a year rent and around 27,600F a year wages to their large staff. As a result of these high costs, their lack of reserve capital, and continued persecution by old creditors, the business was declared bankrupt in 1863 and was sold in 1864 to Paul Emile Placet for 15,050F.[32]

If the great fell with the small, the men who entered the field in the 1840s maintained their studios for a longer period of time than did the arrivistes of the 1850s. A graph based on the number of years that a studio was listed in the Bottin shows that 40 percent of studios founded before 1851 endured for more than twenty years, whereas 49 percent of studios founded between 1852 and 1861 lasted only one to five years. Although data for studios founded between 1861 and 1871 have not yet been analyzed, it can be hypothesized that about half of the proclaimed photographers in the Bottin directory practiced the trade for less than five years. Most of those who saw the new medium as an easy way to make a living did not go bankrupt but closed or sold their shops and returned to other commercial activities.

The picture that the bankruptcy reports, Bottin listings, and industrial statistics give us of commercial photography during its most dynamic two decades is one of lost illusions and idealistic dreams of wealth that never materialized or quickly vanished in the changing urban environment. Spurred on by manuals declaring how easy the process was and news stories describing the luxurious studios and flamboyant life-styles of men like Disdéri, Nadar, and Carjat, first-generation Parisians in the prime of life climbed onto the bandwagon and imitated the techniques of successful operators. They were more often than not cruelly

deceived by both the profits and the demands made upon them by dissatisfied clients. As an anonymous comedy, "Le Photographe, ou les métiers trop faciles" reveals, the photographer confronted ignorant grocers who wanted to pay 10F for a portrait large enough to go over their mantelpieces, and was hounded by landlords demanding the rent and bootmakers and cooks who had to be given free portraits instead of payments. By the end of the play, the harassed photographer declares, "J'avoue tout de même que le métier de photographe n'est pas des plus lucratifs. C'est peu fatigant, c'est vrai; on ne voit que des gens endimanchés; parfois on fait des portraits réussis, ce qui console de ceux qu'on ne réussit pas." But he has nothing to eat and three times a week confronts people who complain that their portraits are too expensive. In the last scene, the landlord returns with a bailiff, the young photographer's uncle pays his debts, and the curtain falls.[33]

Some studios did, of course, survive, but the reasons for their success are harder to determine than the reasons for the failures. Nadar, who received the largest amount of publicity during the period thanks to his friendships with writers and journalists, was lauded for the atmospheric celebrity portraits that he produced in the 1850s in his modest rue St. Lazare studio and, as a result of his success, moved to the more expensive blvd. des Capucines in 1860. Ironically, as his letters reveal, the larger studio was less profitable, and its owner spent more and more time on his balloon trips in Belgium and elsewhere. By 1868, Nadar was reduced to writing to a friend for help and outlined his professional fortunes: after gaining 180,000F on the rue St. Lazare, he owed 180,000F by the time that his elaborately accoutered blvd. des Capucines studio opened. His administrator embezzled 45,000F; he lost money with his balloon and succeeded in paying only 18,000F of his debts. His rent had increased to 19,500F a year and his house owed 25,000F for other expenses.[34] The studio, which continued to attract a certain clientele because of the name of its founder, survived the Franco-Prussian war and prospered until the turn of the century under the direction of Nadar's son, Paul.

By avoiding extravagant personal expenses, eliminating extraneous personnel, keeping abreast of changing photographic styles, and resorting to aggressive advertising in the form of paid notices, planted features, participation in international exhibitions, and aristocratic endorsements, a photographer with a studio in a choice location and some reserve capital had a good chance to survive through his adulthood. The one variable that might be considered crucial to success—the quality of the product—was less important. Obviously, photographers who badly judged exposure times and produced imperfectly fixed prints would not

attract clients. However, the copies of the photographs registered for public sale and now preserved in the Bibliothèque Nationale indicate that the techniques for collodion-on-glass negatives and albumen printing were fairly standardized by the 1860s. When the most important segment of commercial production, the carte-de-visite, is examined, even the skillful posing and lighting of the model seem to be within the reach of most urban operators. Originality in portraiture, manifested in De Torbechet Allain and Cie.'s photomontages, Thomassin's racy dancehall girls, Carjat's gesticulating actors, or even Dallemagne's baroque framed artists, was not necessarily rewarded.

Unlike his amateur colleagues, the professional photographer above all had to satisfy his client and make a profit. The extent to which photographers adjusted their personal tastes to those of the public is difficult to determine, since many of them came from the petit bourgeoisie and shared their customers' expectations and aspirations. In the case of Nadar, the shift of studio style from the full-plate prints of the 1850s to the rather run-of-the-mill cartes of the 1860s must be seen as a concession to "la mode." As a consequence of this change, which lowered the cost of his product and expanded his clientele while reducing the time spent adjusting the pose and lighting of each sitter, Nadar developed a distaste for all commercial photography which clearly flavors his book, *Quand j'étais photographe* (1900). Writing to his son in 1892, he admitted that "except for a few years at the beginning, I rapidly assumed an indifference toward our profession which has not been long in changing into an aversion and then a horror."[35] The realities of running a portrait studio, which involved continuously scrounging for backers, courting customers, and standardizing procedures at every step in the production process, removed the glamour and personal expression that Nadar had enjoyed when he first experimented with the medium.

Etienne Carjat, who, like Nadar, was employed as a caricaturist before becoming a photographer, was equally disillusioned by the necessities of day-to-day studio management. In a heartrending letter written to his friend Edouard Lockroy in June 1873, he asked the recently elected deputy to recommend the studio to his friends and described his predicament:

> Des journées entières sans voir un client, et des frais énormes courant toujours. Ajoute à cela que depuis la Commune, une partie—la bête mais la lucrative—de ma clientèle m'a lâché, entre autres, les Rothschild . . que je n'ai guère à cette heure que de bons bougres de citoyens peu lestes d'argent et tu comprendras pourquoi je fais appel aux quelques cœurs chauds que je connais. Il faut sous peine de mort que je fasse des

affaires ce mois-ci. Je ne sais où donner de la tête. Un huissier est venu me visiter samedi, un autre sort de chez moi, celui des contributions, et ma pauvre boutique que j'avais sauvée aux deux tiers, depuis la guerre, menace de croûler juste au moment où je croyais l'avoir solidifiée. Je veux éviter cette catastrophe à tout prix, car je suis trop vieux pour recommencer autre chose, et ma gamine a dix ans. Pardonne-moi cette confidence toute fraternelle; nous ne sommes pas vus aussi souvent que je l'eusse voulu, mais je te connais, et quand aux heures tristes, je regard autour de moi, tu es un des rares dont la douce et loyale figure me sourit franchement.[36]

A few years later, Carjat was able to joke about the photographer's plight in poem entitled "La Lamente de Photographe":

Si, pour un trafic lucratif
Tu veux déserter la peinture,
Ne vas pas choisir l'objectif:
C'est un instrument de torture!
Ses deux lentilles de cristal
Qu'enferme un long tube de cuivre,
Mènent leurs hommes à l'hôpital
Et je te défends de m'y suivre.[37]

Despite the lighter tone of the poem, the message conveyed remains the same: the photographer leads a hard life with no guaranteed rewards.

Nadar's scorn for the commercial photographer and Carjat's complaints can be used to give us some insight into the social status of the profession during the Second Empire. By repeatedly disassociating himself from the likes of Disdéri or Mayer and Pierson and by promoting Gustave Le Gray and Hippolyte Bayard as artists in *Quand j'étais photographe,* Nadar implies that even at the end of the century, when his autobiography was written, photography was still considered to be an unprestigious profession. Grouped with ceramic and chemical industries in the 1847–48 and 1860 Chamber of Commerce surveys, photography had been moved to the "industrie du livre" section of the 1896 professional census.[38] In international and regional exhibitions during the Second Empire, it continued to search for its relative position among all human products: in the 1849 Paris exhibition of industrial and agricultural products, photography was included under "Beaux-Arts" along with mirrors and billiards; in London in 1851 it was in "Class 30— Sculpture, Models and Plastic Art"; in the 1859 Rouen regional exhibition, it was grouped with "dessins, peinture, sculpture, appliqué à l'ornement et à l'industrie." Appearing with precision and physics instruments in Angers in 1864, photographs were lumped with ceramics,

metalwork, printing, and industrial design in the Bordeaux fair of 1865 and with the graphic arts in Vienna in 1873. The photographer was therefore schizophrenically divided into an artist, scientist, printer, and industrial designer. When he aspired to the highest French honor, the Légion d'Honneur, he had to promote himself as an inventer and creative genius.[39] When he dealt with royalty, he was reduced to obsequious kowtowing; when he confronted the artistic establishment, he was rebuffed as a mindless manipulator of machinery, a threat to beauty and the ideal, while his works were secretly used as drawing aids. In the eyes of the law, he was a "commerçant" and taxpayer; in the eyes of the proletariat, he was a rich man; in the eyes of his creditors, a cheat and a scoundrel.

There were, admittedly, grades of photographers just as there were so-called *artistes* who ranged from hack sign painters to academicians. But there can be no denying that photography did not have the prestige of the liberal and fine arts. In his novel *Le Nabab*, which features a variety of famous Second Empire types such as the decadent legitimist, the Anglo-Saxon society doctor, the powerful minister, and the gullible nouveau riche nabob himself, Alphonse Daudet depicts a young photographer in his opening pages. After leaving his elegant patients in the Chaussée-d'Antin, Champs-Elysées, and Faubourg Saint-Honoré, the self-satisfied Dr. Jenkins shocks his coachman by commanding him to a poor suburb near the church of St. Ferdinand des Ternes. Arriving in front of a building surrounded by empty lots and unfinished construction, Jenkins mounts to the sixth floor and confronts his stepson, André, who has recently set up a small photographic studio in this unlikely location. As the representative of bourgeois propriety and social climbing, Jenkins chastises André for dashing his family's hopes and becoming a photographer: "Tout à coup sans dire pourquoi, sans te préoccuper de l'effet qu'une pareille rupture pourrait avoir aux yeux du monde, tu t'es écarté de nous, tu as laissé là tes études, renoncé à ton avenir pour te lancer dans je ne sais quelle vie découtée, entreprendre un métier ridicule, le refuge et le prétexte de tous les déclassés." He then concludes his condemnation of the photographic profession by predicting that the wayward André will lead "une vie de hasard sans issue et sans dignité" if he persists with his bohemian folly.[40]

Although Daudet's characterization is atypical in that his young photographer has a wealthy stepfather and has benefited from a good education, it echoes the dismissal of commercial photographers as "déclassés" or riffraff that was expressed by many men of good breeding. It was perfectly respectable for a gentleman to dabble in the medium during his leisure hours, but to run a studio was something altogether differ-

ent.[41] Fortunately for those of us today who appreciate the works produced by the hundreds of Second Empire Parisian studios, there were ample numbers of individuals who persisted despite the irregular profits, angry clients, and relatively low social status associated with the profession. One can only regret that they could not be transported in true Jules Verne fashion into the twentieth century, where they could receive the rewards and acclaim that were denied to most of them during their lifetimes.

NOTES

1. Léon Laborde, *Rapport du jury central sur les produits de l'agriculture et de l'industrie exposés en 1849*, Paris, 1850, III, 534–38.

2. *Statistique de l'industrie à Paris—résultant de l'enquête faite par la Chambre de Commerce pour les années 1847–1848*, Paris, 1851, 150–52, 515–16.

3. Archives Nationales, Paris, F18* VI, 50–72, F18* VI bis, 1–11.

4. Adrien Dansette, *Naissance de la France moderne: Le Second Empire*, Paris, 1976, 356–58.

5. Jean Sirey, *Les Codes annotés de Sirey—Code de Commerce*, 3rd ed., Paris, 1905, 1–14.

6. Mayer and Pierson sued Betbeder and Schwabe, who had independently copied cartes-de-visite of Palmerston and Cavour produced by the studio. In January 1862, the court decided against Mayer and Pierson; in April, after appeal, the decision was reversed and Betbeder was fined 200F and Schwabe 100F. The judges did not go so far as to claim that all photography was an art, but asserted that photographs could be protected by the copyright laws when "on y voit un produit de la pensée, de l'esprit, du goût et de l'intelligence de l'opérateur." This was by no means the end of the controversy: a November 1862 case between Varcollier and Braconneau concluded that a photographer was a "commerçant," and the debate continued into the twentieth century. For a summary of cases on this subject, see E. N. Santini, *La Photographie devant les tribunaux*, Paris, n.d.

7. Louis Chevalier, in *La Formation de la population parisienne au XIXe siècle* (Paris, 1950), cites census reports which indicate that 58.65 percent of Parisians in 1861 were born in the provinces; in 1866, the number had risen to 61.05 percent, but in 1872 it was down to 57.72 percent. The number of foreigners among bankrupt photographers is much higher than in the Paris population as a whole: in 1861, 5.14 percent of the Paris population were foreigners, in 1866, 5.78 percent, and in 1872, 7.36 percent (p. 45).

8. Jabez Hughes, "Photography as an Industrial Occupation for Women," *The Photographic News* (May 9, 1873), 218.

9. Archives de la Seine, Paris, D11 U3 #12739, November 27, 1869. Faillite Dame Gaspard, Louise Rosalie Lechat.

10. Archives de la Seine, D11 U3, diverse dossiers.

11. Archives de la Seine, D11 U3 #19166, November 13, 1861, Faillite Jean Baptiste Auguste Lacroix; and #5170, July 26, 1865, Faillite Pierre Carjat.

12. Archives Nationales, Minutier Central, XLII #989, January 24, 1855, Dépôt de bail par M. Pitois à Mayer et Pierson.

13. Archives de la Seine, D11 U3 #4966, August 11, 1865, Faillite Dame Veuve Bugette, Antoinette Hobeniche; and #8795, December 3, 1867, Faillite Armand Varroquier.

14. Bibliothèque Nationale, Paris, Cabinet des Manuscrits, N.A.F. 25010, March 1867 letter from Nadar to Petit.

15. Archives de la Seine, D31 U3 #239, January 28, 1858, Acte de Société Furne fils et Tournier.

16. Archives de la Seine, D31 U3 #437, February 15, 1860, Acte de Dissolution Le Gray et Cie; D11 U3 #2486, December 26, 1863, Faillite Ste. Bisson frères; D11 U3 #3952, December 27, 1864, Faillite Ste. De Torbechet Allain et Cie.

17. Archives Nationales, Minutier Central, XXXIII #1262, March 27, 1861, Ste. Petit et Privat; Archives de la Seine, D11 U3 #876, November 8, 1862, Faillite Jean Baptiste Giraldon.

18. The basic difference between a "société en commandite par actions" and a "société anonyme" is that in the former, the founders are responsible to creditors for the entirety of their assets while the liability of the shareholders is limited to the amount of their investments, whereas in a société anonyme, all members are liable only for the amount of their shares. For further details on the regulations governing these two types of companies, see Léopold Goirand, *A Treatise upon French Commercial Law and the Practice of all the Courts,* 2nd ed., London, 1898, 66–89.

19. Archives Nationales, Minutier Central, XXIII, June 19, 1860, Statuts de la Ste. Générale de Photographie Félix Tournachon, dit Nadar et Cie.

20. Bibliothèque Nationale, Paris, Cabinet des Manuscrits, N.A.F. 25010, p. 107.

21. Georges Duveau, *La Vie ouvrière en France sous le Second Empire,* 5th ed., Paris, 1946, 320–22.

22. Archives de la Seine, D31 U3 #388, February 24, 1845, Acte de Société Lerebours et Secretan.

23. Archives Nationales, Minutier Central, XLII #987, October 21, 1854, Bail.

24. Archives de la Seine, D1 P4, Cadastre, rue Louis-le-Grand, 1862.

25. Baden Pritchard, *The Photographic Studios of Europe,* London, 1882, 204; and Archives de la Seine, D1 P4, Cadastre, rue de la Faisanderie, 1862.

26. Centre de Documentation d'Histoire des Techniques, *Evolution de la géographie industrielle de Paris et sa proche banlieu au XIXe siècle,* Paris, 1976, I, 88–97, 144–51.

27. The number of photographers is increasing to fearful proportions. Each day you can see a new sign appear between the grocer and the wine merchant. M. Philibert Audebrand, in the *Gazette de Paris,* went so far as to estimate that if you wanted to conduct a serious census, you would count 20,000 photographers in Paris, that is to say, the number of souls and houses to people a town as large as Batignolles. "Epidémie de photographie," *Revue photographique* (June 5, 1857), 305.

28. The concentration of studios in the center of the city is consistent with the locations of all enterprises: at the time of the 1860 annexation, there were twenty-two industries per hectare in the old twelve arrondissements and three

per hectare in the annexed regions. See *Evolution de la géographie industrielle,* I, Chapter 3.

29. Archives de la Seine, D11 U3 #3952, December 27, 1864, Faillite Ste. De Torbechet Alain et Cie; #1992, August 26, 1863, Faillite Nicolas Florentin Charavet; #13479, March 25, 1870, Faillite Ste. Emile Robert et Cie.

30. Archives de la Seine, D11 U3 #9903, June 10, 1868, Faillite Anne Méline Brochard.

31. Archives de la Seine, D11 U3 #18115, December 4, 1873, Faillite Auguste Bruno Braquehaïs.

32. Archives de la Seine, D11 U3 #2486, December 26, 1863, Faillite Ste. Bisson frères.

33. I swear nevertheless that the photographic profession is not the most lucrative. It's not tiring, that's true; you only see people dressed up in their Sunday best; occasionally you make a successful portrait, which compensates for those which aren't. Anonymous, "Le Photographe, ou les métiers trop faciles," Paris, n.d., B.N. Yth. 25981.

34. Bibliothèque Nationale, Cabinet des Manuscrits, N.A.F. 24989, March 11, 1868, letter from Nadar to an unidentified friend.

35. Bibliothèque Nationale, Cabinet des Manuscrits, N.A.F. 24987, August 25, 1892, letter from Nadar to his son, Paul.

36. Whole days without seeing a client, and enormous costs mounting all the while. Add to that since the Commune a part—the dumb but the lucrative—of my clientele gave me up, among others, the Rothschilds . . . that I only now have good solid citizens who are tight with their money, and you'll understand why I'm calling out to some good hearts that I know. I must under punishment of death do some business this month. I don't know which way to turn. A bailiff came to see me Saturday, another just left, that of the tax office, and my poor shop that I had almost saved since the war threatens to go under just at the point that I thought I'd solidified it. I want at all costs to avoid this catastrophe, because I'm too old to start something else, and my little girl is ten. Please excuse this fraternal confession; we haven't seen each other as often as I would have wished, but I know you, and when I look around at sad moments, you are one of the rare people whose kind and loyal face smiles back at me. Bibliothèque Nationale, Cabinet des Manuscrits, N.A.F. 25161, June 30, 1873, letter from Carjat to Lockroy.

37. If you want to desert painting for a lucrative trade,
Don't choose the objective: it's an instrument of torture.
Its two crystal lenses closed in a copper tube
Lead their man to the hospital, and I refuse to let you follow me
there.

Etienne Carjat, *Artiste et citoyen,* Paris, 1883, 58.

38. Ministère du Commerce, de l'Industrie, des Postes et des Telegraphes, *Résultats statistiques du recensement des industries et professions* [*dénombrement général de la population du 29 mars 1896*], Paris, 1899, section 4.39.

39. For example, see the letter of Mayer and Pierson to the Ministry of Agriculture and Commerce dated January 10, 1863, in support of their application for the Légion d'Honneur. Archives Nationales, F12 5208. This letter cites the photographers' preeminence in the "vulgarization" of photography, lists their technical innovations (first prints on paper exhibited, enlargements, chemical improvements, and so on), alludes to the decoration they received from the

king of Sweden, and concludes with references to the recent court decision in their favor (see Note 6) and to the publication of their book, *La Photographie: histoire de sa découverte* (1862).

40. All of a sudden, without saying why, without thinking of the effect that such a rupture would have in the eyes of the world, you moved away from us, you dropped your studies, renounced your future to jump into I don't know what kind of haphazard life, to take up a ridiculous trade, the refuge and pretext of all the losers. Alphonse Daudet, *Le Nabab*, Paris, 1906, 20–25.

41. An article in the *Magasin pittoresque* saw the medium as "une intéressante distraction" for the man of leisure, a good way of fixing memories for the traveler, an exercise in physics and chemistry for the adolescent, and an amusement even fit for women. Interestingly enough, no mention was made of the suitability of photography as a profession. The article's intended audience, therefore, consisted of persons with leisure time who would not be looking for money-making activities. "La Photographie," *Magasin pittoresque* (January 1863), 43.

The Artifice of Candor: Impressionism and Photography Reconsidered

KIRK VARNEDOE

The artists of the Impressionist circle made a number of paintings that looked like no paintings before. With today's interest in photography, it has become a commonplace to say that these pictures, in their untraditionally candid grasp of reality, look like photographs. Several historical studies, including Aaron Scharf's influential survey *Art and Photography*, have encouraged such comparisons, and have held that the painters' pictorial innovations owe substantially to the impact of the photographs they saw.[1] This line of thinking is, however, inaccurate and misleading.

Discussions of the subject have tended falsely to conflate two basic questions involved. One concerns the actual influence of photographs on paintings in the 1870s. The other concerns the Impressionists' development, in that same period, of what we now think of as "photographic vision." These are not the same things, and while we come more and more to appreciate the importance of the first question, we should not lose sight of the leap that separates it from the second. To understand the originality of these painters, we must examine more critically the extent to which photography does and does not explain nineteenth-century paintings in general, and their images in particular.

What do we mean, first of all, by influence? Certainly it must be more than is implied by the growing literature on particular painters who used photos as sources.[2] No matter now numerous these instances, they don't mean much, since the simple use of a document need not determine anything significant in the nature of a painting. The photos of naked bodies Delacroix sometimes used had no more influence on the nudes in his final canvases than did his scrofulous live models; like

lay figures or line engravings, the photos were terminally utilitarian, and totally dissolved in the creative process.[3] To qualify as a meaningful influence, photography need not have so direct a role, but its impact should be more substantial. If significant aspects of artists' ways of depicting—composition, spatial structure, tonal range, and so on—owe principally to photographs, then this debt should be evident and demonstrable, even where no specific proof of copying exists. To discuss the question in this larger sense, though, we must have a clear idea of just what aspects of photographs might have been influential—that is, what characteristics photographs could have shown painters that they had not seen before, and could not see elsewhere. A popular presumption today would have it that photographs, and especially fast exposures after c. 1860, revealed a great deal that was new and unique: a revolutionary new world of odd perspectives and viewpoints, peculiar compositional croppings, and candid instantaneity. This premise does not, however, bear up under close historical examination.

To the extent that no one ever perceives the world as a flat perspectival image with edges, photographs did show painters a world they could not see experientially—just as thousands of paintings had before.[4] Beyond that fundamental distinction, and aside from some minor technical oddities like solarization or lens flare, the new medium of photography did not show painters any phenomenon they could not have seen with the unaided eye.[5] Ever since there have been rocks to stand behind and cliffs to climb, segmented figures (Fig. 2) and overhead views (Fig. 3) have been there to see. A more proper question in evaluating the medium's impact is, what did photographic pictures show painters that other *pictures* had not shown?

The short answer is: little of any significance. It takes a longer answer, though, to clarify the ways in which photography, instead of constituting an *ex nihilo* revelation about the world, effected instead a particular kind of palace revolution. Operating from within established traditions of representation, photography's influence lay in gradually reinforcing and expanding those special peripheral lineages of picture-making concerned with strict geometric and/or lens-optical organization.[6]

The photographic camera arrived as the mechanical expression of a perspectival system already four hundred years old. Ever since its invention in the fifteenth century, this system had been known to be troublesome.[7] If kept within prescribed limits (by holding to generally accepted norms for viewpoint, distance, breadth of field, etc.), it would provide a pleasingly natural illusion of a window-view on the world. If used in an unorthodox fashion (by going beyond the norms), the same system

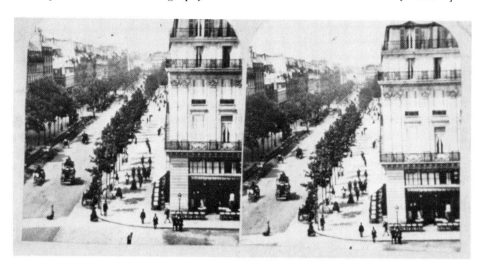

Figure 1. A. Houssin, Boulevard in Paris, *1863, stereoscopic photograph. Bibliothèque Nationale, Paris.*

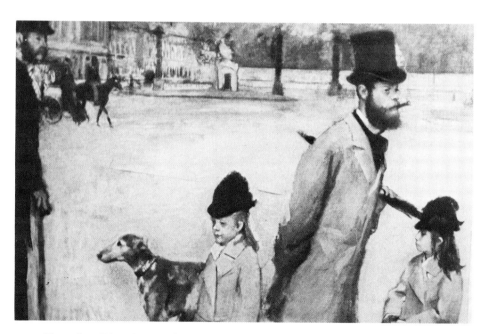

Figure 2. Edgar Degas, Place de la Concorde (Vicomte Lepic and His Daughters), *1875, oil on canvas. Formerly Gerstenberg Collection, Berlin (believed destroyed).*

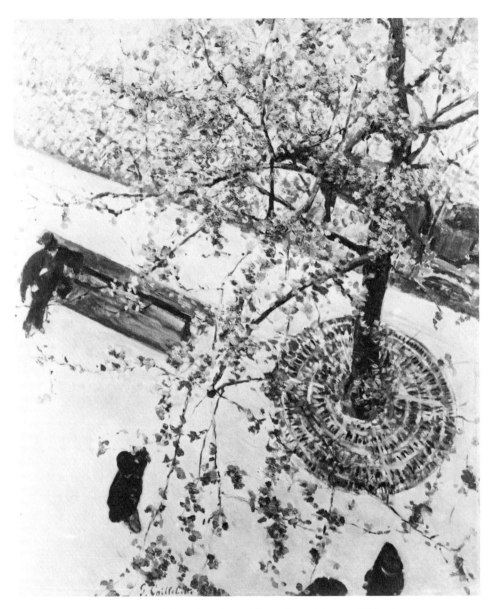

Figure 3. Gustave Caillebotte, Boulevard Seen from Above, *1880, oil on canvas.
Private collection, Paris.*

could produce views whose proportional relationships, albeit consistent and demonstrably accurate in mathematical terms, would seem grotesquely unusual. One could easily choose to avoid such abnormalities, and it became second nature for painters to temper the awkwardnesses that constantly arose even in a "normal" perspective scheme too rigorously followed. Optical devices were less tractable. Experiments with camera obscuras (beginning in the sixteenth century), then camera lucidas (in the early nineteenth century), repeatedly confronted artists like Canaletto or Vermeer with the choice either of denying the unflinchingly geometric vistas they saw or, as they sometimes elected, of accepting or even exploiting their exaggerated effects.[8]

From the very beginnings of the systematic use of perspective, a dissenting lineage developed that rejected "normal" conventions of spatial representation in favor of an exploration of the peculiar, expressive effects of unusual (e.g., wide-angle, anamorphic or foreshortened) spatial structures. The experiments of Piero della Francesca, Uccello, and other fifteenth-century artists initiated an ongoing, if intermittent and usually peripheral, tradition of concern for the unruly truths of "abnormal" perspectives.[9] Mid-seventeenth-century Dutch painters briefly brought these concerns to the center of artistic attention, and the nineteenth century saw them regenerated in force.

Early photographers joined this alternative tradition, but only grudgingly. The evidence of their "how-to" books and of their images shows them consistently concerned to be as "normal" as possible, by adhering rigidly to established formats of depiction, largely derived from traditional art.[10] Far more conservative in intent than Piero or Vermeer, they nonetheless became unwilling minor eccentrics, frustrated in their attempts to muzzle certain intrinsic peculiarities of lens-optical imagery. One of the most fundamental and least controllable of these was perspective itself; and one of the most general effects of the spread of photography was thus to make untempered, topologically consistent perspectival organization of all scenes, from the most complex to the most banal, a representational commonplace.

Within the unaccustomed tyranny of this relentless, seamless space, photographs then propagated numerous smaller quirks. Gross deformations were easy to avoid, but subtler oddities were insidiously persistent. Successive planes of depth were elided; things enlarged menacingly as they came forward, and shrank disappointingly at small distances; the sides of buildings plunged to the horizon in exaggerated pyramidal forms; and empty spaces splayed out dumbly in foregrounds. These effects were all built into the one-point perspective system, and hardly unprecedented; but, to eyes used to being spared such inelegances by

the selective manipulations of painters, they looked odd. The more often people looked at them, however, the less odd they seemed.

Beyond perspective, an even broader context that must also be considered is that of the continuing oscillation in art history between the alternatives Wölfflin identified in his discussion of absolute and relative clarity: on the one hand, the "Classic" idea of representing an object, figure, or scene with diagrammatic completeness and clarity (a palm-out, five-fingered hand, for example); and on the other, the "Baroque" idea of suggesting the same thing by representing only a partial, oblique, or possibly distorted aspect of its appearance (a diagonally foreshortened hand with two fingers visible).[11]

The camera, though it may be Flemish–Renaissance in detailed surface description, tends to traffic heavily in unfamiliar aspects at the expense of clarity. Particularly outside the studio, the best view of one thing in the frame often proved to be the worst, most "Baroque" view of something else nearby. The more complex the scene, the larger the number of compromises, and the greater the degree of compromise in each case. Views of the city in the 1860s showed four-legged men made from enjambed silhouettes, pedestrians with lampposts and wagon-wheels welded to their heads, and a host of other esoteric foreshortenings and obfuscations. Repeated exposure to that "sloppy" kind of depiction inevitably made the four-legged man become more and more readily decipherable, then familiar. Gradually, the unclear, the partial, the confused, and the less informative aspects of things could be accepted as true, and finally, as natural.

These brief outlines suggest how the growing pervasiveness of photography could have encouraged a consensus of tolerance—eventually developing into expectations—about optically derived representation. But they also underline a fact more critical to any consideration of the influence of the medium: there is a difference between the history of photography and the larger history of the ways of representation we often think of as "photographic vision." The visual structures we may think peculiar to photographs, and hence attribute to photography's influence when they appear in paintings, have never required the apparatus of photography. Bold croppings, exceptional perspectival spaces, unusual viewpoints, and so on, have since the fifteenth century depended only on the desire to construct them, or—in the event of a framing and/ or lens device—the willingness to accept them.

The tradition of truth to optical/geometric representation prior to photography is so relatively scattered and inchoate, and photography's dominion over that mode has been so seemingly absolute for more than a century, that we easily forget the two developments are not, either

historically or by technical necessity, contiguous. The establishment of mechanically determined "scientific" empiricism as a modern canon of authenticity has furthermore altered our prejudices concerning the value of untempered and/or eccentric optical images. This world view, evolving in the same historical frame that has seen the spread of photography, has encouraged us to accredit a whole vocabulary of spatial "deformations" and compositional "aberrations" as appropriate symbolic conventions for realist representation. Yet the crucial effect this larger intellectual viewpoint has had on the forms and uses of photography is often confused with the comparatively secondary reciprocal impact that the medium has had on visual habits.

Photography has come to respond so readily to modern ideas of truthful representation, and has reinforced them so authoritatively, that photography now claims exclusive parentage of the accompanying conventions. However, in the last 140 years the alternate tradition of optical/geometric pictorial investigation in art, established centuries before photography, has in fact continued to show a separate rhythm of progress, linked to its own past and independent of the camera.

This means, among other things, that a nineteenth-century painting may share many characteristics with a photograph, without being in the least influenced by photography; and that we should therefore be very wary of unjustly enlarging the claims made for photography's effect. The icy detail of Ingres, the stiff delineation and airless stage-set spaces of Leys and the Pre-Raphaelites, and the obsessive miniaturism of Meissonier can all be shown, whatever their seeming consonance with photography, to owe directly to sources in older art. More cautionary still are paintings like those of Corot in Rome or Eckersberg and Købke in Denmark, suggestively "photographic" in light quality and spatial structure, yet executed well before photography's invention. Most provocative of all, and least easily explicable, are the Impressionists, who pushed unusual geometric/optical imagery into areas that photographs would not touch on until years or decades later. Creeping habituation to photographs, if we could continue to trace it through all its ramifications, might account for some common denominators of representational language shared by virtually all artists after the 1840s, academic or avantgarde, genius or drone. It would not account, though, for the innovations that set the Impressionists apart. Often taken to be the prime instances of the new medium's impact, the Impressionists in fact best exemplify the insufficiencies of attempting to explain the development of "photographic vision" in terms of the influence of photographs.

The Impressionists' pictures have been said to look like photographs. In significant ways that merit stressing, they do not. Certainly they do

not look like the photographs of their day. No amount of searching has
yet produced a photograph from the 1870s or before that looks anything
like Degas' *Place de la Concorde (Vicomte Lepic and his Daughters)* of 1875
(Fig. 2) or Caillebotte's *Boulevard Seen from Above* of 1880 (Fig. 3).[12] It is
extremely unlikely we will ever find such photos. The people operating
cameras then were far too convention-bound to have permitted, much
less attempted, such images. If a photographer of the time had seen the
Degas or the Caillebotte composition through his lens, he would not
have recorded it; and if he had inadvertently caught something like it,
he would have discarded the plate as a useless accident.

Part of the problem, then, is historical, and lies in a misinterpretation
of the chronology of photography. The eccentricities of amateur ef-
forts—radical croppings and imbalance, for example—simply did not
exist before the mid-1880s. The most suggestive "models" or "sources"
are thus photos made years after the paintings. Another problem, how-
ever, is conceptual and more basic. We need to be aware of just how
little could be attributed to odd "snapshots" even if they had existed in
the 1860s or 1870s. The idea of borrowing that is implicit in the linking
of Impressionist paintings to photographs is flawed at its core. Operating
on too simplistic a model of influence, and too narrow an understanding
of each artist's development, it overestimates the radicality, uniqueness,
and potential impact of photographic forms. At the same time, it under-
values both the richness of the traditions of painting and the complexity
of the images the Impressionists created. In short, contemporary photos
resembling these paintings not only do not exist, but would not in them-
selves be adequate "explanations" if they did.

Suggestions of photography's influence are characteristically based
on ideas of resemblance that are partial and superficial. The "tongue-
lickings" that represent figures in Monet's *Boulevard des Capucines* (Fig.
4) have been held, for example, to derive from blurs in contemporary
photos of crowds in motion (Fig. 5)[13]; but the proposed resemblance
ignores the complexity of Monet's picture as a whole. The slow-exposure
photo yields icily clear architecture and trees offsetting smudges of hu-
manity, while Monet mingles distinct and indistinct forms unpredictably
throughout the scene. The flurry of human motion, eerily incongruous
in the photo, is a perfectly consistent, integrated part of the fabric of
Monet's painted vision. That fabric, capturing the envelope of atmos-
phere in sophisticated manipulations of value, color and relative clarity,
is the more telling "source" of the "blur"; as such it has no precedent in
photographs.[14]

Scharf and others have similarly proposed the instances of arbitrary
cropping in 1860s stereo views as an inspiration for the segmentation

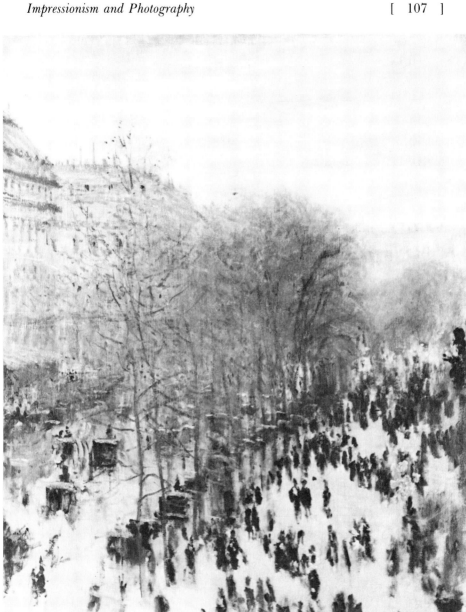

Figure 4. Claude Monet, Boulevard des Capucines, *1873–74, oil on canvas. William Rockhill Nelson Gallery and Atkins Museum of Fine Arts, Kansas City.*

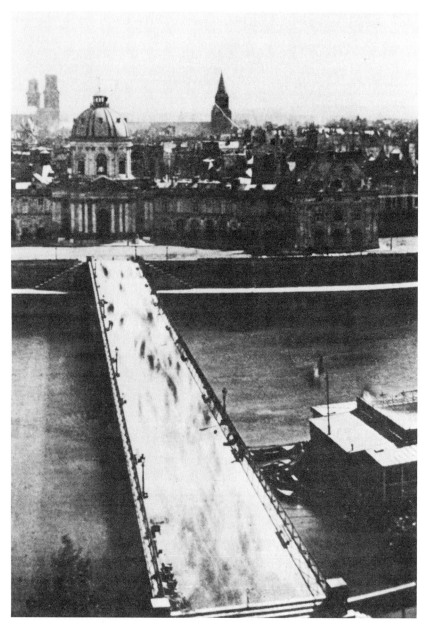

Figure 5. Adolphe Braun, The Pont des Arts *(detail of* View of Paris*), 1868, panoramic photograph.*

of the figures in Degas' *Place de la Concorde*. Yet the tiny incidents in these photos (Fig. 1) are so meager, and the Degas image so bold, as to render the visual "resemblance" nil, and the idea of "prototype" virtually irrelevant.[15] Without simplistically demanding a one-to-one parallel model in photography, we can still balk at identifying such trivial marginalia as the stimulants, even by remote suggestion, of the sophisticated aggressiveness of Degas' experiment. Like Monet's "blur," the visual devices in the *Place de la Concorde* must be considered in terms of the way they interact collectively. The picture is extraordinary not simply because the figures are segmented, not just because the horizon is raised, and not only because there is a bold empty space in the center of the picture, but because Degas combines these decisions in a radically unusual way.

The search for a photographic source for such an arrangement is not only vain but misdirected. There are, after all, numerous visual sources that could be seen as encouraging Degas' tactics, even had photographs not yet existed at all. We can find prominent instances of the severing of the figure by the frame, not just in Japanese prints, but throughout the history of Western art, in Mantegna, in El Greco, or indeed in countless unexceptional portrait images.[16] Certainly Degas knew these well, but this is not the point. His style was a fusion of the unfamiliar with the familiar, a hybrid that Huysmans labeled "strange-exact." Both the strange and the exact elements had existed before: what was new was the manner of combination. Mannerist juxtapositions of scale were made to exist in Renaissance space, Japanese silhouettes were given depth and volume, and Baroque ceiling perspectives were brought down to earth (for example, *Miss LaLa at the Cirque Fernando* (Fig. 6), a kind of secular Tiepolo angel), all with the scrupulously rendered physiognomies and costumes of the Third Republic. Degas' vision was made, not found. The whole was always more than the sum of the parts, and necessarily preceded them in the conception of the image.

Isn't it, though, precisely in the whole of the picture, and in the vision it establishes, that the *Place de la Concorde* seems most strikingly "photographic"? Even if we recognize that in their compositions Degas, Caillebotte and the others were far bolder than contemporary photographers, aren't there still, in these images, governing ideas of fragmented time and candid factuality—in short, a view of reality or an idea of realism—that derive from a "photographic" way of "capturing the world"? The short answer to this more consequential question is: theoretically and superficially, yes; historically and most importantly, no. The long answer must take into account not only the respective progresses of realism and photography a century ago, but also the present biases through which we view them.

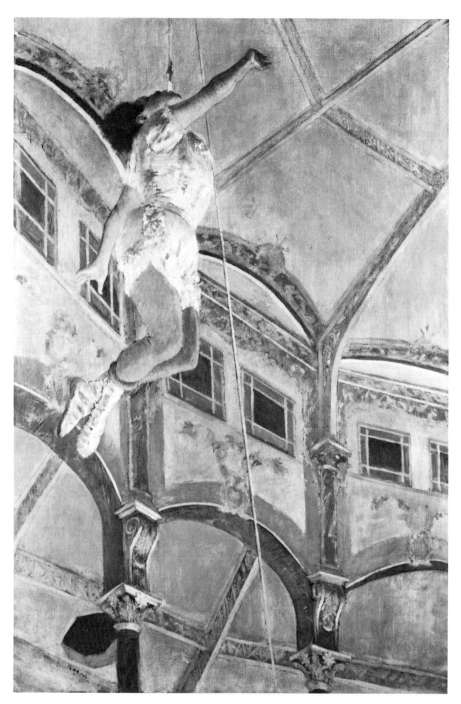

Figure 6. Edgar Degas, Miss LaLa at the Cirque Fernando, *1879, oil on canvas. National Gallery, London.*

The nineteenth century witnessed, besides the manifesto-bearing Realism of Courbet, a variety of divergent strains of realist esthetic inquiry, in literature as well as in painting. One lineage to which the origins of Impressionism can be assimilated became visible as early as Constable's cloud studies. Consonant with the progress of physical science, but not based upon it, this inquiry demanded ever more precise empirical specificity and concentrated more and more exclusively on contingent data rather than the permanent ideal. Progressively eliminating inherited conventions of depiction, it analytically divided time and fact into fragments, independent of allegorical, metaphysical, or even standard narrative binding force.[17] This progress led later realist artists (Flaubert and Zola, as well as Monet and Degas) to seek out, embrace, and develop as devices of artistic communication certain modern substructures of representation—instantaneity, synecdoche, disjunctive raw factual inventory, and so on—that we may now think of as photography's essential tools. Photographers of the day, however, were not involved in this line of inquiry. If they propagated such structures of representation at all, they did so meagerly, involuntarily, more or less covertly, in the course of accepting the unwelcome consequences of the limitations of their medium.

Considering 1870s realism in relation to photography, we must restate the same kinds of cautionary distinctions made earlier with regard to the independent lineage of optical/geometric representation. The realist outlook and the medium of photography developed expansively at the same moment in history. But photography did not produce the nineteenth-century realist mentality any more than perspective produced the Renaissance.

The danger is that an apparent harmony on the level of conceptual analogy—between realism as a fact-based aesthetic and a certain idea of photography as a mechanically "true" process—will lead us to presume a closer historical partnership than actually existed. In our retrospective view, such an error is encouraged by the formalist notion that the "essential structures" of a medium (color and flatness in the case of painting, fact-bound mechanical instantaneity in the case of photography) should be explicitly evident in works produced in that medium—in short, that all photographs are "photographic." To counter that distorting premise, we need to be more precise as to what photography's products showed in the 1870s, as distinct from what we may feel its processes promised.[19] The crucial innovations of the Impressionists illuminate not only the difference between their realism and the photographs of their time, but also the gap between those photos and an idea of photography we have formed since.

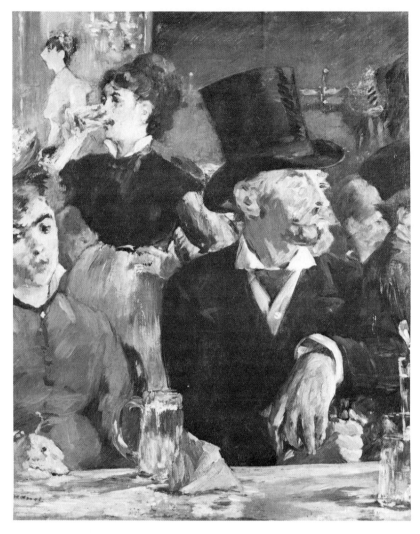

Figure 7. Edouard Manet, At the Café, *1878, oil on canvas. Walters Art Gallery, Baltimore.*

In the same period when photographers aspired to greater control and selectivity, the Impressionists aspired to greater spontaneity or receptiveness: photography was embracing the comforts of established professionalism while painting sought a risky new authenticity. Think of Monet's wish to see as if his eyes had just opened for the first time, or Degas walking the streets of Paris looking for things and points of view that had not yet been painted.[19] Think of the apparent informality and inclusiveness of Degas' portraits of the 1860s, in comparison to the

Figure 8. Lefort, Café Scene, *c. 1867(?), stereoscopic photograph. Bibliothèque Nationale, Paris.*

stringent idealism of Nadar's. Or study the different results that obtained when the two routes converged on a similar subject. When we compare a Manet scene of Parisian café life (Fig. 7) with a slightly earlier photographic treatment (Fig. 8), the listlessly awkward fakery of the posed photo emphasizes by contrast the compelling sense of candor of the Manet. The photo *is* intrinsically instantaneous and direct in the process of its making, but these conditions, far from being exploited expressively, are only handicaps to the concealment of the scene's laborious confection and stilted artificiality. The Manet *seems* instantaneous and direct because a series of pictorial devices—cropping, decentered attention, and so on— have been orchestrated into a "moment" whose disruption of traditional conventions, and consequent apparent candor, thoroughly belies its actual calculated artifice. Neither this photo nor any other of the 1860s or 1870s could have given Manet much of a model for his devices, or any model at all for his orchestration.

These are the same distinctions that should be made with regard to the *Place de la Concorde*. By the multiple directions of the figures' gazes, the contrasted dynamics of the poses, and the sophisticated use of the frame, Degas fabricated a complex, intimate sense of the casual and momentary that is the opposite of the anonymous, homogenized frozenness of the stop-action street photos of his day (Fig. 1). He and Manet

Figure 9. H. Jouvin, Place de la Concorde, *1863, stereoscopic photograph. Bibliothèque Nationale, Paris.*

should be seen not as indebted to photographs, but as rejecting and triumphing over the kind of realism photography offered them.

The photographs *contain* accident and instantaneity, but only as a kind of meaningless static. The Impressionist pictures are *about* accident and instantaneity, and shape it into something meaningful. With structures of time, just as with structures of space, what photographers involuntarily tolerated as eccentricities, these painters independently and aggressively pursued and developed as the basis of a cohesive view of reality. That idea of reality—that kind of realism—was not borrowed from photography or any other source, nor caught by a simple acceptance of chance. It was invented: observed by intelligent selection, and given pictorial form by a knowing blend of traditional and innovative representational conventions. Describing this achievement in terms of "photographic vision" is less useful and more superficial than calling Michelangelo a Romantic, or Botticelli a Mannerist. We need to set aside the idea of the influence of photographs, and set aside, too, the epithet "photographic vision," to see the paintings as they deserve to be seen.

If we are to identify fully and correctly the originality of Degas' decisions in the *Place de la Concorde,* for example, we must consider them in terms of the new reality they collectively embody, and in regard to the new pictorial totality they posit. What *is* this picture? A portrait of

Figure 10. Benedict, Lateran, Rome, *1867, stereoscopic photograph. Bibliothèque Nationale, Paris.*

the Vicomte Lepic and his daughters? A genre scene? A cityscape? Concerned to illuminate private experience in a public place, the image combines the conventions of bourgeois portraiture—dominance of the field by a cropped figure in intimate psychic distance—with the multiple *staffage* and diffuse narrative focus of a genre scene, and the locale and deep space of a cityscape. It is not unusual that we are this close to Lepic (i.e., the cropping isn't necessarily innovative). What is unusual is that we are this close to him while he is (a) not central; (b) in a deep space; and (c) not justifying the proximity, either by acknowledging our presence in a conventional portrait pose or by concentrating on some legible narrative activity. The picture simultaneously uses and subverts former categories of understanding in order to embrace a new kind of subject: private individual *plus* public milieu *plus* action, in one indivisible perception. Ideas—of the splicing of intimate life with the crowding and pace of the modern city, and of the significance of contingent moments of unguarded experience—are the real motor force of the innovations here.[20]

The world invented in the *Place de la Concorde* has become familiar, and familiarity has bred a kind of contempt. Degas seems to define a condition of fragmented urban life that is by now almost a cliché. It is in part because such ideas have become so widely accepted as accurate perceptions of modern existence that we feel treacherously at ease with

Figure 11. Thiebault, View of a Boulevard, *1858, stereoscopic photograph. Bibliothèque Nationale, Paris.*

the picture, and see it as "photographic" in the sense of a snapshot, an informally captured truth. We have become accustomed to the oddities of scale and framing that result from amateur or journalistic photography, and too easily connect them to Degas' creations.[21] More fundamentally, we have become inured to the idea that the accidental is significant, the instant revealing, and the contingent important. Accrediting that reality as a modern discovery, and presuming photography's superior access to it, we then almost fatally annex Degas' achievement into photography's supposed sphere. This attribution is a trap.

There are actually two traps to fall into with regard to the Impressionist paintings we have been discussing. We were formerly taught to see the experiments of Degas et al.—with deliteralized narrative, accentuated foreground planes, and so on—primarily as way-stations en route to the fulfillment of a nonliterary, anti-illusionist, formalist concept of painting. (Japanese prints were then favored as a source of explanation, because they were already so flat and antinaturalist.) Since the early 1960s, it has become more fashionable to locate the relevance and modernity of these same pictures in their informal, or aformal, moments of "photographically" direct response to the world as given. (Hence the unconscious accidents of photos have taken over from the Japanese designs as a favored source explanation.)[22] Each of these approaches has been helpful in focusing on aspects of the paintings, but the two have

been falsely separated (the sense of immediacy *depends* on the formal self-consciousness); and both risk snaring us in the deformations of hindsight.

These pictures become "proto-formalist" by virtue of what happened later in painting, and they became "protophotographic" by virtue of what happened later in photography, but what they *were* was a group of experiments in a bizarrely stylized way of representing. Nothing should be allowed to desensitize our awareness of how unfamiliar, unnatural, and willful this mode of vision was when the pictures were conceived. Their arrangements were determined neither simply by their function as design nor simply by their necessary relation to some objective reality, but by their expressive usefulness in giving shape to a new point of view in the double sense: a will to see the world in a different way, and—as a necessary complement—a different idea of the way the world was.

We have become inheritors of that point of view by a devious route. After the early 1880s, and especially after the advent of the Kodak in 1888, the deliberate decontrolling of representational conventions that Realism had undertaken accelerated into a free-for-all in amateur photography. The means for producing pictures swiftly, cheaply, and without much forethought became available to masses of people who knew little or nothing about art in general, much less the Impressionists in particular, but whose attitudes toward the peculiarities of optical perspective, already softened by years of looking at photographs, were unprecedentedly tolerant. This resulted in a vast tide of unpretentious images in which satisfactorily served function (regarding François' first communion suit or bringing home an *aide-mémoire* of a vacation beach) overrode concerns for niceties of organization and incidental disappointments such as cropped heads, curious voids, antlike people, and so on. While this brought tremendous quantitative expansion of oddities in the lineage of optical/geometric representation, it was another unintentional, extracurricular explosion that had little effect on serious, main-line Realist representation, which continued (in Salon painting, the Photo-Secession, and early film, for example) largely to deny the "evidence" of this less disciplined vision.

The line of *controlled* inquiry that Manet, Degas, and Caillebotte had advanced—the inquiry into the expressive potentials of a new realist vision—meanwhile lay fallow. Painting aggressively swung away from realist concerns into antinaturalism; and the continuation of the Impressionist experiments with unorthodox concepts of space, time, and point of view were redirected into far more insistently nonmimetic, expressive, or decorative, languages of representation (hence Munch's descendance from Caillebotte, or Gauguin's from Degas).[23] Only much later, after the

advent of the Leica and Surrealist thought, was serious attention again devoted, by photographers and filmmakers this time, to that line of modern Realist experiment that painters of the 1870s began.[24]

NOTES

1. Besides Scharf's *Art and Photography* (Baltimore, 1968; 1974), the other study that has most encouraged the popularization of such thinking is that of Van Deren Coke, *The Painter and the Photograph* (Albuquerque, 1964, 1972). Though Coke's book appeared before Scharf's, the latter seems to me the more focused and penetrating consideration of the issues. I was greatly stimulated by reading *Art and Photography* when it first appeared, and references in my earlier articles show that I was convinced by the premises of the book. Gradually, however, further study of both realist painting and 1870s photography has led me to believe Scharf was fundamentally in error in his notion of the relationship of Impressionism and photography. It is thus to Scharf's discussion of Impressionism that my present remarks are primarily directed. In Coke (1972), see especially pp. 13, 15, and 81. In Scharf (1974), see Chapter 7, "Impressionism," 165–79; and Chapter 8, "Degas and the instantaneous image," 181–209.

2. The most complete compilations of such instances are found in Coke, *op. cit.*; and in the recent catalogue by Erika Billeter, *Malerei und Photographie im Dialog* (Zürich, 1978).

3. See "Delacroix and Photography," in Scharf (1974), 119–25.

4. The relationship between depiction and sensory perception constitutes far too complex a subject to treat substantially here. A brief introductory reading list on the matter would include several volumes that have been important to my own thinking: E. H. Gombrich, *Art and Illusion* (Princeton, 1960, 1961); the updating of Gombrich's thinking in "Illusion and Art," in Gregory and Gombrich (ed.), *Illusion in Nature and Art* (London, 1973); R. L. Gregory, *Eye and Brain* (New York, 1966, 1973), and *The Intelligent Eye* (New York, 1970); J. J. Gibson, *The Senses Considered as Perceptual Systems* (Boston, 1966).

5. This generalization includes those images (such as occur in microphotography) that depended for visibility on some optical aid, but not specifically on the camera. It does not include more recent developments such as Edgerton's stroboscopic photographs of bullets in flight, which clearly do reveal phenomena beyond human thresholds of perception. In the matter of stop-action as it applies to the Impressionists, however, it is worthwhile to cite the case of L. Wachter, the cavalry officer who, a decade before Muybridge's photographs, published perfectly accurate renderings of the horse in motion, with its legs in correct positions, drawn from unaided observation. The book is in the collection of the George Eastman House, Rochester: *Aperçus équestres au point de vue de la méthode Baucher* (Paris, 1862). I am grateful to Robert Sobieszek for this reference.

6. This part of my argument, concerning the place of photography within larger traditions of perspectival and optical picture-making, is especially indebted to Peter Galassi, who is preparing an essay on the origins and inventions of photography that will deal in far greater detail with the historical considerations sketched here. (See P. Galassi, *Before Photography* [New York, 1981].)

7. For a survey of the history of perspective, see B.A.R. Carter, "Perspective," in H. Osborne (ed.), *The Oxford Companion to Art* (Oxford, 1970). See also W. M. Ivins, *On the Rationalization of Sight* (New York, 1973); John White, *The Birth and Rebirth of Pictorial Space* (New York, 1967, 1972); and Samuel Y. Edgerton, *The Renaissance Rediscovery of Linear Perspective* (New York, 1975).

On the relation of perspective and photography see M. H. Pirenne, *Optics, Painting and Photography* (Cambridge, 1970). For a specific consideration of the problem in relation to Caillebotte, see my essay, with Peter Galassi, "Caillebotte's Space," in *Gustave Caillebotte: A Restrospective Exhibition* (Houston, 1976).

8. The history of the camera obscura is surveyed in "The Prehistory of Photography," in Helmut and Allison Gernsheim, *The History of Photography* (New York, 1969). The use of optical devices by Dutch seventeenth-century painters is a subject of much recent research and debate. See Arthur Wheelock, *Perspective, Optics, and Delft Artists Around 1650* (New York, 1977); and the opposing view by Walter Liedtke in "The *View in Delft* by Carel Fabritius," *Burlington Magazine*, 1976, 61–73, and in his review of Wheelock's book, *Art Bulletin*, Sept. 1979, 490–96. Despite their disagreements on Fabritius's extraordinary wide-angle picture, both authors (Wheelock with regard to Vermeer, Liedtke more universally) discount or minimize the contribution of optical devices to the experimental spatial structures of the Dutch painters—a conclusion parallel to the one I draw here with regard to the role of photography in the experimental compositions of the Impressionists.

9. On the wide variety of early perspective "solutions," see John White, *op. cit.* For a particularly detailed examination of perhaps the most outstanding case of extraordinary perspectival manipulation, see Rudolph Wittkower and B.A.R. Carter, "The Perspective of Piero della Francesca's 'Flagellation,' " *Journal of the Warburg and Courtauld Institutes*, 1953, 295 ff.

10. For a selection of comments from such manuals, see Varnedoe with Galassi, "Caillebotte's Space," *loc. cit.*, 72 n. 5, 12.

11. Heinrich Wölfflin, *Kunstgeschichtliche Grundbegriffe*, orig. 1915. See especially "Clearness and Unclearness (Absolute and Relative Clearness)" in the translated edition, *Principles of Art History* (New York, 1950), 168–69 and 196 ff.

12. The image illustrated by Scharf (198) in direct comparison to the *Place de la Concorde* was made in 1887—a fact Scharf shows in the caption but tends to slide over in the text, where he cites the photo within a reference to "the astronomical number of instantaneous views . . . published from about 1860." No photo resembling Scharf's illustration has been dated before the mid-1880s, much less to the 1860s. The decade between 1875 (when Degas made his image) and the beginnings of widespread amateur photography in the middle and late 1880s, is the critical gap blurred in Scharf's treatment. As for the Caillebotte overhead view, Fig. 3, Scharf acknowledges (176) that no photo showing such a view exists for many years after 1880, when the painting was shown. Aside from a rather lame comparison to a Nadar balloon photo, it is unclear, then, why Scharf appends this picture to his discussion. For another photographic comparison with the *Place de la Concorde*—all the more unconvincing for having been taken from an elevated viewpoint, rather than from street level—see Max Imdahl, "Die Momentfotografie und 'Le Conte Lepic' von Edgar Degas," *Festschrift für Gert van der Osten* (Cologne, 1970), 228–34.

13. Scharf proposed this explanation (171–73), and the idea has been expanded upon by Joel Isaacson in *Claude Monet* (London, 1978), 16. Scharf ac-

knowledges that, since stereo views of Paris had shown stop-action scenes from early in the 1860s, Monet would have been reaching back for an anachronistic photographic "defect." The 1868 photograph cited by both Scharf and Isaacson (Fig. 5) is a detail from a panoramic view. Its blur results from the archaically slow exposure time required by this special picture-making apparatus.

14. Leaving aside the question of influence, there is another issue lurking here, as to whether the particular effects of halation, unity of field, massing of light and shadow, etc., in early landscape photographs may not resemble Impressionist imagery in some more convincing fashion. This question needs more examination than can be given here, and it must suffice for the moment to say that the kind of approach evinced in the case of the blurred pedestrians is insufficient to the problem.

15. For the specific assertions that Degas studied and learned from stereo views, and that they provided the stimulus for his manner of composing, see Coke, 81; and Scharf, 183. The type of image cited by both (e.g., Fig. 1) was available in quantity in the 1860s. However, a thorough search of the reference provided by Scharf—a complete album series of *Paris Instantané* published by Jouvin, in the collection of André Jammes—fails to yield an image even remotely suggesting Degas'. Jouvin's own view of the Place de la Concorde (Fig. 9) is instructive as to the nature of the album as a whole.

Scharf loads his argument by reproducing greatly enlarged and radically cropped details of stereo images (182, 200). By thus wholly changing the horizon, the balance, and the proportional system of the image, he pushes it somewhat closer to Degas; but a Brueghel treated in this fashion could no doubt also be made to resemble Degas.

Scharf is right, though, in holding that stereo views are the most likely source for the comparison he searches. The shortened lenses of stereo cameras allowed for very quick exposures, and most instances of "stop-action" photography in the 1860s appear in these views. Furthermore, since a main delight of the stereoscope was the 3-D effect, stereo photographers were more likely than others to establish dramatic spatial structures. Finally, these view cards at that time constituted the most prolific commercial enterprise (other than highly convention-bound carte-de-visite portraiture) in photography, and the least disciplined. Especially given the unpredictable effects derived from shooting through two lenses simultaneously (while composing through one), stereo photographs should be the most fruitful field for accidental eccentricities.

Luckily, this hypothesis can be examined quite fully. The fund of stereo views at the Bibliothèque Nationale in Paris provides invaluable evidence, since French publishers of the views were required by law to deposit examples, and each view was then dated as to year of acquisition. A thorough search of the Bibliothèque Nationale's holdings produced, however, no significant prototypes for the Impressionist compositional devices in question. The most extreme instance of a figure cut by the frame (Fig. 10) and the most extreme instance of an overhead view (Fig. 11) were highly exceptional, virtually unique instances among the thousands of photos, and they seem timidly remote from the radical compositions of the painters.

16. On Mantegna's segmentation of the figure, in relation to Degas, see E. Tietze-Conrat, "What Degas Learned From Mantegna," *Gazette des Beaux-Arts*, Ser. 6, XXVI (1944), 413–20. My thanks to Theodore Reff for this reference.

17. This radically foreshortened description of a very complicated matter

is distilled from the admirable formulations of Linda Nochlin on "The Nature of Realism," in *Realism* (Baltimore, 1971). Nochlin states with great economy that the "emphasis on the temporal fragment as the basic unit of perceived experience, like the equation of concrete fact with reality itself, accompanied the reduction of traditional moral, metaphysical, and psychological values in Realist works" (31). For an analysis of "photographic" devices in Realist literature, see the early sections of Alan Spiegel's *Fiction and the Camera Eye* (Charlottesville, 1976).

The relationship of the inquiry initiated by Constable to the development of "photographic vision" is suggested by thoughts he set down before the invention of photography. "The world is wide; no two days are alike, nor even two hours; neither were there ever two leaves of a tree alike since the creation of the world; and the genuine productions of art, like those of nature, are all distinct one from each other.

"In such an age as this, painting should be *understood*, not looked on with blind wonder, nor considered only as a poetic aspiration, but as a pursuit, *legitimate, scientific,* and *mechanical.*" Lorenz Eitner (ed.), *Neoclassicism and Romanticism, 1750–1850, Sources and Documents*, vol. 2 (Englewood Cliffs, 1970), 65.

18. Consider, for example, the confusion fostered by Scharf in his use of the word "snapshot." "In 1858," he relates (181), "exposures at ¹/₅₀th of a second were possible; they marked the appearance of the 'snapshot.'" By page 187, referring to Degas' *La Femme aux chrysanthèmes* of 1868, he has dropped the quotes on the word, and says that the asymmetry and "fortuitous character" of the Degas painting are "entirely germane to snapshot photographs of the time." These propositions trade unfairly and deceptively on our present idea of a "snapshot," an idea conditioned by years of family albums. The "snapshots" of 1868 to which Scharf refers bear no resemblance to such twentieth-century amateur images, or to Degas' compositions. They were instead pictures like Fig. 1, related to later "snapshots" only by the tenuous and inconsequential conceptual similarity of having been made in the same medium with a similar exposure time.

19. See Nochlin's discussion of these urges to avoid traditional *schemata*, in *Realism*, 19–20. Nochlin stresses there what needs restressing here: that Monet's protestations, and the search for "fresh vision" in general, are not to be equated with a simple-minded or passive "spontaneity" of response, but with a difficult struggle against old conventions and toward new solutions. "Spontaneity" and "candor" are hard-won and highly sophisticated fabrications for these painters— a point nowhere so clearly demonstrated as in Robert Herbert's recent analysis of Monet ("Method and Meaning in Monet," *Art in America*, Sept. 1979, pp. 90– 108).

20. As has often been noted, it is Degas' ideas on portraiture that seem to lie behind the pamphlet, *La Nouvelle Peinture*, published by the writer/critic Duranty in 1876. Several of Duranty's descriptions in the long manifesto-like program that begins *"Nous ne séparerons plus le personnage du fond de l'appartement ni du fond de la rue . . ."* seem directly connected to the paintings of Degas (and Caillebotte). Henri Focillon long ago recognized the high originality of this concept, and its role in generating the compositional decisions of works like the *Place de la Concorde: "Pour la première fois peut-être dans l'histoire de la peinture, le portrait échappe à sa définition abstraite, il se mêle à la vie; l'être humain ne se suffit plus comme âme et comme visage, il fait partie d'un milieu et il passe. Il n'est pas le résumé*

permanent de toute une existence, lisible dans son passé comme dans son avenir, mais une minute de sensibilité, faite des traits d'un moment, de son costume ce jour-là, du décor de l'intérieur ou de place publique où, l'oeil du peintre le saisit au passage ou au cours d'un bref repos. De là ces mises en page insolites, qui semblent donner la prépondérance à l'accessoire. . . . On dirait que les regards du peintre sont d'intelligents instantanés, dans le cadre desquels la vie prend place sans être émondée ni contrainte . . ." (La Peinture aux XIXe et XXe siècles [Paris, 1928], 182–83).

21. Scharf cites (184–85) a great deal of earlier literature mentioning photography in regard to Degas. None of these comments—all of which were written in the twentieth century—affirm an influence of photography on Degas. The artist's friend Jacques-Emile Blanche stated quite accurately in 1917 (as quoted by Scharf): "His [Degas'] system of composition was new: perhaps one day he will be reproached with having anticipated the cinema and the snapshot. . . . The instantaneous photograph with its unexpected cutting-off, its shocking differences in scale, has become so familiar to us that the easel paintings of that period [between 1870 and 1885] no longer astonish us . . . no one before Degas ever thought of doing them, no one since has put such 'gravity' . . . into the kind of composition which utilizes the accidents of the camera." Though the last line leaves some room for confusion, it seems to me that Blanche was saying, correctly, that Degas originated a kind of composition that we have since come to associate with snapshots. Scharf reads this same passage as Blanche noting "the precocity of his old friend in having used the special characteristics of the instantaneous photograph."

It is debatable, furthermore, whether Degas' pictures do in fact resemble, in a significant sense, a snapshot from any date. Certainly Degas himself would be chagrined to see his compositions categorized with the haphazard and accidental products of the Kodak. Perhaps the snapshot resembles Degas in the sense that a beach stone may resemble a Henry Moore—because the work of art instructs us to see form in the artless "accident." For a further examination of this issue, see S. Varnedoe, "Easy Pictures, Uneasy Art," *Arts*, Oct. 1976.

22. Scharf (198) sees a "propitious conjunction in the early 1860s of both Japanese prints and instantaneous photographs" as having been of "fundamental importance" for Degas. He notes the radical compositional devices that occur in Japanese prints, but holds that they do not occur there as frequently as they occur in photographs (196). This observation obscures the fact that these devices (i.e., the Japanese "looming foreground forms and steep perspective scales") have not been shown to exist at all, much less in preponderance, in photographs of the 1860s or 1870s. Nonetheless Scharf concludes that "it is highly probable that the many compositional innovations and peculiarly natural poses which appear in his [Degas'] work have their source, not in traditional art, nor solely in Japanese prints, nor purely in his imagination but largely in photography" (183).

23. On the connections between Munch and Caillebotte, see *Gustave Caillebotte: A Retrospective Exhibition*, 69–71 and 149–50; and also my article "Christian Krohg and Edvard Munch," *Arts*, April 1979, 88–95.

24. The post-World War I revival of interest in the kind of imagery explored by the Impressionists in the 1870s produced some uncanny echo effects, such as the wholly independent near-duplicates of Caillebotte's compositions and/or points of view by André Kertész and Lazlo Moholy-Nagy (see *Gustave Caillebotte: A Retrospective Exhibition*, 153–57). These photographers of course composed with

a strong consciousness of abstract art, particularly the graphic designs of El Lissitsky, while no such model exists to explain the astonishing conception of the 1880 paintings.

Research included in the present essay was made possible by a Fellowship for Independent Study from the National Endowment for the Humanities. Several collectors and curators of photography in Paris helped me, and I would like to acknowledge the kind aid of: André Jammes, Gérard Lévy and his assistant Françoise Lepage, Claude Néagu of the Monuments Historiques, Bernard Marbot of the Bibliothèque Nationale, and Mme. Roger of the Société Française de la Photographie.

I have developed this article in constant dialogue with Peter Galassi and Sam Varnedoe, both of whom have made substantial, much appreciated contributions to its content and form. Elyn Zimmerman patiently and generously read numerous drafts, and I am indebted to her for countless improvements on every level.

Aesthetics and Documentation: Remarks Concerning Critical Approaches to the Photographs of Timothy H. O'Sullivan

JOEL SNYDER

INTRODUCTION

This essay is concerned with a set of critical and historical issues that center about a single question: are there any reasons that prevent a critic or historian from analyzing and criticizing the photographs of Timothy H. O'Sullivan in the same way and with the same tools we routinely employ in dealing with acknowledged works of visual art crafted in other media? The question can be generalized quite easily to encompass photographs made by other photographers who worked under similar conditions, or to photographs per se. The underlying question here concerns the legitimacy of analyzing photographs in terms, say, of their adherence to conventional forms of depiction or in terms of their expressive power. Additionally, the essay is concerned with the extent to which it is useful or analytically respectable to think of the criticism of photographs like those of O'Sullivan as resting upon special aesthetic principles or requiring a special critical vocabulary.

I

According to Henry Adams, who observed the process first hand, physics did not become the focus of popular interest in America until rather late in the nineteenth century when extraordinary advances in mechanics seemed to promise an imminent account of the unity of the fundamental forces of nature.[2] Each step along the path of progress to this synthesis depended upon the preceding one, and ultimately all depended upon the principle of the uniformity of nature. For Adams, education itself was the harnessing of chaotic energy into an "economy

of forces," resulting in a unified and coherent self acting in conformity with a world of forces understood to be similarly unified and coherent. All the work of science from the sixteenth century onward appeared to him to be moving toward a culmination in which the ultimate coherence of the world would be proved through mathematical and mechanical explications of Force. But then, catastrophically, as Adams saw it, the underpinnings of physics were dislodged and destroyed by Madame Curie's announcement of the isolation of radium and her description of its properties—an account that was thoroughly at odds with the principles of physics as they had come to be known. An economy of forces and with it the conception of a natural order seemed, for Adams, to be ruled out by the discovery of radium. In Curie's modern revelation, nature appeared inherently chaotic. The heroic role that was to be played in this historical drama by a German physicist could not have been foretold by Adams, but Einstein was to maintain the hold physics exercised on the popular imagination by rushing in at the last moment and delivering the denoument in the form of an equation—$E = MC^2$—thus retrieving the uniformity of nature. The retrieval was purchased at a staggering price. Nature and its uniformities, as revealed by physics, were to become unintelligible to all but a small handful of mathematical physicists.

Throughout much of the nineteenth century, geology, or the study of the earth's crust, held the attention of the large popular audience that was later to switch its allegiance, if not its comprehension, to physics. Among professional scientists, geology was a major arena of scientific discourse and disputation. While physicists had long subscribed, on principle, to an unshakeable belief in the uniformity of natural processes, geologists argued well into the 1870s about the issue of uniformity or discontinuity of the processes responsible for the present structure of the earth. The study of the earth's crust produced equivocal findings and contradictory conclusions. Some geologists saw vast periods of relative stability in the rock strata they examined, while others, examining the same specimens, concluded that the earth's history consisted of periods of calm interrupted by frequent, violent, and inexplicable periods of what they termed "catastrophes." In 1859, the Uniformitarians among the geologists were abruptly given fresh and unexpected support from a surprising source: an English gentleman biologist. In *The Origin of Species,* Charles Darwin suggested that the genesis of the multiform varieties of life could be explained scientifically in terms of a process of speciation through evolution which, in turn, was linked to a series of postulates concerning the relative equilibrium or uniformity of terrestrial conditions over tens, hundreds, and perhaps thousands of millions of

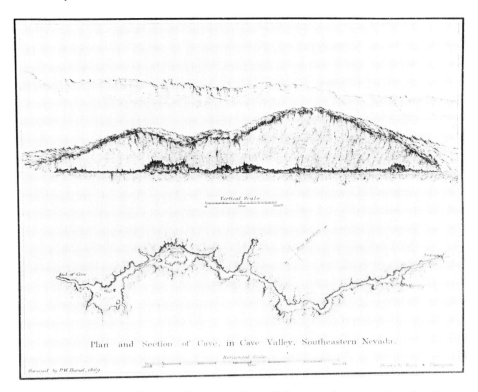

Figure 1. Plan and Section of Cave, in Cave Valley, Southeastern Nevada, *lithograph from pen-and-ink drawing by Weyss and Thompson. Captain George M. Wheeler,* Report Upon United States Geographical Surveys West of the One Hundredth Meridian, Vol. I, Geographical Report, *Washington, D.C., 1889, Plate I, facing p. 25.*

years. Darwin's evolutionary biology precipitated a revolution in the science of life forms and linked that study to the science of geology. Thus, the search for fossils of long-extinct species and the pressing scientific need to fill in the gaps in the fossil record—the science of paleontology—were joined to the study of the development of the earth itself. Geology, paleontology, and evolutionary biology were combined together in a broad discipline that was, throughout the 1860s, '70s, and '80s, one of the largest diamonds in the tiara of theoretical, speculative science.

In America, the study of the land was as much a matter of practical necessity as it was a scientific enterprise. The vast American desert, the Great Basin, which spread from the eastern slopes of the Sierra Nevadas to the western slopes of the Rocky Mountains, stood as an immense,

Figure 2. Mountain Stations. Form 1. Horizontal Sketch, *lithograph from sketch by staff topographer. Capt. George M. Wheeler,* Report Upon United States Geographical Surveys West of the One Hundredth Meridian, Vol. I Geographical Report, *Washington, D.C., 1889, facing p. 353.*

unexplored corridor separating the settled eastern and western regions of the nation. American geology, what Clarence King, the young geologist from Yale, called the study of "American facts," became, in the 1860s an amalgam of observation, speculation, and practical recommendation for land use in the future.

This is the context against which the western American exploration photographs of Timothy H. O'Sullivan must be viewed. When O'Sullivan first went west, geology was still a leader among the sciences and the most popularly studied science; the revolution in physics was still decades away; evolutionary theory was eight years old and hotly disputed for its claims about the generation of life forms and about the history of the earth. America was now three thousand miles away from the great centers of science—England, France, and Prussia—and some Americans hungered for the development of an American science that could claim

Figure 3. Mountain Stations. Form. 2. (Horizon Sketch), *lithograph from sketch by staff topographer. Capt. George M. Wheeler,* Report Upon United States Geographical Surveys West of the One Hundredth Meridian, Vol. I Geographical Report, *Washington, D.C., 1889, facing p. 355.*

a distinction equal to the European. Beginning in 1867, O'Sullivan traveled to the West on expeditions directed by Clarence King, whom the rarely effusive John Hay called "the best and brightest man of his generation," and by George Montague Wheeler, a West Point graduate of considerable scientific and administrative skill.[3] O'Sullivan produced many hundreds, perhaps thousands, of photographs during the seven years he worked in the West for King and Wheeler. Insofar as I have been able to determine, his photographs, whether in the form of albumen prints or as remarkably faithful lithographic copies derived from them, were never singled out for mention in the numerous reviews of the expeditionary final reports that followed upon their publication, nor were they later republished as exemplary photographic works in the way that say, photographs by Hill and Adamson and Julia Margaret Cameron were exhibited by Stieglitz in *Camera Work.* O'Sullivan's exploration pho-

tographs went unnoticed for two-thirds of a century before they entered
the history of photography in 1937, when Ansel Adams brought an
album of prints made by O'Sullivan for the Wheeler expedition to the
attention of Beaumont Newhall at the Museum of Modern Art in New
York City.

II

What can we legitimately say about O'Sullivan's photographs, be-
yond stating what we know about how and where they were made? It
has been suggested recently by vigorously opposed "schools" of photo-
graphic criticism that the key to understanding the contribution of O'Sul-
livan, or of any nineteenth-century "documentary" photographer, can
be found in the circumstances of his employment. We are told, in one
view of the matter, that it is wrong to look for artistic or pictorial values
in photographs like those made by O'Sullivan because they were made
with "purely documentary intention." Extreme devotees of this position
are suspicious of what they see as a curatorial and art historical conspiracy
at work in the process of illegitimately treating documentary photo-
graphs as works of art. Opposed to this critical stance is the view that
finds an artistic, or more aptly a purely photographic, merit in O'Sul-
livan's work (or, again, works produced in similar circumstances by other
photographers). His photographs are seen as the outcome of an intuitive
understanding of the nature of photography—an understanding brought
about by the scientific or documentary character of his mission. In these
latter terms, O'Sullivan can be seen as an unself-conscious Isaiah, pre-
paring the way for the announcement of the Good News by Stieglitz and
Weston declaring photography to be an art, but an art different from
all others and most especially different from painting.

I want to review both these critical positions because I believe that
each reveals a number of important and unwarranted assumptions that
work to the detriment of the study of photographs, and because many
critics of photography subscribe to one or the other of the positions.
Moreover, while they appear to be opposed, these critical stances depend
upon common principles and, in the case of O'Sullivan's work, a belief
in the same alleged but, I shall argue, false statements of fact.

PURE INTENTION

A number of recent critics of photography have been issuing a
disturbing challenge to the way in which histories of photography have
come to be written.[4] They pose a question that is supposed to carry its

Figure 4. Natural Column, Washakie Bad-Lands, Wyoming, *chromolithograph after study by Gilbert Manger. Clarence King,* Report of the Geological Explorations of the Fortieth Parallel, Vol. I, Systematic Geology, *Washington, D.C., 1878, frontispiece facing title page.*

own answer: with what warrant, or by what right, does a historian criticize photographs like those made by O'Sullivan—photographs that were made with "purely documentary intention"—as if they were works of art. And we are to believe that the self-evident answer to this question is that no such warrant or right does or could exist. When a critic asks a question like this, at least two premises are assumed: the first is one that is supposed to be factual—O'Sullivan can be shown to have been working as a pure documentarian. The second assumption is theoretic—it is supposed that a work made for "purely" documentary reasons is barred, by birth so to speak, from possessing artistic value, or, at least, from possessing the kind of artistic value that a self-consciously produced work of art by, say, Albert Bierstadt could properly be thought to possess.

It seems to me that the factual assertion about the nature of O'Sullivan's motivations is simply in error, and this is a point to which I shall return when I discuss some of the available facts regarding his employment and the uses of photography on the expeditions. I want first,

however, to take a look at the theoretic assumption because it seems to me both equivocal and "loaded." The theoretic assumption goes something like this: a photograph made for documentary purposes has the wrong genetics—the wrong origins—to qualify for candidacy as a work of art. Now, this statement seems grounded in two further assumptions: first, the only way that a picture can become a work of art is if its maker intends for it to be one; and second, a documentary picture is intrinsically cut off from aesthetic value. Both of these statements are convincing as long as they remain unanalyzed. They depend upon unclear notions about human intentionality, about the nature of documentation, and perhaps most important, about the enterprise of picture making. One need not believe, along with the art historian Erwin Panofsky, or the art critic Clement Greenberg, that so-called low art is always a parasite of the high variety to believe, nonetheless, that pictures do not dwell in hermetically sealed-off categories that have no influence upon one another. It does not take an expert eye to see the influence of, for example, architectural and travel illustration that predated photography upon architectural and travel photographs. Similarly, photographic portraiture, especially in the early days, relied heavily upon the conventions drawn from the practices of miniaturists and book and journal illustrators. Why then should it seem odd to us that a documentary photographer, even one supposedly equipped with a purely documentary intention, might concern him or herself with issues of subject definition, pictorial coherence, perspicuity, clarity, the range of tonal values, and with issues of placement within and relative to a frame? It is worthwhile to think about the standards that might possibly be used to determine whether or not a picture is a good geological study. Should we allow, as the purely documentary intentionalists clearly need for us to allow, that these standards are necessarily non- or antiaesthetic? I cannot imagine why. In order for a photograph to be judged by a geologist to be a superb geological study, must it be free of all the tropes and figures of landscape painting and of the other graphic arts? Must it be geologically informative, but aesthetically dead? What if such a photograph revealed hitherto unknown information about the deposition of sediment during the Pre-Cambrian period in Utah, but was also gorgeous to look at, irrespective of the available information? Must it be rejected because of its formal, pictorial properties—because, say, it is unacceptably beautiful? There is nothing in the "nature" of scientific illustration that requires geological studies to be uncomposed (if this were possible) or aesthetically offensive. But now, what of the motives of the picture maker? Must the photographer, in order to have a purely documentary intention, actively disavow all these tropes and figures, or is it enough for him merely to be ignorant

Figure 5. Summits, Wahsatch Range, Utah, *chromolithograph after study by Gilbert Manger. Clarence King,* Report of the Geological Explorations of the Fortieth Parallel, Vol. I, Systematic Geology, *Washington, D.C., 1878, Plate I, facing p. 45.*

of these conventions? Or, perhaps it is enough that these conventions simply did not come to mind while he made the photograph. Just how ignorant of pictorial practice must a photographer be to qualify as a purely documentary photographer? Must he never look at work by Caspar David Friedrich, never gaze at Turner's *Liber Studiorum,* never look at travel pictures or landscapes hanging on parlor walls? Where will these proscriptions stop, and more to the point, how will we ever know if the picture maker violated them?

Trying to get to the bottom of these issues is frustrating, in great part because it is not at all clear what is being claimed. Again, it is helpful to try to imagine what a fine geological photograph made with the purest of scientific intentions might be supposed to look like. On the assumption that it must not be artful, we must suppose it to look like everything a work of art is not. But this fails to define anything at all. Works of art do not have one formulable way of looking. I admit that I cannot imagine what this kind of photograph would look like, but more to my point, even if someone could figure out what it would look like, it wouldn't

Figure 6. Shoshone Falls Idaho, *chromolithograph after a study by Gilbert Manger.* Clarence King, Report of the Geological Explorations of the Fortieth Parallel, Vol. I, Systematic Geology, *Washington, D.C., 1878, Plate XVI, facing p. 590.*

look like a photograph by O'Sullivan. Now, if one recalls that ideas concerning truth in art were a central concern of certain highly influential art theorists of the nineteenth century—in particular, Ruskin, who devoted long chapters to truth in art, to the truth of mountains, the truth of vegetation, the truth of rocks, and so on—the division of the documentary motive from aesthetic motivation seems like one that may itself be untrue to the facts. Add to this the fact that Clarence King, O'Sullivan's first chief, was a founding member of the Society for the Advancement of Truth in Art (the American Ruskinite Society), and the situation under investigation grows enormously complicated.

Beyond these considerations of art and documentation, the conception of human intentionality that is at work here seems remarkably slim to me. What is a documentary intention? Are intentions always atomic things that never get molecularized? Must there be one discrete intention in back of every picture? Saying that a photographer works with a documentary intention is simply a glorified way of saying that he has a certain job to do. The job is to make informative pictures of certain kinds

Figure 7. Mouth of the Lower Grand Canyon of the Colorado River, *chromo-lithograph based upon photograph by T. H. O'Sullivan.*

 Plate No. XX is an illuminated sketch made from a photograph taken in the Grand Canyon near its mouth and is hence typical as to form, showing its peculiarities of erosion that gave rise to great varieties of profiles. The coloring is in some respects more brilliant than that in nature, although less vivid than in some of the beds, as for instance, the red walls of limestone. The sun breaking through upon the vari-colored sedimentary beds enlivens a contrast of colors that no artist can accurately copy.

—*Captain George M. Wheeler,* Report Upon United States Geographical Surveys West of the One Hundredth Meridian, Vol. I, Geographical Report, *Washington, D.C., 1889, illustration facing p. 163.*

of things, and it may involve making them in a particular manner—in a way that is determined by the pictorial habits entrenched in the field of study, or by the stipulations of experts in the field (e.g., by evidence technicians or astronomers in conjunction with, say, technical representatives of Eastman Kodak). But the manner of depiction will never be a function of non- or antiaesthetic principles. There is nothing in the nature of scientific investigation that necessitates the adoption of specific pictorial formulae that are aesthetically displeasing or, for that matter, formulae that are anaesthetic. Scientists are not in the habit of apologizing for the production of informative pictures that happen to be, for whatever reasons, say, beautiful, graceful, or formally novel. It goes without saying that we generally do not congratulate the makers of formally flawless scientific pictures for their artistic powers. The production of such pictures seems, without doubt, to be a by-product of some ulterior purpose. But my point has only been that scientific pictures are not blocked, by some inherent requirement of science, from utilizing conventions that originate in prevailing graphic practice (including the practice of artists). If we take the matter one step further and ask what formal devices were available to a photographer like O'Sullivan for the production of landscapes, we will have to conclude that the only landscape conventions available to him were those already familiar to him and to his audience. If we then wanted to establish a claim on behalf of O'Sullivan's putative artistry, we would have to determine if the remarkable quality of his photographs is an accident, a by-product of the work he did for the surveys, or if it is somehow necessarily related to his and his employers' understanding of that work.

One helpful way of getting rid of the impulse to use high-sounding terminology to describe the activity of making documentary photographs is to concentrate upon more mundane matters. Let us say that I need to shave. Must I form a "peculiarly shaverly intention" to get on with the affair? Even if I were to form an intention to shave, would the intention prescribe the manner and means of shaving—would it tell me what equipment to use and how to use it? Similarly, if I want to wash my car, do I need to form a carwasher's intention? Finally, what if I want to make a snapshot of my children at play? Do I need a pure snapshooter's intention? Given my exposure to works of Vermeer, Velazquez, Degas, Klee, and Klimt, can I ever form such an intention? Do I know too much? Have my snapshots been tainted by art? Am I even capable of making a good snapshot any longer?

I believe we would be far better off if we stopped thinking in terms of documentary intentions, pure or otherwise, and of documentary photographs per se and begin thinking in terms about the documentary use

Figure 8. *T. H. O'Sullivan,* Shoshone Falls, Snake River, Idaho, *1868.*

of pictures in general. Thus, we would stop asking if O'Sullivan's photographs are somehow essentially, inherently documentary, and our attention would be directed toward the various means he employed to make pictures that had documentary usefulness. If we begin to think of documentary in these terms, we will not be surprised to find that the means of depiction vary with the specifics of intended use. On this account, there would be no reason at all to posit a division between documentary and aesthetic character, between informative value and artistic merit.

So, what I find disturbing about the critical practice that I have been examining here is that it fails to define what is meant by purely documentary, and it makes use of an atomistic and I believe wholly misguided notion of human intention. Further, it fails to come to terms with the most obvious facts about what I term "functional illustration"—the fact that it has a history in which style changes—nor does it seem capable of explaining such change. It fails to note, for example, that eighteenth-

and nineteenth-century manuals of illustration, devoted to the training of travel, architectural, and geological-landscape illustrators, quite clearly draw upon conventions of representation that are derived from many areas of graphic practice, including the area we now call "high art." Finally, it fails to note the obvious fact that it is quite impossible to draw a line that separates the clearly functional from the purely aesthetic.

PURE PHOTOGRAPHY

The other manner of dealing with photographs like those of O'Sullivan likewise locates their aesthetic or, perhaps more accurately, their "purely photographic" value in the conditions of the photographer's employment. On this view, O'Sullivan's photographs are understood to be canonical photographic works because they were made for purely objective, scientific purposes. This widely held view can be summarized in a number of critical observations made by James N. Wood in his essay on O'Sullivan that appears in *Era of Exploration*.[5] Wood maintains the following:

> (1) O'Sullivan's photographs are at least in part aconventional, and this owes directly to their having been made as scientific records or documents.
> (2) O'Sullivan's job required him to meet the needs of government surveys rather than the needs of the pictorial marketplace.
> (3) The needs of that marketplace were for picturesque landscape views, and such pictures are inherently unscientific.
> (4) The artistic merit of O'Sullivan's photographs can be located in his "uncompromisingly photographic vision"—a vision that was engendered or reinforced by the demands of geological recording.

In a nutshell, the argument goes something like this: O'Sullivan was not competing with landscape painters or photographers who borrowed landscape conventions for their work. He was engaged in objective recording. Photography is by nature an objective medium. O'Sullivan, unconstrained by pictorial convention, made photographs that are purely photographic; that is, he did not confuse the medium of photography with the medium of painting. The merits of his photographs are the merits of pure photography, properly understood.

This is the currency of much photographic criticism: the opposition of the photographer's fact to the painter's fancy; of the photograph's record to the painter's imagined world; of scientific values per se to the

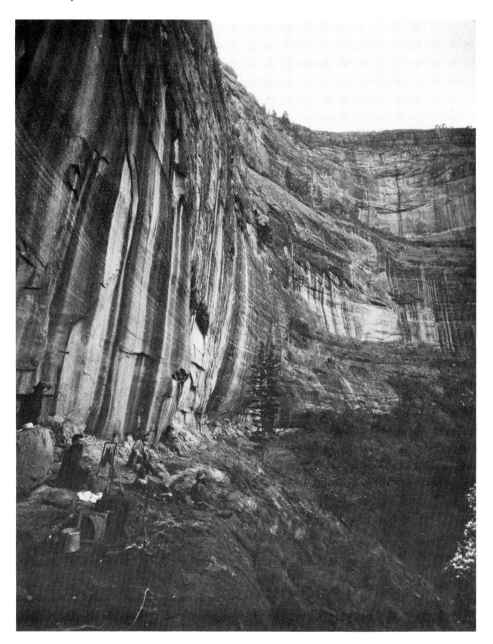

Figure 9. T. H. O'Sullivan, Canyon de Chelly, New Mexico, *1873. O'Sullivan, extreme left, shows himself observing the progress of the artist A. H. Wyant, who is seen painting the "spires" of Canyon de Chelly.*

aesthetic values of painters or sketchers. And all these are joined to a historically unsupported notion of what geological depiction was thought to be when O'Sullivan was working in the West. All we are told is that whatever geological recording might be, it is necessarily opposed to painters' practice. This view, like the one first discussed, depends upon a depleted view of the aims and methods of geological illustration in the last century as well as an unanalyzed and unsupportable conception of the nature of pictorial practice itself.

The strategy at work in this explanation of the value of O'Sullivan's work is essentially formalist in character—one that a historian of photography (or at least an American historian of photography) comes by naturally and honestly. On the formalist reading of the various arts, each medium has its specific potencies and limitations that it shares with no other. These characteristic possibilities define the limits of artistic production for the medium, and the history of its use is the self-conscious working out of problems that are peculiar to the medium.[6] According to Wood there are two reasons that explain why O'Sullivan was able to demonstrate his photographic genius: (1) his job was scientific in nature, and he was therefore obliged to make objective records, and (2) he was (happily) sealed off from the broader pictorial culture, from the "critical milieu based on the esthetics of painting." This fear of the pernicious effects of painting upon serious photographers is a comparatively familiar one to students of photography—it is a restatement of Edward Weston's "photo-painting standard." The formalist drift of Wood's argument becomes reasonably apparent once the suppressed premises are filled-in:

1. Photography, by nature, is an objective recording medium.
2. Painting, by nature, is a subjective medium.
3. The nature of photography was unknown when O'Sullivan was photographing in the West.
4. O'Sullivan's job was to do objective, scientific illustration.
5. O'Sullivan was ignorant of the conventions of landscape painting.
6. Conclusion: Ignorant of the nature of photography, but freed by his job from the necessity of aping the conventions of painted landscapes, O'Sullivan was able to express his intuitive understanding of the nature of photography and thereby to express his pure photographic vision.

This fear of the taint of paintings, the strict adherence to the photo-painting standard, gives rise to what I have come to call the "pictorial idiot principle" in its most extreme form. This proposed law of photography urges us to believe that there is an inverse relationship between

what a photographer knows about painting and the other graphic arts and the value of his photographs; the more he knows the worse they are, the less he knows, the better they are. I can think of no other area of human endeavor, no matter how romantic in orientation, in which this sort of principle would be accorded a hearing.

I have tried to show some of the issues that arise when we begin to think analytically about the notion of pure documentation, when it is thought of in opposition to aesthetic value and when it is thought of as something like a precondition of such value. I have suggested that there is no reason to think of documentation as being antithetical to art, or, on the other hand, as constituting the essence of pure, or good, or aesthetic photography. I have also suggested that the notion of documentary intention is, upon analysis, vacuous. But there is still a factual issue to deal with. Both of the opposed modes of criticism discussed above assume that the key to understanding O'Sullivan's photographs is somehow wrapped up in his job description, in the function he was supposed to fulfill as a photographer for two government surveys. We still need to determine the role of a photographer on the King and Wheeler surveys. What were the projected and actual uses of O'Sullivan's photographs? Did King and Wheeler see an otherwise unobtainable kind of scientific objectivity in photographs that made them preferable in all respects to illustrations produced in other media? Did they believe in the mutual opposition of science and art, or were they somewhat more relaxed about the relation of the two? Just what were O'Sullivan's orders, and what was the context in which they were issued?

III

O'Sullivan was hired by Clarence King in April 1867 as photographer to the newly formed Geological Explorations of the 40th Parallel. He photographed for the survey through the field seasons of 1867, 1868, and 1869 and again in 1872. King hired Carleton Watkins out of San Francisco to make some photographs on one occasion, but with that exception O'Sullivan was *the* photographer for the survey. As far as I have been able to determine, all of the published King survey photographs were made by O'Sullivan. It is easy to suppose that King wanted photographs of the sites visited by his survey because of the scientific superiority of photographic illustrations over graphic records made by any other means, but this is a careless supposition. What is clear is that even before King hired O'Sullivan, he planned to publish multiple volumes of the various findings of his survey, and he also planned for these

volumes to become what they did in fact become—a classic statement of interdisciplinary scientific observation, theory, and conjecture. He planned from the first to illustrate these texts. O'Sullivan was hired as one among a number of the survey's illustrators.

In the autumn of 1870, George M. Wheeler hired O'Sullivan away from the 40th Parallel survey with King's permission. O'Sullivan was transferred to the new survey for the field season of 1871 with the understanding that he would return to King's team at the end of the season. He went back on King's payroll late in the autumn of 1871, worked for the 40th Parallel Survey through the field season of 1872, and returned in the winter of 1873 to Wheeler's command, which now was officially titled Geographical and Geological Explorations of the 100th Meridian. O'Sullivan worked for Wheeler through the field seasons of 1873 and 1874 and then returned to Washington, D.C., where he spent the remaining seven years of his life.

In September 1870, while Wheeler was in the process of making his final staff selections for an army-directed exploration of the Grand Canyon of the Colorado River, he wrote his commanding officer, General A. A. Humphreys, who was also the supervisor of King's civilian expedition, requesting the transfer of O'Sullivan from King's staff to his new command. A portion of Wheeler's letter is revealing, and I quote from its final section:

> This gentleman [O'Sullivan] has been for some time employed by Clarence King, has large experience, and in case that his services can be obtained, it is judged that his addition to the number of assistants will result in a valuable set of views illustrating the nature of the country, especially in the vicinity of the canyons of the Colorado, *since no regular artist will be attached.* [Emphasis added.][7]

Here Wheeler gives no evidence at all that he sees any difference between views made by a photographer and views produced by artists, at least insofar as expeditionary purposes are concerned. Both expeditions made use of O'Sullivan and geographical draftsmen and landscape artists. The correspondences between Wheeler, King, and General Humphreys give unquestionable support to the conclusion that photography was not accorded a special, privileged illustrative role in the surveys. This is not to deny that properly made photographs were understood to be accurate, but, like other kinds of well-made pictures, they were thought to be accurate in certain respects. Handmade illustrations were understood to be in most respects the equal of photographs and in some respects far superior to them. One point is certain: both King and Wheeler used photographs and handmade illustrations interchangeably—when a pho-

Figure 10. T. H. O'Sullivan, Nevada, *1867.*

tograph was unavailable, a good landscape drawing would do, and vice versa.

Prior to the field season of 1872, King wrote Humphreys requesting permission to hire Carleton Watkins for a few weeks' work in the High Sierras while O'Sullivan was expected to be working in Utah, Colorado, and Wyoming. Watkins's weekly rate was quite high, and Humphreys, who was always concerned with budgetary matters, did not respond to King's request. Once the season was under way and it was too late to engage Watkins, King again wrote to Humphreys:

> In my general plan submitted last winter, I proposed to employ Mr. Watkins at a liberal rate. Owing to the snow and the difficulty of reaching points, I deem it wise to give that up, and am all the more willing as Mr. [Alfred] Bierstadt, the artist, has joined the party and has given me liberty to copy any and all of his studies.[8]

It would be hard to make my overall point more forcefully. King gives no indication that handmade illustrations by an artist like Bierstadt were in any way inferior to photographs, *insofar as the needs of the expedition*

were concerned. Bierstadt was well educated in pictorial practice and in the history of art. He was, if anything, too much of a self-conscious artist for King's personal taste. Nonetheless, Bierstadt, who worked from well within the "critical milieu of painting"—whose powers of observation and imagination and whose knowledge of the conventions of landscape painting were developed in academic schools of painting—was qualified, according to King, to produce pictures that could be given the same documentary use that would have been assigned to photographs by Watkins. The conclusion is inescapable: King did not locate the documentary value of an illustration in the quality of the intention that produced it, or in the particular medium in which it was made.

It is easy to think that photographs are essentially accurate records. But it does not take too much thought to show this is not the case. Eastman Kodak publishes handbooks dealing with various kinds of photography—medical, police, astronomical, to name just a few—and each of these books details highly specific means for making photographs that provide particular kinds of information, needed for highly specific applications. No one way of photographing will answer for all these purposes. There is no such thing as accuracy pure and simple, and consequently there is no single photographic procedure that can produce pictures that are accurate for any and all purposes. To be accurate is always to be accurate in some specifiable respect. Reflecting on just these kinds of considerations, George Wheeler, writing in the annual report of his survey for the 1872 field season, set down a few thoughtful paragraphs about the place of photography in geological exploration:

> I will also state some of the practical uses which may result from the application of the art of photography as an auxiliary in our interior surveys. It has been considered that the professional uses of photography, as an adjunct to a survey of this character, are few, so far comparatively little good beyond that which is of general interest as expressive of the scenic features of the specified areas. The materials gathered from its use apply only to the departments of geology and natural history. In these departments, where, it is well understood we are obliged to leave the field of exact science, the special value that comes from a geological series of photographs results in the determination of a relative comprehension of the size and contour of the rock beds and of the general features of the topography.[9]

Wheeler notes that there are few uses for photography on his survey and that even these are "comparatively little good,"—hardly an endorsement of the alleged inherent accuracy and objectivity of the medium.

Figure 11. T. H. O'Sullivan, Mouth of Paria Creek, Grand Canyon of the Colorado River, *1871.*

Moreover, this statement involves a comparison ("comparatively little good") of photographs with some other kind of graphic illustration, and Wheeler clearly believes that some other illustrative medium is of more use than photography for certain expeditionary purposes. Even more to the immediate point, Wheeler specifically indicates that photographs are useful only in those areas of investigation that are not concerned with "exact science." What is in back of these remarks concerning the inexactness of photography is Wheeler's frustration with the impossibility of quantifying the magnitude of depicted objects and the distances between them in photographs. If, as he believes, the exact sciences owe their exactitude of the possibility of assigning numerical values to the objects of investigation, photographs fail to allow for such quantification and therefore fail to be exact in the way needed. One major function of both the King and Wheeler surveys was the production of accurate

maps, and it was just this highly exacting assignment that was beyond the range of photography in the 1860s and 1870s. When Wheeler says that the uses of photography are "comparatively little good" for his survey, the comparison he has in mind is between photographs and handmade sketches that bear the sorts of numerical legends that allow the precise judgment of the size of, say, mountains and of the distances between them. The use of photographs as adjuncts to surveying—as instruments of exact measurement—had to await the invention of a practical grid system that could be incorporated into photographic negatives. This system was not perfected until some years after the King and Wheeler expeditions had ended.

What audience does Wheeler have in mind when he suggests that the role played by photography on geological surveys is to express "scenic features" of "general interest"? The viewers of O'Sullivan's photographs (in the form of albumen prints or as lithographic studies based on them) consisted, among others, of geologists, evolutionary biologists, paleontologists, military officers, congressmen, mining engineers, entrepreneurs, and visitors to the exploration displays at the Centennial Exposition in Philadelphia and at the Vienna Exposition of 1876. This is a broadly based audience whose members had little in common beyond their interest in the "scenic features" of an unknown and previously unexplored region of the United States; to put this in less elevated words, they were curious to see what this newly explored region looked like. The inescapable fact of the matter is that O'Sullivan's illustrations were made to satisfy a "general interest" that might have been served quite adequately by the adoption (self-consciously or through habit) of the prevailing conventions of the picturesque landscape. In general, however, O'Sullivan did not make "pretty" landscapes, and if there is a problem, as I believe there is, in explaining why his pictures take the remarkable form they often do, it rests on the plain fact that most photographers and illustrators of the period sought to depict the new lands in terms of the British Picturesque landscape tradition, while he rarely did.

O'Sullivan's photographs were made primarily as illustrations for the final reports of the surveys, in which they appear in the form of carefully executed lithographic copies prepared by Julius Bien of New York City. They appear in these volumes side-by-side with lithographs derived from pencil and pen sketches, watercolors, and oil paintings. In the commentary that accompanies the illustrations in the final reports, no special significance is attached to fact that a picture was photographic in origin, or for that matter, that it originated in the hand of a painter.

In the great rush to validate an unsecured intuition about the critical difference between pictures made in different media—between paintings

Figure 12. T. H. O'Sullivan, View Across Black Canyon, the grand walls in perspective, *Colorado River, Arizona, 1871.*

and photographs—critics of O'Sullivan's work and photographs made apparently under similar circumstances have compartmentalized art and science and have spread these categories so far apart that finally it seems they are totally opposed. I have tried to show that the survey chiefs, King and Wheeler, subscribed to no such opposition and that the modern insistence upon the inevitability of the opposition has the effect of falsifying the historical record and misrepresenting the context of O'Sullivan's production. Photographs were understood to be part of descriptive geology; they were unusable for purposes of quantification. These illustrations depict the newly explored places in the only way available to a picture maker—by means of prevailing landscape conventions, or through opposition to those pictorial habits. These conventions come from a wide variety of sources: from handbooks of functional illustration, from travel books, from decorative forms of landscape illustration found in magazines or hanging on office or parlor walls, and too, they come from those works of "high art" that are understood to be canonical. Rather than use the notions of documentary intention, or of purely photographic vision, we are better advised to think of O'Sullivan's survey pictures as vernacular landscapes, as pictures made quite self-consciously to be informative and expressive by a photographer who happened to be (but need not have been) unschooled in the prevailing norms of "high art." This is quite a different matter from maintaining that O'Sullivan was working outside of a tradition and out of range of the expectations of his audience (expectations concerning the appropriate forms of landscapes). O'Sullivan worked as an illustrator to portray—to characterize—the exotic and often hostile lands he visited, and he did this with great success and to the clear satisfaction of the men who brought him to the interior. That his photographs are coherent seems indisputable to me. It is not, at least in principle, disreputable to find them visionary as well. I admit to seeing them that way, to finding in the best of them (and many are his best) a stark, severe, disorienting, and still somehow matter-of-fact aspect that is not so much modern as it is a throwback to a late eighteenth-century concern with sublimity unrelieved by picturesque devices. I have suggested elsewhere that a common theme runs through O'Sullivan's photographs: King's modified catastrophism and Wheeler's published accounts of fearful places he visited during the surveys.[10] No matter how arguable my own suggestions about the aesthetic value of O'Sullivan's work may be, the fact remains that his photographs are generally unlike those made by other expeditionary photographers who were in the West at roughly the same time. If, as I have tried to show, the notions of objective record or documentary intention cannot account for the differences between O'Sullivan's photographs and the others, clearly the source of these

differences will have to be sought elsewhere. I have indicated that there is nothing about the nature of photography and nothing about the goals of the expeditions to the West that constrain a critic or historian from seeking the sources of these differences in those areas of graphic practice that are generally thought to be the province of art historians. Clearly, there are many other areas of investigation that will prove useful in the formulation and explanation of O'Sullivan's work. If, however, we seek to learn something about the pictorial qualities of these photographs, we shall have to deal with them in terms of what they are—pictures.

NOTES

1. A version of this paper was delivered at the symposium on photography held in honor of Beaumont Newhall, at the University of New Mexico, in April 1984. All students of photography owe an enormous debt to Newhall, not only for his work as an historian, but for the passion with which he has championed the serious study of photography. Beyond this general debt, I owe him a special one for his interest, support and encouragement—all of which he has given freely since we first met in 1967.

2. Henry Adams, *The Education of Henry Adams*, Boston, 1961. See especially chapters 25, "The Dynamo and the Virgin," and 31, "The Grammar of Science."

3. Hay is quoted by Henry Adams, ibid., 416. Adams saw King as an exemplary modern American—brilliant, adventurous, scientific, and yet uncommitted to scientific reductionism.

4. See, for example, the following essays: Abigail Solomon Godeau, "Calotypomania," *Afterimage* 11 (Summer 1983); "Auguste Salzman and his Time," *October 18* (Fall 1981); Michael Starenko, "Photography and Other Art Historical Lacunae," *Afterimage* 9 (February 1982); Alan Sekula, "On the Invention of Photographic Meaning," *Artforum* 8 (January 1975); and Rosalind Krauss, "Photography's Discursive Spaces: Landscape/View," *Art Journal* 42 (Winter 1983). Some of these authors raise interesting questions about the economic motives behind what Solomon Godeau calls the "photography boom," while others cannot understand how photographs can be the object of aesthetic analysis and categorization. I do not doubt that there are economic motives at work in the "art business," or that they are responsible in part for the "boom." For myself, however, I am not interested at all in the economic motivations of collectors of photographs or, for that matter, of collectors of Coca Cola bottles (of whom, I understand, there are many). The issues involved in the economics of the photography market are properly the subject of classes taken along the path to an MBA degree. I am, however, very much interested in the reasons advanced by these and like-minded writers for their belief that O'Sullivan's photographs (and the works of photographers like him) are not the proper subject of a photographic art history (for want of a better name). It seems to me that the only reason offered is that these photographs were not made with the proper intention to qualify as art works. But this is not so much a reason as it is a stipulation. And as a stipulation, it is just not terribly interesting. If Turner forgot to have

an artistic intention while making *Rain, Steam and Speed,* would that painting now be understood as a work of nonart? Could Turner have forgotten such a thing? For more on the futility of the notion of having the "right" intention to make art, see my "Documentary Without Ontology," *Studies in Visual Communication* 10, 1 (Winter 1984).

5. Weston Naef and James N. Wood, *Era of Exploration,* Buffalo and New York, 1975, 125–36.

6. The purists insist upon locating O'Sullivan's artistry in his unself-conscious use of the medium to express his pure photographic vision. The documentary intentionalists deny art status to O'Sullivan's work because he was not engaged in the sort of activity, was not located in the sort of milieu, and did not construe his activity in the sorts of ways they say are the necessary preconditions for the production of works of art. It seems to me that both "camps" share some of the same notions regarding the conditions that qualify a work as art. And clearly, I do not share these beliefs. Were it demonstrable that a person making pictures in the late 1860s and early 1870s had to conceive of himself and his work in the same terms that, say, Monet did in order to produce works that we can appreciate as being proper art works, then it would follow as a matter of course that O'Sullivan's photographs are something other than works of art. I have not suggested here or elsewhere that I take O'Sullivan to have been working in the manner of a painter like Monet. Certainly, O'Sullivan did not think of himself as an artist, nor for that matter did he think of himself as a scientist like King. I am not terribly interested in determining if we have a right to call O'Sullivan an artist. I am interested in establishing the possibility of addressing his work in the same way that we routinely address works of visual art—in terms of, say, expressive power, innovation, and formal cohesiveness. It may be a fact that we expect painters to be situated in certain ways before we will consider their products as works of art, irrespective of whether it makes sense for us to think in these terms. Nonetheless, it is not a fact that we treat the work of architects, movie directors, or graphic designers (among others) in the same way. Stanley Cavell, the Harvard philosopher, insists upon addressing some Hollywood films of the thirties as works of art, and I find his insistence exemplary. (See, for example, Cavell's *The Pursuits of Happiness,* Cambridge, 1982.) Likewise, the art historian Erwin Panofsky finds some motion pictures made by Hollywood studios of the thirties and forties artful and has no trouble dealing with them as works of art. (See Panofsky's "Style and Medium in the Motion Pictures," included in numerous anthologies of film criticism.) If a work engages the issues one expects to find in works of art and does so with intelligence, wit, invention, and depth, how shall we deny it art status without denying something fundamental about ourselves at the same time?

7. Wheeler to Humphreys, September 7, 1870, Letters Received by Corps of Engineers, Record Group 77-2047, National Archives, Washington, D.C.

8. King to Humphreys, August 14, 1872, Letters Received by Corps of Engineers, Record Group 57-M622-3, National Archives, Washington, D.C.

9. Lieutenant George M. Wheeler, *Progress Report Upon Geographical and Geological Explorations and Surveys West of the 100th Meridian in 1872,* Washington, D.C., 1874, 11.

10. Joel Snyder, *American Frontiers: The Photographs of Timothy H. O'Sullivan, 1867–1874,* Millerton, N.Y., 1981.

How Stieglitz Came to Photograph Clouds

SARAH GREENOUGH

In the fall of 1922 at the age of fifty-eight Alfred Stieglitz made ten photographs of clouds, thus beginning a project that occupied his attention for the next several years. In his now famous article "How I Came to Photograph Clouds," he wrote that he began to photograph clouds to refute a charge by Waldo Frank that the power of his work was due to "hypnotic" control over his illustrious subjects. "I was amazed when I read the statement. I wondered what he had to say about the street scenes—the trees, interiors—and other subjects, the photographs of which he had admired so much: or whether he felt they too were due to my powers of hypnotism."[1] In fact, Frank had written that Stieglitz "moulded," not hypnotized his sitters.[2] Nevertheless Stieglitz was incensed and began to photograph clouds to prove that his art was not due to privileged subject matter or hypnotic control. Clouds, after all, were "there for everyone—no tax as yet on them," he wrote, and surely no one could accuse him of hypnotizing something which moved so freely and quickly across the sky.[3]

Yet are we really to believe that Frank's comment alone instigated this remarkable series of photographs? Stieglitz continued to photograph clouds for the next eight years, making over 350 studies. Certainly he could have refuted Frank's supposed charge with far fewer images in a far shorter time. Nor does Frank's comment explain why after 1922 Stieglitz made such abstract photographs, unlike any of his previous work; why he titled them first *Music: A Sequence of Ten Cloud Photographs,* then *Songs of the Sky,* and finally *Equivalents;* why he hoped the composer Ernest Bloch on seeing them would exclaim, "Music! music! Man, why that is music!"; or what justification he had to claim that these small,

black-and-white images were equivalent to his feelings.[4] Clearly there were other reasons for the cloud photographs; clearly they embodied ideas of profound significance for Stieglitz.

Stieglitz himself believed that their roots lay in his earliest works made while a student in Germany in the 1880s. "Thirty-five or more years ago I spent a few days in Murren (Switzerland), and I was experimenting with ortho[chromatic] plates," he wrote. "Clouds and their relationship to the rest of the world, and clouds for themselves, interested me, and clouds which were most difficult to photograph—nearly impossible. Ever since then clouds have been in my mind most powerfully at times, and I always knew I'd follow up the experiment made over 35 years ago."[5] His photographs of clouds from 1922, *Music: A Sequence of Ten Cloud Photographs,* are similar to some of his student works, for example *Approaching Storm, Lake Thun,* 1888 (Figs. 1 and 2). Both the early and the later images are almost baroque in their theatricality; above mountains or hills soar massive clouds through which stream shafts of sunlight. But the 1922 photographs are significantly different from those that followed (Fig. 3). Beginning in 1923 Stieglitz photographed clouds so that they ceded their identity as natural phenomena and functioned instead as abstract forms. He did not photograph the clouds as the fitting complement to the landscape below, as he had done in his early European studies and those from 1922; instead these clouds are divorced from all references to the ground. Titled *Equivalents,* these later cloud photographs, with their interest in the expressive potential of abstract form, are far removed from the romantic images of Stieglitz's student days.

It is also difficult to find precedents for the *Equivalents* in Stieglitz's photographs made before 1920. In the first place, he made very few landscape photographs before that time. But more important, as he himself admitted, his earlier photographs are depictions of the picturesque aspects of European peasant life, representations of the charm of New York City at night or in the rain or snow, or illustrations of the transition of New York from a nineteenth-century city into a twentieth-century metropolis. They are photographic statements depicting Stieglitz's ideas about things—the peasant, the city, man in the city—but they are not, as the *Equivalents* are, expressions of pure emotions. They are representations of the artist's response to his environment, not illustrations of his subjective state.

The sources for the *Equivalents* do not lie in his photographs made before 1920, but in his 1923 essay "How I Came to Photograph Clouds" Stieglitz did correctly locate their roots. He wrote that he began photographing clouds to see what he had "learned in 40 years about photography."[6] The *Equivalents* are the culmination of his lifetime investigation

Figure 1. Alfred Stieglitz, Music: A Sequence of Ten Cloud Photographs, No. V, *1922. Alfred Stieglitz Collection, National Gallery of Art, Washington, D.C.*

Figure 2. Alfred Stieglitz, Approaching Storm, Lake Thun, *1888. Alfred Stieglitz Collection, National Gallery of Art, Washington, D.C.*

of the medium of photography, the direct result of what he had learned editing *Camera Notes* and *Camera Work* and directing both the Photo-Secession and his gallery "291." More specifically, the sources for Stieglitz's photographs of clouds lie in the Symbolist heritage of the Photo-Secession, the theories of modernism advanced at "291," and the movement of cultural nationalism that preoccupied Stieglitz and his associates during and after World War I.[7]

Long before Stieglitz published articles by Bergson or Maeterlinck in *Camera Work,* and long before he began to associate with critics and photographers who had direct links with the Symbolists (F. H. Day, Edward Steichen, Sadakichi Hartmann, or Benjamin de Casseres, for example), he had formulated in *Camera Notes* a coherent aesthetic of photography deeply indebted to Symbolism. This aesthetic provided the foundation on which he based his understanding of both art and photography, and it was the springboard for his future activities as both a gallery director and editor. Stieglitz, however, was not its main theoretician or even its most important spokesman; rather this aesthetic was most cogently expressed by the Englishman A. Horsley Hinton and the Americans Dallett Fuguet, William M. Murray, and J. F. Strauss. Scattered throughout their articles in *Camera Notes* are numerous Symbolist

Figure 3. Alfred Stieglitz, Songs of the Sky, *1923. Alfred Stieglitz Collection, National Gallery of Art, Washington, D.C.*

dictums: photographers were urged to abandon Realism, to cease to copy nature and instead appeal to the imagination; to suggest rather than delineate; and to cultivate a distinct artistic personality. But of far greater importance was the frequent assertion that with this suggestive art the photographer could become a truly creative artist. Hinton explained, "If we so portray the particular scene as to convey the same emotion to others, [then] we have created something which only existed in our imagination."[8] By using the image of concrete things to suggest subjective states, photography would be able symbolically to communicate "the abstract thoughts and subtle feelings which language is inadequate to express."[9] It would be an art which would appeal not to reason

but to intuition, it would impart not an intellectual but sensuous, emotional pleasure, and it would defy explanation. It would, as Hinton wrote, "make one feel. . . . Feel what? Has not my reader listened to music which has thrilled him through and through, and could he not have said that such and such music made him feel. . . . Simply this, made him *feel.*"[10]

This aesthetic helped to mold a generation of American photographers yearning to elevate photography to the ranks of the fine arts. When Stieglitz began publishing *Camera Notes* in 1897, there were few (if any) Americans whose work he could reproduce to elucidate these ideas; by its demise in 1902 there were several, including Edward Steichen, Gertrude Käsebier, Clarence H. White, Frank Eugene, and Joseph T. Keiley. These photographers also formed the core of Stieglitz's select organization, the Photo-Secession.

There is no doubt that Stieglitz supported this Symbolist theory of pictorial photography. As early as 1892 he heartily subscribed to the belief that "to surrender one's self to the imitation of nature would be to surrender all freedom, all individuality, and all ideals."[11] As editor of *Camera Notes* and later *Camera Work,* he made it the dominant theoretical issue under discussion; as founder of the Photo-Secession he made it the criterion of membership; and as an art collector it influenced his purchases. At the turn of the century Stieglitz is said to have owned reproductions of Franz von Stuck's *Sin* and *Oedipus and the Sphinx,* Arnold Böcklin's *Isle of the Dead,* and Franz von Lenbach's *Eleanor Duse*—a collection which epitomizes German Symbolist art.[12]

But Stieglitz's own photographs at this time were not strongly influenced by Symbolism, and his images are significantly different from those of the Photo-Secession. Contemporary critics recognized this and termed Stieglitz's work "realistic" and that of the Photo-Secession "impressionistic."[13] He did occasionally use some of their techniques (a compressed tonal range or manipulated gum bichromate prints, for example), but the detached introspection which is so typical of the work of White, Käsebier, or Steichen is nonexistent in Stieglitz's photographs. It is true that Stieglitz made few photographs between 1897 and 1907, the years when Symbolism was most strongly espoused in *Camera Notes* and *Camera Work.* But those that he did make (*Icy Night,* 1898, for example) are picturesque not mysterious, explicit not elusive, and have more in common with the art of the so-called Ash Can School than they do with that of the Photo-Secession.

Even at this time, however, Symbolism was of central importance to Stieglitz because it prepared him to accept modern art. On first impression, it appears that Stieglitz must have made an astounding leap to have

collected works by Böcklin and Stuck in 1900 and only a few years later exhibited the art of Matisse, Picasso, Braque, Picabia, Dove, and Hartley. But the work of these modernists was the logical extension of the ideas discussed in *Camera Notes* and *Camera Work.* For years, writers in these periodicals had condemned Realism, asserting that it was not the aim of art to mimic nature, but like music to express the feelings of the artist. And because they prized emotive expression and scorned the objective depiction of reality, these writers also frequently suggested that art did not even need to be representational. In a 1906 issue of *Camera Work,* Charles Caffin went so far as to insist that "if painting is to maintain a hold upon the intelligence and imagination . . . it must take on something of the quality which is the essence of music—the *abstract.*"[14] In short, the Symbolist ideas in *Camera Notes* and *Camera Work* provided Stieglitz and others with a solid foundation on which to base their understanding of modern art.

The introduction of modern art to America has been extensively discussed, but it is important to note that even though these artists were frequently scorned, many praised their attempts to formulate a new language of art. "It is a large order, this building up by a few artists of a new language all by themselves," a critic wrote in 1913. "You think of the laborious task of constructing over again an entire language, say in terms of Chinese ideographs."[15] It was not just a new language of form and color these artists were exploring, they were also formulating a new critical vocabulary for art. Their aim was not to affix labels, not to codify or categorize art, but to propose new ways of looking at, thinking about, and speaking of art. Their language was not new—it owed much to Symbolism—but it did nevertheless clarify their intentions and reveal their understanding of the function of art. For those associated with Stieglitz, this critical vocabulary centered around comparisons between art and music, art and photography, and the concept of equivalence.[16]

With the introduction of modern art to America, comparisons between art and music flourished and were used both to justify and explain abstract painting. In a review of the Armory Show in 1913, Caffin wrote that these artists wanted to express "pure feeling . . . that is to say, feeling unalloyed by association of ideas; the sort of feeling, in fact, that one may experience while listening to music."[17] Picabia, one of the most vocal proponents of this analogy between art and music, explained that "a composer may be inspired by a walk in the country. . . . Does he attempt a literal reproduction of the landscape scene? . . . No, he expresses it in sound waves, he translates it into an expression of the impression, the mood."[18] He insisted that just as "words are obstacles to [pure] musical expression," for music without words leaves the composer far freer, so

too is the depiction of recognizable objects an obstacle to pure artistic expression.[19]

This propensity to rationalize abstract art by comparing it to music accounts for the profusion of works by "291" artists with titles related to music. Some simply borrowed musical titles, much as Whistler had done years before: Hartley's *Musical Theme (Oriental Symphony)*, 1912–13, or somewhat later Georgia O'Keeffe's *Blue and Green Music*, 1919. Others, such as Max Weber in his work *Interior with Music*, 1915, attempted to translate specific musical compositions into visual terms.[20] Still others followed the example set by composers and used numerical titles, which provided no information about the subject of the picture or even the emotion which produced it, but simply identified the work: *Abstraction No. 3*, by Dove, for example.[21]

Another way that the "291" artists justified abstract art was to compare it with photography. Picabia summarized their beliefs when he asked, "Why should we try any longer to record material facts about objects or human beings, when the camera in the hands of an artist can tell them so well?"[22] Painting and photography are not alike; as Picabia explained, "The artist sees that photography can reproduce actuality better than any artist can, and so he sees that he must have a field to himself." That field, he continued, is the imagination. Photography "helped art to realize consciously its own nature, which is not to mirror the external world but to make real, by plastic means, internal mental states."[23] Because of the ability of photography to record objective reality, the "291" artists came to define painting as "the attempt to render external an internal state of mind or feeling, to project on to the canvas emotional, temperamental, mental, subjective states."[24]

The final way the "291" artists defended abstract art was with the concept of equivalence. It was essentially a modernist rethinking of the Symbolist ideas of correspondence and synaesthesia. Yet instead of maintaining that specific objects corresponded to or could evoke higher mental states, the "291" artists, as they came to embrace abstraction as the sole means to illustrate a subjective state, began to assert that pure color or abstract form could be "equivalent" to a subjective state. It was not, of course, an idea unique to the "291" artists or even to American thinking: Kandinsky did not use the term *equivalent*, but he certainly advocated the use of pure color and form as symbols of inner states; Roger Fry in his introduction to the controversial 1912 show at the Grafton Galleries explained that the Post-Impressionists "do not seek to imitate form, but to create form; not to imitate life, but to find an equivalent for life."[25] It was, however, an idea used with particular frequency and conviction by the "291" artists, critics, and photographers.

Marius de Zayas, the Mexican caricaturist and one of Stieglitz's closest associates, was the first to advance the concept. In the introduction to Picasso's 1911 exhibition at "291," he explained that Picasso "receives a direct impression from external nature," which he analyzes, develops, and translates "with the intention that the picture should be the pictorial equivalent of the emotion produced by nature."[26] The abstract patterns on the canvas are not, de Zayas explained, a representation of nature, but the visual equivalent of an emotional response to it. (This is a misreading of Picasso's work, but one the "291" artists accepted.) In 1913 de Zayas discussed the concept of equivalence at further length. Like other "291" artists, he recognized that a subjective state, which is immaterial, could only be represented by symbols. He noted that in mathematics, immaterial things are represented by abstract equivalents, signs which not only symbolize concepts but function as their equivalent. De Zayas proposed that artists should also use plastic equivalents—color and form—to represent abstract states of being. "The old art," he wrote, "permitted, and even more, imposed the representation of feelings and emotions through concrete form. Modern art permits the representation of feelings and ideas through material equivalents—abstract form."[27]

Those associated with Stieglitz came to use the concept of equivalence in two ways. For some, such as Williard Huntington Wright, an equivalent was a nonobjective "statement for life itself by the use of forms which have no definable aspects."[28] For the majority of "291" artists, however, an equivalent did not need to be nonobjective, just abstract. Abraham Walkowitz wrote, "I do not avoid objectivity nor seek subjectivity, but try to find an equivalent for whatever is the effect of my relation to a thing."[29] Oscar Bluemner concurred, noting that the abstract artist "selects from life or nature and transforms the visible manifestations into corresponding effects—equivalents"; he refracts "expressions of life through pictorial equivalents."[30]

The "291" artists and critics continued to advance the concept of equivalence long after the close of the gallery in 1917. In the early 1920s Paul Strand wrote that O'Keeffe used color to construct "graphic equivalents" of life experiences.[31] And Paul Rosenfeld noted that she found her equivalents through an almost mystical identification of self with the landscape; she synchronized her "inner rhythms" with "the great rhythms that pulse outside . . . in the earth, in the air."[32] But what was of particular importance to Strand, Rosenfeld, and others associated with Stieglitz, was that the landscape did not become a symbol of an emotional state; it was its visual equivalent. Thus, Strand declared, the paintings become "psychic equivalents, deeply related to those of music."[33]

Stieglitz was intimately involved with these discussions of the dif-

ferences between art and photography, the need for art to assume the
nonmimetic, emotive qualities of music, and the concept of equivalence.
So much was he involved, in fact, that he made them the aesthetic cor-
nerstones of *Camera Work* and "291." Scattered throughout his writings
from this period are further indications of his interest in these ideas. In
1910 he declared that "291" stands for those artists "who secede from
the photographic attitude towards the representation of form."[34] At the
time of the Armory Show he praised those artists who "decline to go on
doing merely what the camera does better" and stated that "art begins
where imitation begins."[35] Representation, whether by painting or pho-
tography, of the "mere outside of things" was not enough. Abstract art,
he asserted, was the "true medium."[36] "I believe it is possible that, just
as our ears react to pure abstract music, our eyes can be acted upon by
painting in purely abstract form. If that can be attained, it will mean
that the highest and noblest flower of painting has blossomed."[37]

But despite his enthusiastic acceptance of these ideas, Stieglitz did
not incorporate them into his work for several years, indeed not until
the early 1920s. Many reasons account for this. In the first place, he was
extremely busy directing "291," editing *Camera Work,* and in 1915 and
1916 assisting with the publication *291.* He had little time for his own
work. But more important, throughout the 1910s Stieglitz was more
concerned with "pure," "straight" photography, with creating images that
exploited photography's unique characteristics and particularly its for-
mal qualities. It took him several years to merge his appreciation of the
expressive potential of abstract painting with his understanding of and
respect for the ability of photography to record reality. It was the move-
ment of cultural nationalism that forced this reconciliation.

During and after the First World War there was a growing belief
among American artists, writers, and cultural historians that this country
could "no longer be *of* Europe," as the critic Waldo Frank wrote.[38] While
they actively campaigned against the war, James Oppenheim, Van Wyck
Brooks, Paul Rosenfeld, William Carlos Williams, Marsden Hartley, and
Sherwood Anderson, to name but a few, saw it as a rite of passage for
the American character. They believed its intense suffering and appalling
destruction would force Americans to recognize that they must be not
only politically independent, but intellectually and culturally free from
European influence. "We are living in the first days of a renascent pe-
riod," Frank and Oppenheim wrote in 1916, "a time which means for
America the coming of that national self-consciousness which is the be-
ginning of greatness."[39] In order to hasten the coming of this national
self-consciousness, these artists, critics, and writers also believed it was
imperative they reveal to Americans the American soul. Many followed

the example set by Brooks in his seminal study *America's Coming of Age* and searched for a "usable past." Works such as Frank's *Our America,* William's *The Great American Novel,* Rosenfeld's *Port of New York,* Hartley's *Adventures in the Arts,* or Hart Crane's *The Bridge* examined America's literary, social, or artistic past. They searched for the spiritual roots of the American character.

Yet, for many, historical investigations were not enough; they alone would never reveal the collective American spirit. It is "no good chasing [the American] over all the old continents," D. H. Lawrence wrote in 1923 in his highly acclaimed work *Studies in Classic American Literature,* "but equally no good *asserting* him merely." If he exists, "he must be somewhere inside you."[40] Several years earlier Romain Rolland had written that Americans are "born of a soil that is neither encumbered nor shut in by past spiritual edifices. Profit by this. Be free. Do not become slaves to foreign models. . . . Your true model is within yourselves. Your approach to [the understanding of America] must be the understanding of yourselves."[41]

For this generation, self-expression was a profound and urgent responsibility. (Malcolm Cowley and Brooks wrote that it was the gospel of the 1920s.[42]) The artist, they believed, was a gifted individual who made visible, and thus understandable, feelings and ideas which others only vaguely perceived. Brooks explained that no new society would emerge, no social revolution occur, until "a race of artists, profound and sincere, have brought us face to face with our own experience."[43] Writers, poets, and artists insisted that the only way to reveal the collective American soul was to express their own souls. "Give voice to your soul," Rolland wrote, "and you will find that you have given birth to the soul of your people."[44]

As his 1923 photograph of the gelded horse, titled *Spiritual America,* so clearly demonstrates, Stieglitz was intimately involved in these discussions. The war is primarily "a Great Hope," he wrote O'Keeffe in 1917, "the order of the whole world is in the remaking."[45] Frank, Rosenfeld, Anderson, Crane, and Williams were among his closest companions in the 1920s. He wrote that Frank's *Our America* moved him profoundly; Rosenfeld's *Port of New York* was "full of very fine stuff"; and Lawrence's *Studies in Classic American Literature* "touched me to the quick. The book I have been waiting for for years."[46] Throughout the 1920s Stieglitz repeatedly asserted that he was fighting for "America without that damned French flavor!"[47] To Anderson he wrote, "I have believed in American workers—I have fought for them—their spirit— their creations."[48] To Crane he said, "this country is uppermost in my mind—What it really signifies—what it is." But, he continued, "I do not

try much analysis—I do not arrive at my results that way . . . to *understand* anything one must endeavor to have one's *inner* house in order."[49] Like others of his time, Stieglitz steadfastly believed that the American soul would never be known simply by studying the past. Americans must "dig from within," he insisted; they must unreservedly express themselves. And they must recognize that each artist's expression was an expression of America. Dove, O'Keeffe, and Marin, he stated, are "the real America. . . . So am I."[50]

By 1922, therefore, Stieglitz believed it was culturally imperative for him to give expression to his soul and thereby help reveal the collective American soul. And, whereas in 1915 and 1916 he wrote of his wish to make "pure," "direct" photographs which captured the "essence" of form, by the summer of 1922 he increasingly spoke of his desire to "put his feelings into form," to prove that "the spiritual quality which painters and sculptors attain" could also be achieved in photography.[51] From his days directing "291" and editing *Camera Work* he had come to believe that abstraction was the most effective means for the visual artist to express a subjective state; it alone rivaled the emotive power of music. And he had adopted the belief that abstract forms and color could be visual equivalents of emotional states.

It was also in the summer of 1922 that Frank wrote the article which Stieglitz thought accused him of hypnotism. It was the final impetus. It did cause him to search for an inanimate object, something which he could not control, to disprove Frank's supposed charge. And this search eventually led him to photograph clouds. But the ideas embodied in *Music: A Sequence of Ten Cloud Photographs, Songs of the Sky* and the *Equivalents* had been developing for forty years.

NOTES

1. Stieglitz, "How I Came to Photograph Clouds," *Amateur Photographer and Photography* 56 (September 1, 1923), 255.
2. Waldo Frank, "A Thought Hazarded," *Manuscripts* 4 (December 1922), 5.
3. Stieglitz, "How I Came to Photograph Clouds," 255.
4. *Ibid.*
5. *Ibid.*
6. *Ibid.*
7. Marianne Fulton in "Stieglitz to Caponigro: An American Photographic Tradition," *Image* 26 (June 1983), 10–13, proposes that the sources of the *Equivalents* are Platonic philosophy, the writings of Emanuel Swedenborg, and Ralph Waldo Emerson's transcendentalism. While Stieglitz's cloud photographs certainly reflect much that is embodied in these concepts, it is the purpose of this

article to suggest that the direct antecedents of the *Equivalents* are to be found closer to home, in the ideas discussed at "291" and in *Camera Notes* and *Camera Work*. Rosalind Krauss in "Alfred Stieglitz's 'Equivalents,' " *Arts* 54 (February 1980), 134–37, discusses the cloud photographs as "Symbolist masterpieces" because of Stieglitz's use of cutting. She explains that the *Equivalents* are "most radically and nakedly dependent on cutting, on the effect of punching the image, we might say, out of the continuous fabric of the sky at large." And she continues, these photographs penetrate "to the deepest level of Symbolist thought—Symbolism as it understood language to be a form of radical absence—absence, that is, of the world and its objects, supplanted by the presence of the sign." This paper does not argue with this conclusion but merely wishes to suggest how Stieglitz arrived at this understanding of Symbolism. For further discussion of these cloud photographs and their sources, see my dissertation, "Alfred Stieglitz's Photographs of Clouds," Ph.D. diss., University of New Mexico, 1984.

8. A. Horsley Hinton, "Some Distinctions," *Camera Notes* 3 (January 1900), 98.

9. J. F. Strauss, "Symbolism," *Camera Notes* 5 (July 1901), 28.

10. Hinton, "Both Sides," *Camera Notes* 2 (January 1899), 79.

11. Charles Ames, "The Relation of Art to Nature," paper read before the Boston Industrial Art Leaders Association, January 2, 1892, 16. In the Stieglitz Archive, Collection of American Literature, Beinecke Rare Book and Manuscript Library, Yale University (hereafter cited as YCAL), there is a copy of this paper which Stieglitz annotated. Next to the passage cited Stieglitz wrote "excellent." He also underlined the following statements by Ames: *"Art springs from the power of a man's mind to create ideals and its impulse to realize them. Nature deals with the accidental; Art selects with what is permanent"* (10). "Art *selects, creates,* and *preserves,* and has definite aim and *unity,* and all with reference to the *soul of man"* (10). *"The artist is to supply what the raw material of nature lacks. His effort is not to create* mere illusion, but to body forth an idea, and anything worthy of the name of a work of art is in some sense a genuine *creation"* (11).

12. Edward Steichen, *A Life in Photography,* New York, 1963, n.p.

13. See J. T. Keiley, "American Pictorial Photographers: Alfred Stieglitz," *Photography* 17 (February 20, 1904), 149. In addition, Stieglitz was alternately praised for his "straightforward" depictions which were a relief from the "mysterious and bizarre" work of the Photo-Secession, and criticized for a lack of mystery in his photographs. Sadakichi Hartmann expressed both of these apparently contradictory remarks. See "A Plea for Straight Photography," *American Amateur Photographer* 16 (March 1904), 102, 104, and "The Photo-Secession at the Carnegie Art Galleries, Pittsburg, Pennsylvania," *Camera Work* 6 (April 1904), 49.

14. Charles Caffin, "Of Verities and Illusions," *Camera Work* 13 (January 1906), 43–44.

15. Samuel Swift in the New York *Sun,* reprinted in *Camera Work* 42–43 (April–July 1913), 48–49.

16. For a thorough examination of the comparisons between the visual arts and photography and music used by American artists and critics in the 1910s, see Judith Katy Zilczer, "The Aesthetic Struggle in America, 1913–1918: Abstract Art and Theory in the Stieglitz Circle," Ph.D. diss., University of Delaware, 1975. For a briefer discussion of the analogy to music, see Howard Risatti, "Music and

the Development of Abstraction in America: The Decade Surrounding the Armory Show," *Art Journal* 39 (Fall 1979), 8–13.

17. Caffin, "International Exhibition is Creating a Sensation," New York *American* February 24, 1913), 8.

18. Francis Picabia, as paraphrased in "A Post-Cubist's Impressions of New York," New York *Tribune* March 9, 1913, part 11, 8.

19. Picabia, as paraphrased by Hutchins Hapgood, "A Paris Painter," New York *Globe*, reprinted in *Camera Work* 42–43 (April–July 1913), 50.

20. In his 1930 retrospective exhibition at the Museum of Modern Art, Weber wrote that *Interior with Music* was "an expression of a conception of music as it wafts in space and is encased or seized in rhythmic architectural contour." *Max Weber: Retrospective Exhibition*, New York, 1930, 17.

21. Gabrielle Buffet in "Modern Art and the Public," *Camera Work* (June 1913), 10–14, wrote that in order to create "pure" works of art, painters must abandon narrative titles. Titles should have no more relevance to an understanding of pictures, she wrote, than musical titles have to the comprehension of sound.

22. Picabia, as paraphrased by Samuel Swift, "Art Photographs and Cubist Painting," New York *Sun*, reprinted in *Camera Work* 42–43 (April–July 1913), 46.

23. Picabia, "A Paris Painter," *Camera Work*, 50.

24. *Ibid.*

25. Roger Fry, Introduction to the Post-Impressionist Exhibition, Grafton Galleries, 1912, reprinted in *Vision and Design* Middlesex, England, 1920, 1940, 145. The term *equivalent* was also frequently used in popular journals. For example, Henry Nevison, in "The Impulse to Futurism," *The Atlantic Monthly* 114 (November 1914), 629–30, explained that the modern artist does not paint representational scenes, but "strives to find plastic equivalents for all appearances of our actual life."

26. Marius de Zayas, "Pablo Picasso," *Camera Work* 34–35 (April–July 1911), 66.

27. De Zayas, Preface to exhibition, reprinted in *Camera Work* 42–43 (April–July 1913), 22.

28. Williard Huntington Wright, *Modern Painting: Its Tendency and Meaning*, New York, 1915, 294–95.

29. Abraham Walkowitz, statement, *The Forum Exhibition of Modern American Painters*, exhibition catalogue, New York, March 13–25, 1916, n.p.

30. Oscar Bluemner, "Audiator et Altera Pars," *Camera Work* (June 1913), 33, and "Walkowitz," *Camera Work* 44 (October 1913), 25.

31. Paul Strand, "Georgia O'Keeffe," *Playboy* 9 (July 1924), 19.

32. Paul Rosenfeld, *Musical Chronicle*, New York, 1923, 6.

33. Strand, "O'Keeffe," 19.

34. "Photo-Secession Notes," *Camera Notes* 30 (April 1910), 54.

35. Stieglitz as paraphrased in "The First Great 'Clinic to Revitalize Art,'" New York *American* 26 (January 1913), 5-CE.

36. Stieglitz to Heinrich Kuhn, October 14, 1912, YCAL.

37. As quoted by Dorothy Norman, *An Introduction to An American Seer*, New York, 1960, n.p.

38. Frank,, *The Rediscovery of America*, New York, 1929, 66.

39. Frank and Oppenheim, editorial, *The Seven Arts* 1 (November 1916), 52.

40. D. H. Lawrence, *Studies in Classic American Literature*, New York, 1923, 1968, vii.

41. Romain Rolland, "America and the Arts," *The Seven Arts* 3 (November 1916), 48.

42. Malcolm Cowley, *The Exile's Return*, New York, 1934, 1976, 2, wrote that the doctrine of Greenwich Village in the 1920s was "self-expression. . . . Each man's, each woman's purpose in life is to express himself, to realize his full individuality through creative work and by beautiful living." In *Letters and Leadership*, New York, 1918, 38, Brooks stated that America had begun a new age which demanded "an intense cultivation" of "the creative life." The "gospel" for this age must be "self-expression."

43. Brooks, *Letters and Leadership*, 38.

44. Rolland, "America and the Arts," 49.

45. Stieglitz to O'Keeffe, Letter B 170, December 28, 1917, and Letter B 165, December 18, 1917, YCAL.

46. Stieglitz's comments on *Our America* as recounted in a letter from Margery Naumberg to Waldo Frank, November 1919, Waldo Frank Archives, University of Pennsylvania; *Port of New York*, Stieglitz to Seligmann, July 11, 1925, YCAL; *Studies in Classic American Literature*, Stieglitz to Seligmann, September 9, 1923, YCAL.

47. Stieglitz to Rosenfeld, September 5, 1923, YCAL.

48. Stieglitz to Anderson, October 1, 1924, YCAL.

49. Stieglitz to Crane, July 27, 1923, YCAL.

50. Stieglitz to Duncan Phillips, February 1, 1926, Phillips Collection, Washington, D.C., and Stieglitz to Rosenfeld, September 5, 1923, YCAL.

51. Stieglitz, "Photography by Paul Strand," *Camera Work* 48 (October 1916), 11–12; Stieglitz as quoted by Herbert Seligmann, *Alfred Stieglitz Talking*, New Haven, 1966, 61; and Stieglitz "Is Photography a Failure?" The New York *Sun* (March 14, 1922), 20.

Edward Weston's Toilet*

AMY CONGER

Five weeks after having returned to Mexico City from California in the fall of 1925, Edward Weston spent two weeks working on, worrying about, and writing about one series of photographs—those of the plumbing fixtures in his house on Avenida Veracruz. Since this was an extremely rare theme to have portrayed in any form of print then, it can be traced with fewer complications and leaps of faith than more common ones. It does not seem farfetched to investigate its origins in his work since he himself commented that he had been considering it as a subject for a long time.[1]

Although the French philosopher Gaston Bachelard apparently felt "unbounded contempt for those who . . . try to explain the flower by the fertilizer,"[2] obviously there is something to be learned about Weston's creative process and artistic contribution from analyzing the ingredients of the fertilizer, although what it enriches is, of course, always the primary concern. It seems that Weston knew about most of the ingredients of the fertilizer that will be described but that he was not conscious of them; he did not respond in an intellectual way recalling them in the heat of the creative moment—which in this case lasted several days—or while he was recording his feelings in his *Daybooks*. It is not a case of Weston deceiving us by omission, of not having told us "the whole truth" in his *Daybooks*. Weston recorded intense emotional experiences in his

*Photographs and quotations by Edward Weston © 1981 by the Arizona Board of Regents, Center for Creative Photography, Tucson. Reproduced by permission.

journals instead of venting them on those around him. He noted: "But write I must, no matter to what end. It is the safety valve I need in this day when pistols and poisons are taboo."[3] While he was dashing off these highs and lows in his life, he was not considering the thoroughness of his notes in terms of eventual historical and critical scrutiny.

This study also shows that despite the isolationist, Arcadian, "ain't nature grand" temperament sometimes associated with Weston, for which he was certainly responsible in part, he was quite aware at this time of artistic and literary happenings usually associated with East Coast intellectuals of the late teens and twenties.[4]

On October 21, 1925, Weston began photographing his toilet. He concentrated on this project until November 4. From the *Daybooks* it would seem that basically he spent two weeks running back and forth between the bathroom and the darkroom. He made at least seven negatives of the W.C. In the first, he inadvertently included a piece of cardboard which made it unacceptable. In the second, probably 4 M (Fig. 1), the plateholder was not perfectly centered in the camera back; he made one more with his 8×10 Seneca view camera on the tripod, and then four more with the camera resting on the bathroom floor. In the 1930s he recorded three of these negatives in his log as 4, 5, and 6 M (Figs. 1–3); the sink was 7 M. (M stood for "Mechanical or manufactured, belonging to our machine age.")[5] The first three works in this category, 1, 2, and 3 M, were photographs he had made in 1922 in Middleton, Ohio, on his way to New York City to meet Alfred Stieglitz. In the early 1950s, he selected the two angular views, 4 and 5 M, as well as the sink, to be included in the selection of 832 of his photographs known as Project Prints. No more than two vintage prints of any of the toilets have been located, although his log indicates that he made at least six of the first one, 4 M.[6]

Weston described at length what he experienced making this series:

> *October 21.* "Form follows function." Who said this I don't know, but the writer spoke well!
>
> I have been photographing our toilet, that glossy enameled receptacle of extraordinary beauty. It might be suspicioned that I am in a cynical mood to approach such subject matter when I might be doing beautiful women or "God's out-of-doors,"—or even considered that my mind holds lecherous images arising from restraint of appetite.
>
> But no! My excitement was absolute aesthetic response to form. For long I have considered photographing this useful and elegant accessory to modern hygienic life, but not until I actually contemplated its image on my ground glass did I realize the possibilities before me. I was thrilled!—here was

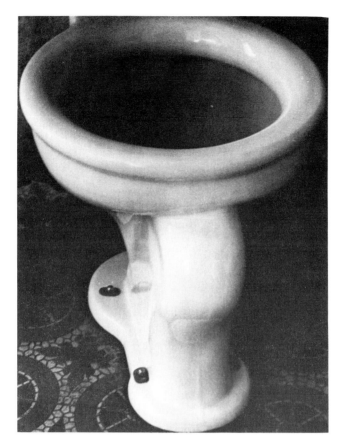

Figure 1. Edward Weston, Excusado, *4M. Courtesy of the Museo del Arte Moderno, Mexico City.*

every sensuous curve of the "human form divine" but minus imperfections.

Never did the Greeks reach a more significant consummation to their culture, and it somehow reminded me, in the glory of its chaste convolutions and in the swelling, sweeping, forward movement of finely progressing contours, of the Victory of Samothrace.

Yet the blind will turn longingly back to "classic days" for art! Now I eagerly await the development of my exposed film. . . .

October 23. The portrait of our privy could not have been finer but for a piece of carelessness on my part: during exposure I shoved a sheet of cardboard within range of the lens. So today I am working with my new enthusiasm. It is not an easy thing to do, requiring exquisite care in focussing—and

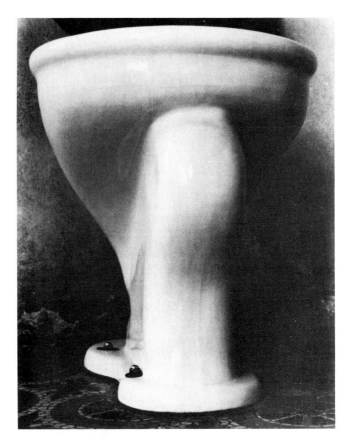

Figure 2. Edward Weston, Excusado, *5M. Courtesy of the University of California at Santa Cruz, Special Collections.*

of course in placing—though the latter I am trying to repeat. Elisa had only this morning polished up the bowl, though hardly in anticipation, so it shines with new glory.

The household in general make sarcastic remarks re my efforts,—Brett [Weston, his son] offering to sit upon it during exposure, Mercedes [Modotti, Tina's sister] suggesting red roses in the bowl, while both criadas [maids] believe me quite crazy. I showed the first negative to Felipe [Teixidor, his friend] who unhesitatingly offered me congratulations,—and Felipe is one of the first persons among my friends whose opinion is invariably sought for and well considered.

Evening of the 23rd. A good negative—technically at least— of the W.C. is washing. . . .

October 24—evening. Already the W.C. negative is printed!— a beautiful print too. Charlot [Jean Charlot, French painter]

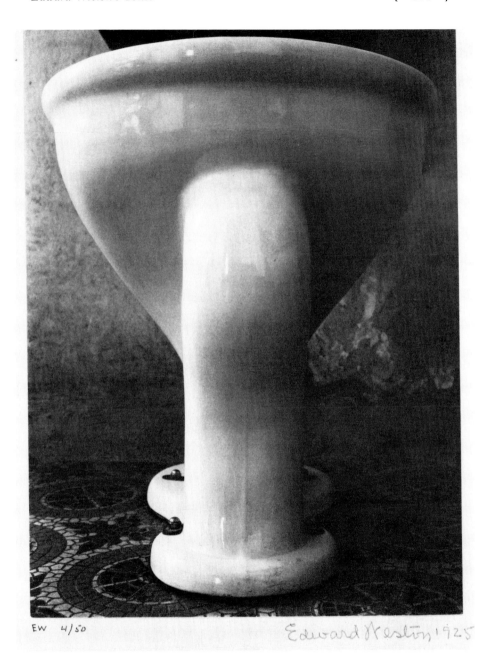

EW 4/50

Edward Weston, 1925

Figure 3. Edward Weston, Excusado, *6M. Courtesy of the International Museum of Photography at the George Eastman House, Rochester, New York.*

and Paul [O'Higgins, U.S. muralist] have seen it and agree
that it is one of my most sensitively observed photographs.
Now that it is printed the tile floor does not distract, in fact,
quite takes its place as a satisfactory base—suggestive yet un-
obtrusive. What absolute joy to be working again. . . .

Tea with Diego [Rivera, the artist] and Lupe [his wife],—
the three of us, Tina [Modotti], Brett and I. Of course I must
carry my portfolio of new work to show Diego, saving for the
climax the "Excusado." After his first exclamation,—"In all my
life I have not seen such a beautiful photograph," Diego sat
silently considering the print for many moments. This was
more significant to me than any praise. . . .

October 28. No use to "kid" myself longer. I am not ab-
solutely happy with the toilet photograph. My original con-
ception on the ground glass allowed more space on the left
side, hardly a quarter inch more, but enough to now distress
me in the lack of it. Not my fault either, excepting I should
have allowed for the play of the holder in the camera back.
I finally trimmed the right side to balance and though I admit
a satisfying compromise, yet I am unhappy, for what I saw
on the ground glass, I have not,—the bowl had more space
around it.

I spent hours yesterday contemplating the print, trying
to say it would do, but I am too stubborn and refused to say.
This morning I am no wiser which may mean that I should
do it over. Yet if I restrain my impulse and put away the print
for a week, I may become perfectly satisfied, not acquiescing
to something badly done but accepting a different conception
quite as good. And I am anxious to work more! . . .

October 30. Trying variations of the W.C., different view-
points, another lens. From certain angles it appeared quite
obscene: so does presentation change emotional response.

Only one more negative so far, which I might have liked,
not having done the first one. However I am not through,
the lines seen from almost the floor level are quite elegant,
but to work so low I must rig up some sort of camera-stand
other than my tripod.

November 1. It was more simple than I had thought: by
placing my camera on the floor without tripod I found exactly
what I wanted and made four negatives with no change of
viewpoint except that which came from substituting my short
focus R.R. [Rapid Rectilinear lens]. Unhesitatingly I respond
to my new negatives, and shall choose one to print from. ˉ

November 4. Questioned—I could hardly answer which of
my loves, the old or the new privy I like best: perhaps the

first, yet the second, or rather the last which is such a different conception as to be hardly comparable, is quite as elegant in line and as dignified as the other. Taken from floor level the opening circle to the receptacle does not enter into the composition, hence to nice people it may be more acceptable, less suggestive; however, "to the pure"—etc. I like best the negative made with my R.R. lens of much shorter focus, for by getting closer and underneath the bowl I attained finer proportions.

But I have one sorrow, all due to my haste, carelessness, stupidity, and I kick myself with pleasure. The wooden cover shows at the top, only a quarter inch, but distracting enough. Of course I noted this on my ground glass, but thought I must make the best of it; such a simple act as unscrewing the cover did not occur to me. I have only one excuse for myself, that I have done all these negatives under great stress, fearing every moment that someone being called by nature would wish to use the toilet for other purposes than mine.

Now shall I retouch the cover away—difficult to do—being black, or go to the effort and expense of doing my "sitting" over? I dislike to touch a pencil to this beautiful negative—yet it is in the unimportant background—and to do the thing over means a half day's work and confusion plus expensive panchromatic films. I shall start to retouch and see how I react! . . .

To take off the toilet's cover, either by unscrewing or retouching, would make it less a toilet, and I should want it more a toilet, rather than less. Photography is realism! Why make excuses?[7]

Two months later, on Christmas Day 1925, he again mentioned cynicism in relation to this subject. The first time he had said that he might be suspected of being in a cynical mood. This time, however, he wrote in a letter to his friend, the photographer Johan Hagemeyer: "I photographed our Excusado—the best thing I have done—it mirrors all my cynicism over life."[8] (Note that he had also just made the series of nude backs of Anita Brenner.)

Even though most people take it for granted that the toilet, like the zipper, has always been available, it is difficult to determine how much a novelty flush toilets actually were at this time. Although they existed at Knossos three thousand years ago and Queen Elizabeth had some sort of flush toilet in the sixteenth century, these are isolated examples. Public urinals were constructed as soon as the sewer system was improved in Haussmann's Paris,[9] but I have never noticed them as the subject of or in photographs by Atget or others from that period, although no sys-

tematic study of the subject has been made. In 1859, Baudelaire mentioned chamber pots, not toilets, along with skeletons, when he sought examples of subjects that would be "repellent" to the more timid of those photographers who believed art consisted of the closest imitation of nature possible.[10]

The history of bathtubs has been researched to a certain extent, but the W.C. has been virtually ignored, even in the *Encyclopedia Britannica* (1974). Although by the last quarter of the nineteenth century, running water was finally found in city houses in the United States,[11] the flush toilet consistently followed the bathtub. Although a few alternative designs were proposed in the nineteenth century, the one included in the 1923 Sears Roebuck catalog remains almost unchanged today.[12] It seems that the toilet was ignored in print even more consistently than the black slave was in U.S. photography, although for the same reasons: they were both unpleasant but useful parts of the inventory of daily life.

Production of and demand for sanitary fixtures in the United States remained stable from 1915 to 1921 at about 2.4 million pieces a year. By 1923 production had risen to 4.8 million a year, and by 1925, 5.1 million.[13] Bathrooms were obviously becoming a much more interesting subject.

Information about the popularity of the flush toilet in Mexico is even more incomplete. In August 1923 when the Colegio de San Pedro y San Pablo was inaugurated, the murals by Dr. Atl were described as well as the "quasi-luxurious toilets American style." Perhaps provoked by his friend Diego Rivera's review of Roberto Montenegro's frescoes in the same building, which was published on March 2, 1924, Weston went there in the first days of March and made his photograph of the stairwell.[14] We do not know, however, if he saw either the frescoes or the toilets. It is likely, though, that, at one time or another, he had heard Diego's famous "oration on the beauty of American plumbing."[15]

It is interesting to note that one of Weston's photographs of the toilet was published as a full-page reproduction in 1928 in *Forma,* an avant-garde art magazine.[16] This is the only time that any one of these pictures was published anywhere before the 1950s. It has been suggested that it was the reason that *Forma* ceased publication with this issue, but the editor, Gabriel Fernandez Ledesma, dismissed this theory as nonsense.[17]

Although it seems that the toilet was treated with more candor in Mexico than in the U.S., ironically, in *Forma,* this photograph was titled in English *W.C.* When Weston exhibited two of the series in Los Angeles in 1927, he called them *Plumbing Fixtures.* However, in the 1930s when he entered them in his log and when he included them in retrospective

shows in 1939 and 1941, he chose the title *Excusado,* the Spanish word. Perhaps it was thought that foreign euphemisms might soften the overall effect of the subject matter.

In March 1924 Weston remarked that he had just received a gift copy, dedicated by the author to him, of his good friend Paul Jordan Smith's book *On Strange Altars.* The first chapter of this book is a critical analysis of James Joyce's *Ulysses,* which was then banned in the United States and England because of its graphic references to sex and elimination. Smith's essay ended with these paragraphs:

> Vulgar it is, certainly,—as vulgar as a bed pan; as vulgar as life itself. But it is relieved by moods of singular beauty, it swings one from the stinks of the lavatory to the realms of luminous ether. It is everything: realism and romanticism, wisdom and nonsense, scatological hideousness and transcendental aspiration.
>
> And, finally, alas, there has probably never been a book, since the invention of printing doomed to exert such a baneful, such a malignant and perverting influence as *Ulysses.* It is the Demogorgon of literature.[18]

As soon as Weston had returned to Mexico in the fall of 1925, five weeks before he began working in his bathroom, he wrote his friend Miriam Lerner in Paris. Although he knew someone who had a copy of *Ulysses* in Mexico City, he asked her to send him several. By Christmas of that year, *Ulysses* was finally a part of the Weston household.[19]

Weston, however, must have already been familiar with at least the first half of *Ulysses.* It had been published serially in the *Little Review* from March 1918 until December 1920, and he had subscribed to that magazine from at least 1916 until probably 1926.[20] Four issues with selections from *Ulysses* had been confiscated by the U.S. Post Office, and the question of obscenity came to trial in New York in February 1921. The editor, Margaret Anderson, was represented by John Quinn, a prominent attorney and art collector who owned works by contemporary artists, including seventeen by Morton L. Schamberg.[21] One of the character witnesses for *Ulysses* was the poet John Cowper Powys. Weston had made at least two portraits of him in 1918 and had commented to Hagemeyer how favorably impressed he was by his talks.[22] Powys had also written the introduction to *The Book of Robo* while he was in San Francisco in December 1922. Robo was Roubaix de L'Abrie Richey, Weston's friend, and the then deceased husband of Tina Modotti, who lived with Weston from 1923 through 1926.[23]

The high point of the trial was when the prosecuting attorney was

requested to read those sections from a few pages which were considered obscene. One of the judges quickly told him that he could not do it because there was a lady in the courtroom. John Quinn pointed out that the lady was the editor who was being prosecuted. The judge reiterated his refusal, saying that, certainly, she didn't understand the obscenities. Anyway, Margaret Anderson was convicted and forbidden to publish more segments from *Ulysses*. This mood, along with the fairly generalized fear of editors to defend the cause of *Ulysses*, describes an ambient Weston must have been aware of.[24]

In 1923 William Carlos Williams, who was later to be Weston's friend, commented on Joyce's contribution: "But you must not mistake his real, if hidden, service. He has in some measure liberated words, freed them for their proper uses. He has to a greater measure destroyed what is known as 'literature.'"[25]

When *Ulysses* was brought to trial again in 1933 and this time pronounced innocent owing to the fact that the overall effect of the book was being considered, as opposed to that of the individual words and passages, one of the three prevailing judges stated in his verdict: "Art certainly cannot advance under compulsion to traditional forms, and nothing in such a field is more stifling to progress than limitation of the right to experiment with a new technique." The other judge who confirmed the new verdict described *Ulysses* as "a rather strong draught . . . emetic rather than aphrodesiac."[26]

Among other sources that Weston could have known was an article published in the *Little Review* in 1920 by the painter Marsden Hartley. It was titled "The Beautiful Neglected Arts," and in it Hartley described plumbers as "creators of aesthetic delights."[27]

Sometime before he died in October 1918, the painter, photographer, and sculptor Morton L. Schamberg made an oil painting of his studio in which the kitchen sink is a major element in the composition. More significant, however, is his undated sculpture of a plumbing trap, standing upside down, in a miter box which he titled *God* and which Walter C. Arensberg owned by 1918.[28] The compositional unity of this photographic print seems so carefully considered that it is not unreasonable to wonder if he might have intended the sculpture as a setup and the photograph as the end product.[29]

Margrethe Mather, Weston's former assistant, claimed to have been photographing toilets when he was in California in early 1925 and implied that she obtained the idea from her. Weston gladly admitted that he owed a great deal to her. In 1926 or 1927 he said: "I don't remember, but offer thanks if the idea came through her. I was sure to have done my toilet, suggestion from outside or not."[30] Because of the lack of physical evidence and the personalities involved, this seems to be an

academic question. This sudden interest in plumbing could have been, of course, purely coincidental or it could have been something in the water at the time.

The most obvious precedent for Weston's *Excusado* is Marcel Duchamp's *Fountain,* which was a urinal turned on its side and signed "R. Mutt/1917" (Fig. 4). There are two problems with this relationship. The first of these is to determine if Weston might have been familiar with this Dada monument, which is somewhat dependent upon whether the outcry created in New York could have been heard in California. The second is to determine what Duchamp's intentions were and how this ready-made was interpreted then, in 1917, not today, and compare this to the way Weston approached his subject.

Duchamp entered the *Fountain* in the first exhibition of the Society of Independent Artists in the spring of 1917. The show had been advertised widely as "no jury, no prizes"; in other words, anything submitted would be shown. However, the hanging committee, which consisted of the painters Rockwell Kent and George Bellows, placed it behind a partition, according to Duchamp, and it could not be seen in the gallery with the other 2,500 works.[31] The tag which is wired onto the left side of the urinal, visible in the photograph of it taken by Alfred Stieglitz, may be the entry fee receipt.

As a result of this discriminatory treatment, Arensberg and Duchamp resigned from their positions in the Society of Independent Artists. A special note about the reason for Duchamp's resignation appeared in the April 14 issue of *American Art News.* The writer, however, had only heard about the work and described it as "a nude young woman stepping into a real papier maché bathtub, with a real cake of soap affixed to the canvas."[32]

In May 1917 the second and last issue of *The Blind Man,* a Dada publication financed by Arensberg, dedicated several pages to this miscarriage of justice—or of aesthetics. Alfred Stieglitz's photograph of it was published, and the editors, including Duchamp, wrote a protest about the violation of the principles involved. It reads:

> They say any artist paying six dollars may exhibit.
> Mr. Richard Mutt sent in a fountain. Without discussion this article disappeared and never was exhibited.
> What were the grounds for refusing Mr. Mutt's fountain:—
> 1. Some contended it was immoral, vulgar.
> 2. Others, it was plagiarism, a plain piece of plumbing.
> Now Mr. Mutt's fountain is not immoral, that is absurd, no more than a bath tub is immoral. It is a fixture that you see every day in plumbers' show windows.

Whether Mr. Mutt with his own hands made the fountain or not has no importance. He CHOSE it. He took an ordinary article or life, placed it so that its useful significance disappeared under the new title and point of view—created a new thought for that object.

As for plumbing, that is absurd. The only works of art America has given are her plumbing and her bridges.[33]

In the same issue of *The Blind Man* several other pieces were published, which included direct or indirect references to the *Fountain*. These included a poem by the painter Charles Demuth which was titled "For Richard Mutt"; an article titled "Buddha of the Bathroom" by Louise Norton, wife of the editor of *Rogue*, in which she specifically discussed the rejection of this piece and mentioned "its chaste simplicity of line and color!"; poems by Walter C. Arensberg and Francis Picabia, titled "Axion" and "Medusa," both of which use symbolism that could certainly be associated with the *Fountain;* and a letter from Alfred Sieglitz advocating that in the future all works be submitted anonymously to the Society of Independent Artists' show.[34] Demuth also wrote a letter to the editor of the *New York Sun* about its rejection,[35] and in 1923 William Carlos Williams, possibly with the *Fountain* in mind, commented:

Expressionism is to express skilfully the seething reactions of the contemporary European consciousness. Cornucopia. In at the small end and—blui! Kandinsky.

But it's a fine thing. It is THE thing for the moment—in Europe.

The same sort of thing reversed, in America has a water attachment to be released with a button. That IS art. Everyone agrees that that IS art. Just as one uses a handkerchief.

It is the apotheosis of relief.[36]

Arensberg, whom Weston did not meet until 1930, purchased the *Fountain*—only to lose it later.

Apparently the *Fountain* was a shocking and humorous, not-soon-forgotten event in the art world. Although the work itself was not illustrated or clearly described in national publications or in magazines we know Weston subscribed to, like the *Little Review* or *Playboy*, he would have found out about it sooner or later because he had many contacts with intellectuals and artists on the East Coast. He could have been told about it by the writers Sadakichi Hartman, Alfred Kreymborg, Max Eastman, or Carl Sandburg, all of whom were involved in the avant-garde in New York and had their portraits made by Weston between 1917 and 1921. John Cowper Powys could also have told him about it in 1918 or in 1922 if they actually met on the latter trip. Surely dancers

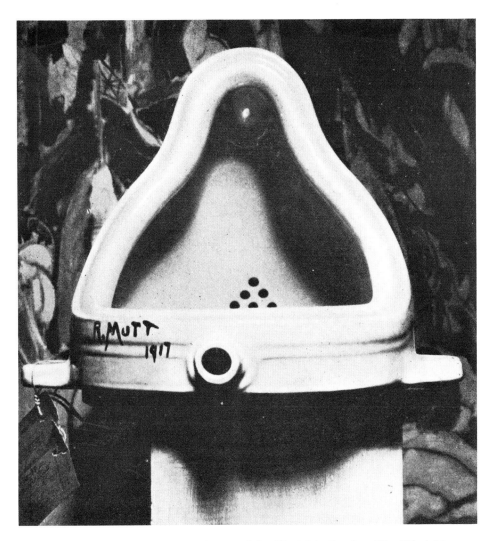

Figure 4. R. Mutt, Fountain. *Photograph by Alfred Stieglitz, from* The Blind Man 2 *(May 1917), 4.*

such as Maud Allan or Ruth St. Denis, the pianist Leo Ornstein, the art critic Antony Anderson, or the pictorial photographer Spencer Kellog would have known about the happening and had the opportunity to mention it during their portrait sittings with him. Moreover, just about anyone Weston met in New York in the fall of 1922 could have explained about the *Fountain,* an object which loses very little in translation from the visual to the verbal. Apparently Duchamp felt this way also since he issued several editions of urinals later. It is important to note that these

later issues were not exact replicas but, in one case, miniatures, and in the other it seems, urinals available commercially almost fifty years later.[37]

Duchamp's intention originally may have been to see how the Society for Independent Artists would react to a urinal presented as a work of art to their exhibition. He claimed that the *Fountain* was conceived rather casually during a conversation with Walter Arensberg and the painter Joseph Stella.[38] No one at that time ever claimed that the urinal was a thing of beauty but, instead, a matter of choice which "created a new thought for that object."

On the other hand, critics today have described the "autoerotic symbolic connotation of the urinal and its hermaphroditic overtones"; they have maintained that Duchamp was saying "Beauty is around you wherever you choose to discover it" and that it "prefigured much modern sculpture in its strictly formal emphasis."[39] Fortunately, it has only been suggested casually that this plumbing fixture was really an homage to the New York patron of Dada, Walter Conrad Arensberg, who was on at least one occasion referred to by his initials W.C.[40]

Duchamp said: "[I chose] the object which has the least chance of being liked. A urinal—very few people think there is anything wonderful about a urinal. The danger to be avoided lies in aesthetic delectation."[41] He elaborated on this: "A point which I want very much to establish is that the choice of these 'readymades' was never dictated by aesthetic delectation. This choice was based on a reaction of visual indifference with at the same time a total absence of good or bad taste . . . in fact a complete anesthesia."[42] He added: "Dada was very serviceable as a purgative. And I think I was thoroughly conscious of this at the time and of a desire to effect a purgation in myself."[43]

These were not Weston's intentions. He never believed his photographs of the toilet were a joke or a purgation. His works, moreover, show too much concern with form, placing, and tone to convey sarcasm. Instead, they communicate his sincere admiration. He did not distort the toilet by, for example, portraying it at an unusual angle but presented it in the most direct manner he could. The series immediately before this consisted of simplified, monumental forms against a plain ground: the torsos of Neil. His next series were nude backs showing variations of form that can be easily likened to toilets. Although Weston used basically the same subject as Duchamp, for him the plumbing fixtures, as well as his photographs of them, involved almost complete aesthetic delectation. In 1927 when Henrietta Shore asked him why he photographed the toilet, he answered: "Why, it was a direct response to form. . . . I felt so,—that was my reaction."[44] For Weston, any other toilet at any

other place or time, including Death Valley in 1939, would not have been an equivalent.

While Weston was excited by the heat of the creative process, while he joyfully described the toilet in his *Daybooks* as "human form divine but minus imperfections," exclaimed over "the glory of its chaste convolutions," and compared it to the prettiest of Greek sculptures, the *Victory of Samothrace*, he was not interested whatsoever in literally recalling visual and verbal precedents. At that moment the toilet was his discovery; there was no dialectic whatsoever taking place between the intellectual and the intuitive, or as he stated, "the war between my heart and brain" was not being fought.[45]

Weston had to have known that at least Marcel Duchamp and James Joyce, whose names were not new to him in Mexico, had used the toilet as an instrument for rejecting conventional values, tastes, and affectations.[46] Mere mention of the toilet, or of anything to do with it, was tantamount to a declaration of war against pictorialism—and one of Weston's fears when he first arrived in Mexico was of being seduced by exotic and picturesque scenes.[47] Certainly the statement he made by taking these photographs was an important factor in getting all of this out of his system. The cynicism he mentioned may have had something to do with rejecting many of society's restrictions and expectations. In 1931 he wrote: "—though my work has no trace of political propaganda . . . it is none the less radical,—it predicates a changing order."[48]

NOTES

1. Edward Weston, *The Daybooks of Edward Weston*, edited by Nancy Newhall, Millerton, N.Y., 1973, vol. 1, 132 (henceforth, cited as DBI; vol. 2 cited as DBII).

2. Cited in Dore Ashton, *The New York School*, New York, 1973, vii.

3. DBI, 126.

4. DBII, 111.

5. Edward Weston, Log, n.d., n.p., Weston Estate, Center for Creative Photography, University of Arizona, Tucson (henceforth, cited as WE/CCP).

6. Ibid.

7. DBI, 132–35.

8. Edward Weston to Johan Hagemeyer, December 25, 1925, CCP.

9. Siegfried Giedion, *Mechanization Takes Command: A Contribution to Anonymous History*, New York, 1948, 681.

10. Charles Baudelaire, "Photography," in *Essays and Images*, edited by Beaumont Newhall, New York, 1980, 112.

11. Giedion, *Mechanization Takes Command*, 684.

12. *1923 Sears Roebuck Catalogue*, edited by Joseph J. Schroeder, Jr., Northfield, Ill., 1973, 696.

13. Giedion, *Mechanization Takes Command*, 685.

14. Jean Charlot, *The Mexican Mural Renaissance: 1920–1925*, New York, 1979, 102–5.

15. Anita Brenner, *Idols Behind Altars*, New York, 1939, 282.

16. *Forma* II, 7 (1928), 18.

17. Elvira García, "Ochenta Años de Trabajo de Gabriel Fernandez Ledesma," *La Semana de Bellas Artes* (June 4, 1980), 5; Gabriel Fernandez Ledesma, interview with author, Mexico City, June 18, 1980.

18. DBI, 57; Paul Jordan Smith, *On Strange Altars*, New York, 1924, 34.

19. DBI, 68; Edward Weston to Miriam Lerner, September 17, 1925, Bancroft Library, University of California at Berkeley; Tina Modotti to Edward Weston, January 25, 1925, WE/CCP.

20. Ben Maddow to the author, October 1980; also see DBI, 190.

21. It is unclear when Quinn obtained them, but they were in his estate when he died in 1924. Ben Wolf, *Morton Livingston Schamberg*, Philadelphia, 1963, 39.

22. Edward Weston to Johan Hagemeyer, May 12, 1918, CCP.

23. Roubaix de L'Abrie Richey, *The Book of Robo*, Los Angeles, 1923, n.p.

24. Margaret Anderson, *My Thirty Years' War*, New York, 1969, 221; Paul Blanshard, "Sex and Obscenity," *The First Freedom*, edited by Robert B. Downs, Chicago, 1960, 186; Richard Ellmann, *James Joyce*, New York, 1982, 503; L. Reid, *The Man From New York: John Quinn and His Friends*, New York, 1968, 454.

25. William Carlos Williams, *The Great American Novel*, cited in Dickran Tashjian, *Skyscraper Primitives: Dada and the American Avant-Garde: 1910–1925*, Middletown, Conn., 1975, 111.

26. John M. Woolsey and Augustus N. Hand, "United States v. 'Ulysses'" in *The First Freedom*, 89; Anne Lynn Haight, *Banned Books: 387 B.C. to 1978 A.D.*, New York, 1978, 66.

27. Marsden Hartley, "The Beautiful Neglected Arts," *Little Review* 6 (April 1920), 59.

28. Margaret Kline, assistant curator of twentieth-century art at the Philadelphia Museum of Art, telephone conversation with the author, April 13, 1984.

29. Schamberg was in the same cultural circles as the photographer Paul Strand. Together with Charles Sheeler, the three of them had an exhibition in New York in the spring of 1917 and were awarded the top prizes at the Wanamaker Exhibition in 1918. Strand commented: "We all talked the same language—Sheeler, Schamberg, and Stieglitz." (Calvin Tomkins, *Paul Strand: Sixty Years of Photographs*, Millerton, N.Y., 1974, 143.) This association suggests that Schamberg's *God* could have been related to Strand's 1922 article entitled "Photography and the New God," which dealt with the relationship between man and technology.

30. Edward Weston, n.d. (December 1926 or soon afterwards), WE/CCP. The entire text of this note reads:
An amusing tale came to me, re the association of M[argrethe] and Edward: that when she came within my horizon I was "still doing babies on bear-skin rugs." Not true! I could never have afforded a bear-skin rug, it must have been imitation! I put myself now on record as owing a great deal to M[argrethe]—taking from her all she had to offer—and leaving her not when I had all I could get, but because she was draining me of all I had: it got to be far from an even exchange. [Next sentence deleted by EW.]

I will take from anyone all they can give me, and try to return them as much or more.

M [deletion like above but rest not clear] tells me she was doing toilets when I was here from Mexico last time. I don't remember, but offer thanks if the idea came through her. I was sure to have done my toilet, suggestion from outside or not.

31. Marcel Duchamp in Pierre Cabanne, *Dialogues with Marcel Duchamp,* translated by Ron Padgett, New York, 1971, 69. Critics disagree on what actually happened to the *Fountain* at the exhibition.

32. "Duchamp Resigns from Independents," *American Art News* 15 (April 14, 1917), 1.

33. "The Richard Mutt Case," *The Blind Man* 2 (May 1917), 5.

34. Ibid., 5–6, 8, 10, 15.

35. Quoted in Garnett McCoy, "Reaction and Revolution: 1900–1930," *Art in America* 53 (August–September 1965), 81.

36. William Carlos Williams, *The Great American Novel,* quoted in Tashjian, *Skyscraper Primitives,* 111–12.

37. Arturo Schwarz, *The Complete Works of Marcel Duchamp,* New York, 1970, 465–66; 512–13.

38. Ibid., 466.

39. Ibid., 467; Robert Lebel, *Marcel Duchamp,* translated by George Heard Hamilton, New York, 1959, 87; Josef P. Hodin, "European Modern Movements," *Encyclopedia of World Art,* New York, 1961, V, 193.

40. Gabrielle Buffet-Picabia (quoted in Cabanne, *Dialogues with Marcel Duchamp,* 69) referred to Arensberg as "W.C."

41. Schwarz, 466.

42. *The Salt Seller: The Writings of Marcel Duchamp,* edited by Michel Sanouillet and Elma Peterson, New York, 1973, 141.

43. Ibid., 125.

44. DBII, 17.

45. DBI, 81.

46. DBI, 147: n. 19.

47. DBI, 66, 81, 90.

48. DBII, 211.

Contributors

Beaumont Newhall is adjunct professor in the Department of Art and Art History at the University of New Mexico. The most recent honor to come his way was his designation as a MacArthur Fellow, in support of his researches over the next five years.

Mark Haworth-Booth is assistant keeper of photographs at the Victoria and Albert Museum; his most recent publication is the catalogue to the touring exhibition, *The Golden Age of British Photography.*

Eugenia Parry Janis is professor of art history at Wellesley College.

Anne McCauley currently teaches the history of art at the University of Texas. When assistant director at the University of New Mexico Art Museum, she organized and wrote the catalogue to the exhibition *Likeness: Portrait Photography in Europe 1850–1870.*

Kirk Varnedoe is professor of fine arts at the Institute of Fine Arts, New York University. He also was recently designated a MacArthur Fellow.

Joel Snyder teaches at the University of Chicago and is an editor of *Critical Inquiry.* His publications include *American Frontiers: The Photographs of Timothy H. O'Sullivan.*

Sarah Greenough coauthored, with Juan Hamilton, *Alfred Stieglitz: Photographs and Writings* and is currently writing a catalogue of the Stieglitz Collection at the National Gallery of Art.

Amy Conger is on the art history faculty at the University of California, Riverside, and is preparing a catalogue raisonné of Edward Weston's work.